THE ENCYCLOPEDIA OF
DECORATIVE
PAINT
EFFECTS

THE ENCYCLOPEDIA OF
DECORATIVE
PAINT
EFFECTS

*A unique A-Z directory of
decorative paint effects, including
guidance on how to use them*

SIMON CAVELLE

CHARTWELL
BOOKS, INC.

A QUARTO BOOK

First published in the USA by Running Press
This edition published in 2003 by
Chartwell Books
A division of Book Sales, Inc.
114 Northfield Avenue
Edison, New Jersey 08837
USA

This book was designed and produced by
Quarto Publishing
The Old Brewery
6 Blundell Street
London N7 9BH

ISBN 0-7858-1806-5

QUAR.EDP

Senior editor Sally MacEachern
Art editor Bob Flexner
Copy editor Mary Senechal
Senior art editor Penny Cobb
Designers Clare Baggaley, Karin Skanberg
Photographers John Wyand, Chas Wilder
Picture researchers Dipika Parmar-Jenkins and Anna Kobryn
Picture manager Rebecca Horsewood
Art director Moira Clinch
Publishing director Janet Slingsby

Typeset by Genesis Typesetting, Laser Quay, Rochester, Kent
Manufactured in Singapore by Colour Trend, Singapore
Printed in China by SNP Leefung Printers Limited

Dedicated with love to Mrs Jackie Glennon

PUBLISHER'S NOTE

Working with paints,
mediums, and varnishes
demands care, as some of
the mineral pigments used
in paints are poisonous,
and the solvents are highly
toxic. Always follow the
manufacturer's instructions
regarding safety, and store
chemicals and other toxic
substances well out of
reach of children. Neither
the author, copyright holder
nor publisher can accept
any liability for accidents.

Introduction

Many people admire decorative paint effects, such as false marbling or woodgraining, but feel they could never achieve them without employing the assistance of a professional. Professional paint effect experts are often secretive and do everything in their power to maintain an air of mystery and secrecy. In truth, however, anyone, with a little practice and determination, can produce pleasing and successful results.

This book is written with the aim of making a range of paint effects accessible to everyone, from the more experienced decorator to the complete amateur who has never used a paintbrush before. If you are a beginner you will probably find techniques such as sponging easier than some of the more specialist effects such as gilding or *trompe l'oeil;* but don't be afraid to be adventurous. All the techniques described can be tackled by the amateur, provided you read the instructions carefully.

The modern decorator has access to a huge range of colors and textures. While it's true that decorative effects are more challenging than just applying a simple coat of gloss oil-based or latex paint, they are also more fun to do. And the results can transform a quite ordinary room into a very special and individual environment. So, be brave: the first step is always the most difficult but, once it's made, there will be no looking back.

SIMON CAVELLE

Contents

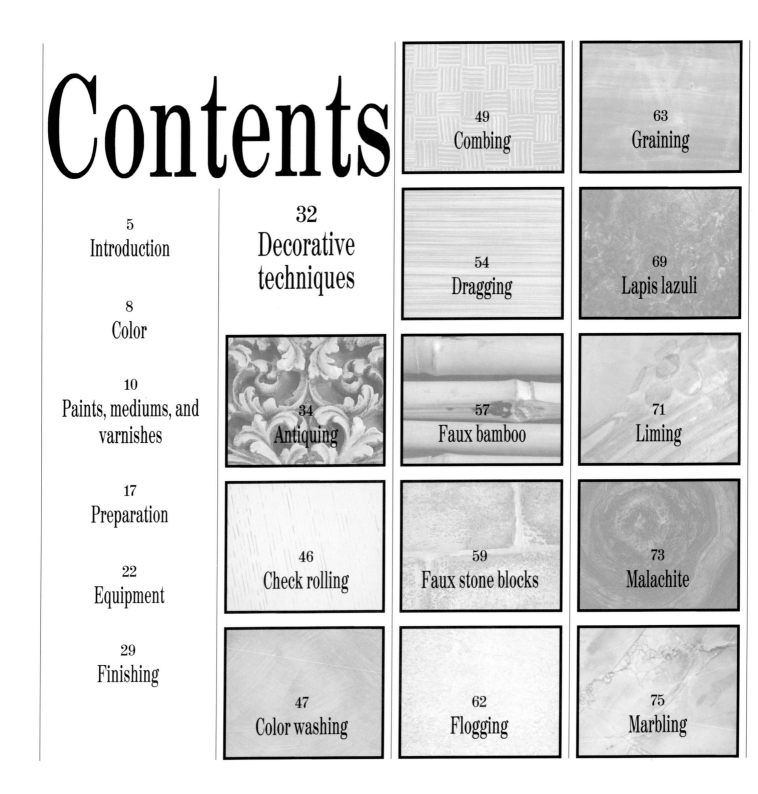

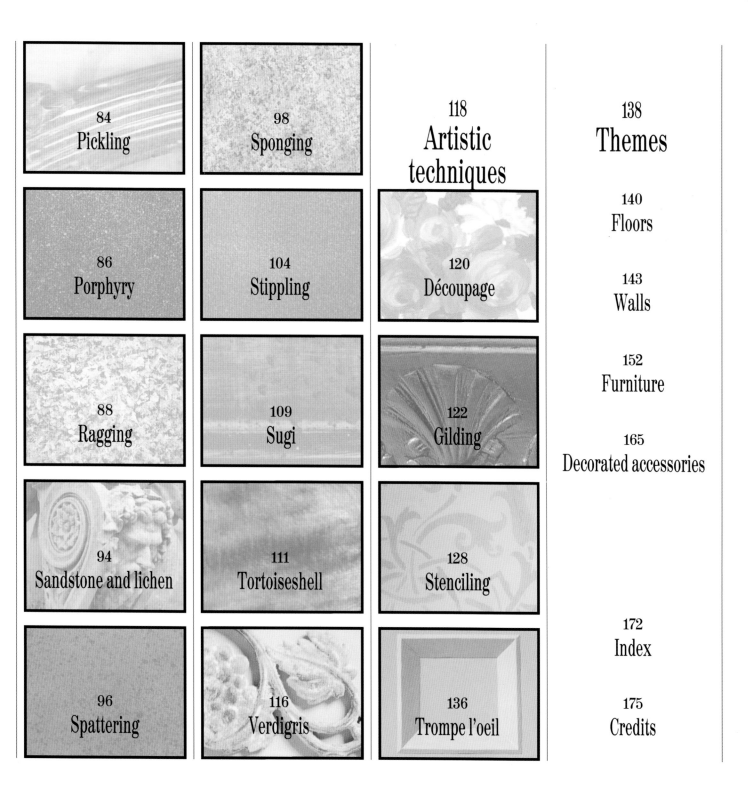

Color

Understanding color

Color mixing depends a great deal on getting to know the individual hues and how they react with one another. The color circle is a way of showing colors' foremost characteristics.

At the center of the circle are the primary colors: red, yellow, and blue. These are the three truly pure colors from which all other colors are derived. The secondary colors are those produced by mixing each primary color with its neighbor: red and yellow make orange, yellow and blue make green, blue and red make purple. In other words, these are the second generation of colors.

The next generation, mixed from two secondaries, are called tertiary colors, and the same exercise of mixing adjacent colors to produce different hues can continue until a full spectrum is produced.

Complementary colors
Complementary colors are those that lie directly opposite each other in the color circle. Because they are opposite they react strongly with each other. Yellow and violet, for example, when placed side by side, become more vibrant and in some cases seem to flicker. Such effects have long been used not only by leading artists, but for commercial purposes too. Oranges and tangerines are often wrapped in purple tissue paper. Butchers display their meat decorated with plastic greenery.

When complementary colors are mixed, they produce a mid-tone, or gray. Because they are so strongly opposed, they become unbiased – rather as mixing a strong acid with a strong alkaline produces a neutral. This effect can be very useful in color mixing. If a color is too vibrant, the tendency might be to add black. However, this action would dirty the color. If the complementary color is added, a less vibrant but still clean color will result.

The color circle can also be divided into warm and cold colors: blues and greens being cold, reds and yellows being warm. Remember,

PRIMARIES

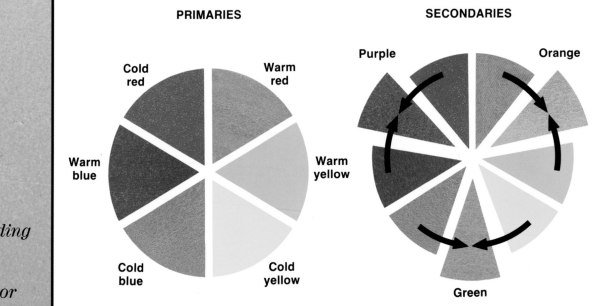

Cold red

Warm red

Warm blue

Warm yellow

Cold blue

Cold yellow

SECONDARIES

Purple

Orange

Green

however, that the colors in the circle are pure colors and owe their qualities to their position in the spectrum. Blues can be warm (with the addition of yellow, for example), and reds may be cold.

A tint is made by adding white to a pure color, reducing its strength and increasing its opacity. A shade comes from adding black to a color, which reduces its vividness and darkens it. A large amount of colored paint sold today is either a tint or a shade. However, care should be taken when mixing tints and shades, as they can easily become muddy.

COMPLEMENTARIES

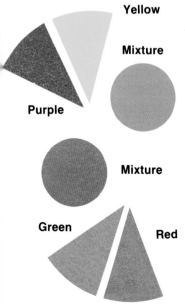

Yellow

Mixture

Purple

Mixture

Green

Red

Using color

Before deciding on your color scheme and selecting a decorative paint effect, think about the room you are decorating. Is it naturally light or dark? Is it to be used throughout the day, or just in the evening – as a diningroom, for example? Is the finish more or less important than the color? The answers to these questions will help you make your decision.

You can visually alter the dimensions of a room by your choice of color. Warm colours, used strongly, appear to advance and reduce the size of a room, while cool colors seem to recede and give an impression of space. Diagrams 1 and 2 help to illustrate this point. Each features an identical room, one with the back wall painted in a warm color and one in a cool color. The colored ceiling in diagram 3 reduces the height of the room, as does painting the ceiling and upper walls (diagram 4). Lighter colors above darker ones as in diagrams 5 and 6, help to give an impression of space and height.

COLOR AND SPACE

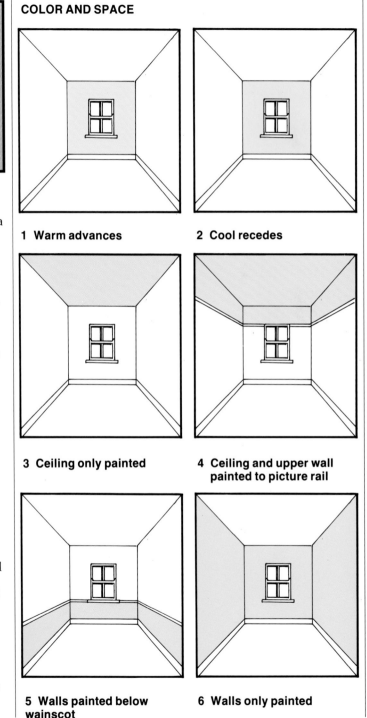

1 Warm advances

2 Cool recedes

3 Ceiling only painted

4 Ceiling and upper wall painted to picture rail

5 Walls painted below wainscot

6 Walls only painted

Paints, Mediums and Varnishes

Glazes

◆

Mixing colors

◆

Applied and subtractive finishes

◆

Applying paints

There is a bewildering range of paints, mediums, and varnishes available. This book is not primarily concerned with standard latex, eggshell, and gloss oil-based paints, but focuses on the paints, mediums, and varnishes used to achieve decorative paint effects. The chart opposite lists the main types, with their uses, solvents, advantages, and disadvantages.

A medium is a liquid in which pigment is suspended. Although paints in general can be described as mediums, in the context of this book a medium is a glaze or a wash. The two types of medium addressed are water-based and oil-based. Oil mediums dry more slowly and are more durable than water-based mediums. This can be an advantage if the finish is to be worked while wet, or is expected to suffer wear and tear. However, while it is wet, it remains vulnerable. The most awkward aspect of the oil-based mediums, however, is their tendency to yellow.

Name	Solvent
Artists' powder colors	Water
Universal colors	Mineral spirits
Artists' oil colors	Mineral spirits
Gouache colors	Water
Undercoat	Mineral spirits
Eggshell latex	Mineral spirits
Gloss oil-based paint	Mineral spirits
Flat latex	Water
Silk or satin latex	Water
Gloss latex	Water
Artists' acrylic colors	Water
Transparent oil glaze	Mineral spirits
Latex glaze	Water
Oil-based primer	Mineral spirits
Nitro-cellulose spray or acrylic lacquers	Lacquer thinner
Polyurethane varnish	Mineral spirits
Japan gold-size varnish	Mineral spirits
Shellac	Denatured alcohol

PAINTS, MEDIUMS, AND VARNISHES

Uses	Advantages	Disadvantages
For tinting oil- or water-based mediums.	Lovely vivid colors which can be used with any medium.	Quite difficult to dissolve, usually leaving some particles at the base of the container that need to be strained off. Normally needs sealer or varnish.
Very strong colors used by decorators to tint paints and glazes.	Called universal because they can tint oil- or water-based mediums, are cheap for the amount of tinting they offer, and easy to mix.	Limited range of colors and may react badly with some oil glazes.
Tints for oil-based paint, glazes, or varnishes.	High-quality colors. Can be thinned with oil or mineral spirits.	Some colors can be extremely expensive. Very slow drying.
For painting designs onto a surface or tinting water-based paints and glazes.	Exceptionally strong colors and therefore good for tinting.	Very expensive. Can only be used with water-based paints and glazes.
Gives a solid color in preparation for gloss or eggshell.	Easy to apply and dries in 8 to 12 hours. Widely available. Pleasant matte finish.	Not a finish in itself, and requires further coats of gloss, eggshell latex or varnish.
Top coat for walls and wood. Can be oil-based for a slight sheen, or water-based for a fast-drying finish.	Good color range. Ideal finish as a ground for paint effects. Wears well – less than gloss but longer than flat latex.	Costs more and takes longer to dry than undercoat. Can sometimes be too transparent and need an extra coat.
Oil-based top coat for woodwork.	Smart, hard-wearing, and resistant to dirt. Readily available in extensive color ranges.	Takes longer to dry than other paints. Any flaws will be more apparent due to the shiny surface.
Most time-efficient and cost-effective way of decorating a wall. Water-based, in a wide range of pale colors. Can be diluted for washes.	Quick to apply and fast-drying – recoatable in four hours. Very little smell. Does not show imperfections. Also available in non-drip.	Very absorbent and needs protection from dirt. Not very resistant to wear and tear.
Same as flat latex but offers a faint sheen.	Quick to apply, dries quickly, and is more hard-wearing than flat latex.	Less durable than oil-based counterparts and – unlike flat latex – tends to show flaws.
Flat latex qualities with higher shine, for use on interior woodwork.	All the advantages of a water-based paint combined with the appearance and easy cleaning of a gloss oil-based finish.	Can only be used on interior surfaces. Not as long-lasting as an oil-based gloss.
For tinting water-based paints and glazes, and for stenciling.	Quick drying. Good color range. Dries to a durable finish.	Even when a retarder is added, quick drying limits their use to smaller areas.
A tinted oil-based medium thinned with mineral spirits, it produces a slow-drying, durable top coat in decorative effects.	Exceptional covering power, which makes it relatively cheap. Dries slowly, giving time for it to be worked on. Provides a transparent coat.	Slow drying leaves it vulnerable for a long time. Tends to yellow when deprived of light (behind pictures and large pieces of furniture).
Tinted water-based medium that creates a quick-drying top coat in decorative paint effects.	Dries to a clear finish without yellowing.	Dries much more quickly than its oil-based counterpart.
Prepares raw wood for undercoat.	Contains more oil than undercoats and seals the wood, which is porous.	Liable to take a long time to dry.
Well known for automobile repairs and suitable for a wide variety of applications, principally on small items.	Very quick drying due to high solvent content. Works with a thin coat. Good for stencils and for providing a smoky effect.	Very expensive and cannot be applied over oil-based mediums. Highly inflammable and can be difficult to apply evenly.
Protects most surfaces, including walls, floors, woodwork and smaller items.	Versatile and hard-wearing. Widely available and offered in flat, satin, and gloss.	Tends to have a yellow tint. Hard when dry, and therefore difficult to rub down.
A quick-drying size used in gilding to stick the metal leaf to the ground.	Dries very quickly, lessening the risk of debris contaminating the surface.	Because it dries so quickly it tends to be brittle and give the leaf less glow than slower sizes.
The shellac known as BIN stain killer makes a useful barrier coat to prevent bleeding of colors and seals knots in new wood.	Dries very quickly and has a solvent base that makes it a successful isolating layer between coats.	Has a relatively short storage time and is not resistant to water or alcohol.

Glazes

Water-based glazes and washes

A wash is merely powder color suspended in a solution of water. Prior to its application the surface must be rubbed with chalk dust or whiting to remove any oil or grease. When dry, washes remain vulnerable and should be protected by a varnish as soon as possible. Thinned-down latex can make a good color wash. The problem that often arises with a latex wash, however, is that the edge dries too quickly and spoils the effect. This can be solved by adding a spoonful of glycerine to each pint of latex wash, which will prolong the drying time.

A water-based glaze or acrylic medium is a polymer emulsion that may be diluted with water. When allowed to dry, it forms a clear transparent film which is extremely resistant to yellowing. These glazes must be tinted with a good quality water-soluble pigment. Acrylic medium can be mixed with a colored latex paint to match a scheme or design, but the opaque mix will flatten the effect.

Acrylic mediums are extremely useful, retaining the benefits of transparency without the difficulties of yellowing. When dry they are water-resistant, and they are available in matte, satin, and gloss finishes. The fact that they are water-based eases the problem of cleaning brushes and equipment, but means that drying times are not long enough for some finishes to be achieved with them. This book shows the best and easiest way of doing each technique.

Oil-based glazes

A glaze is a transparent layer of paint tinted with an artists' oil or universal color, and applied over another glaze or ground of a different color to modify it. Glazes have been used in oil painting for centuries to give depth and a wonderful translucent glow. The glazes that are manufactured today have changed little over the years and contain a high proportion of linseed oil. Oil glazes can provide the most wonderful finishes, but they do have one potentially major drawback – the linseed oil gives them a propensity to yellow.

In the early 1980s the resurgence of paint effects inspired artisans to embrace a wide range of decorative effects without fully understanding their qualities. As a result, powder-blue glazes became green in a matter of weeks, and walls yellowed badly, especially when the finish was deprived of light, behind furniture or pictures, for example.

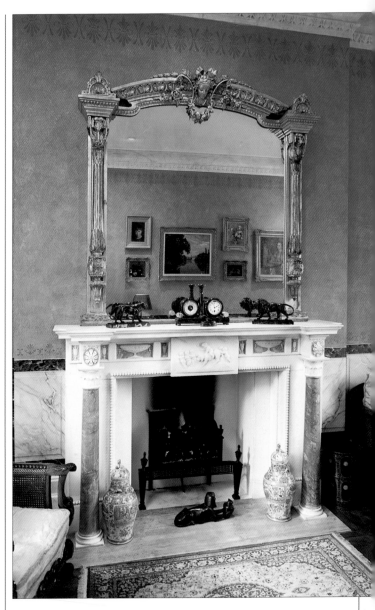

PETER FARLOW
▲ The rich glowing tones of this sumptuous room could only be achieved by using a glaze. The walls have been scumbled (a loose form of color wash) in a magnificent red. Stenciled patterns, the bottom line cleverly echoing the top, add elegance and prevent the red from becoming overwhelming. A wainscot rail in dark marble enhances the majesty of the red and links it with the beautifully marbled panels designed to reflect the marble columns of the fireplace.

▶ An oil-based glaze (right) has turned yellow (left). All oil-based glazes, particularly pale colors, have a propensity to yellow. However, you can prevent or delay yellowing by taking certain precautions.

Today, decorators are aware of the problem and, although a certain degree of yellowing will eventually occur, it can be reduced and delayed for a considerable time. This is especially important where pastel colors are applied on large areas, such as walls. First, be sure to use a good quality artists' oil or universal color. Cheap colors may initially look the same as their expensive counter-parts, but their light-fastness – that is, their permanence – and their strength of purity are bound to be less acceptable. When mixing color and glaze, make sure you concoct a strong mix. This is not as obvious as it sounds. The glaze is transparent, and so is the color you are adding to it. Only by painting a patch will you be able to tell its strength.

Some people feel that a true glaze should be thinned to the right consistency and then applied to create the finish. Any yellowing that occurs should be accepted as a price worth paying for the effect achieved. Others prefer a finish that is not only decorative, but serviceable with a reasonably long life. As a result, they add white oil-based paint or undercoat to

the glaze. This reduces its transparency and slightly flattens the finish, but it also retards any yellowing.

Adopting this route allows you to to take a short-cut. Instead of tinting your glaze with color and then adding white paint, you can add a pre-tinted undercoat or eggshell latex to the glaze. This reduces mixing time and offers you the extra ability to color-match or tone with a range of pre-mixed colors. If undercoat is used, the ratio should be approximately 20 percent paint to 80 percent glaze. For eggshell oil-based paint, use 30 percent paint to 70 percent glaze, because eggshell is more transparent than undercoat. The mix should now be thinned by approximately 20 percent mineral spirits to 80 percent. This should result in a colored glaze with the consistency of cream, which is ready to be applied.

SAFETY WITH GLAZES
Care is essential when using oil-based glazes. The thinned mix will have a very much higher mineral spirits content than paint and will therefore give off more fumes. Make sure your working area is well-ventilated and prohibit smoking. Spread out rags which you have used for cleaning brushes or to achieve a finish and which have become saturated with glaze and leave them out to dry. They must not be disposed of while still wet, as due to their low flash point, there is a danger of spontaneous combustion. Finally, although the oil content will prolong drying time, you should optimize conditions by keeping the temperature and humidity as constant as possible throughout.

Mixing colors

Although a paint store can mix most of the colors you are likely to need, mixing your own colors is very satisfying and means that you can achieve the exact shade you have in mind. Also, many artists' paints are mixtures of colors and will therefore have lost much of their clarity. By mixing pure pigments – in powder, tube or can form – with oil- or water-based paints or glazes you will be better able to achieve the right degree of transparency.

Blues
Ultramarine is nearest to the primary blue of the color circle. It is a pure color with a high tinting strength. To retain its clarity when mixing, combine it with viridian for a blue-green, or alizarin red for the purest of violets. Prussian blue is an ultra-powerful tint. Even a tiny trace will turn yellows and browns into bright green. It goes muddy with reds, however, except cadmium red with which it makes a rich deep black. Cobalt blue is midway between a transparent and an opaque color, but is

easily swamped by other colors when mixed. Cerulean and blue-green oxide are both variations of cobalt.

Yellows

The most natural yellow pigments are the ochres obtained from clays, which have a naturally dulling effect. Synthetic versions of these (known as Mars colors) are slightly clearer and brighter, but are still classed as dulling colors. Cadmium yellow comes in countless tones, the deepest of which are the most opaque, but medium-tone cadmiums equal the primary yellow of the color circle. Mixing with these destroys their clarity. Naples yellows have very strong covering power, so avoid these for glazing.

Reds

Like ochres, natural red pigments come from clays and their names and earth tones often reflect their origins. Cadmium reds, like the yellows, lose their brilliance when mixed. They are unsuitable for glazing, because the pigment remains in fine granules. Cadmium mixed with alizarin comes close to a primary red. Alizarin reds, like cadmiums, come in an endless variety of tones, from orange to violet. They make excellent glazes, especially over an opaque red or green, but if applied too thickly, alizarin loses its glow completely.

Greens

Viridian, which is very close to the spectrum color, is cool and pure in tone. It is transparent and so brilliant that it retains this quality even when mixed with white. Chrome green is much more opaque and suitable as a ground color.

The similarly colored terre verte is appropriate for glazing and is an ideal complement for red.

Browns

The umbers, raw and burnt, are the classic shadow colors. Burnt umber makes a good black when mixed with Prussian blue. It is heavy in tone and opaque – a good general darkener. Raw umber, having more water content, is more transparent. Raw sienna is transparent and makes a brilliant, light glaze. Burnt sienna is more opaque.

Points to consider

There are two stages in color mixing: mixing the color with the medium; and mixing one color with another to achieve a match. The most important point to bear in mind when mixing any paint or glaze is that the two substances should be as near each other's viscosity as possible. If, for example, artists' oil color were squeezed directly into a pot of transparent oil glaze and stirred, the color would not all mix. A lump of pure color would appear at the least expected moment and ruin the effect.

It is advisable to thin down all artists' colors before mixing. With oil color, add a little mineral spirits or turpentine and break the color down into a thinner paste, using a brush or a palette knife. Add the mineral spirits a little at a time, blending it thoroughly with each addition. Use the same technique for watercolor or acrylic color, substituting water for

mineral spirits. Always use the artists' colors rather than the less expensive but lower quality students' ranges. Make sure that the color has a reasonable permanence rating. Good manufacturers issue catalogs that provide information on the performance of their colors and also indicate which are transparent and which are opaque.

The ideal color-mix glaze will have the correct color and depth, will be transparent, and will last the longest possible time without yellowing. However, it may not be possible to achieve all of these qualities simultaneously. For example, if the desired effect is only achievable with an oil-based glaze, and the chosen color is a pale blue, you would either have to add white to reduce the yellowing qualities of the glaze, which would lessen its transparency, or the color or finish would have to be changed. The only way around the pitfalls is careful planning.

If you don't feel ready for color mixing, take a short-cut. Buy the appropriate color of paint – either oil- or water-based – and add the relevant glaze in a ratio of approximately 25 percent color to 75 percent glaze. In the case of oil, this mix should be thinned with mineral spirits by about 20 percent. For acrylic medium, the thinning will vary from finish to finish but approximately 10 percent of water is normally added to the mix.

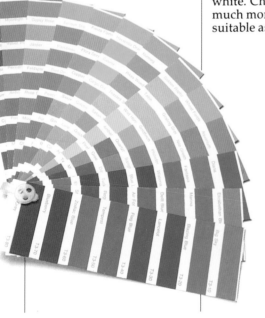

◄ **A selection of manufacturer's color charts showing the huge range of colors, tints, and shades available.**

Applied and subtractive finishes

Decorative finishes may involve adding paint or glaze to a surface, or removing it. An applied finish is added, usually to a dry surface. But when you apply a coat to a surface and then manipulate it in some way, you create a subtracted finish, because the paint or glaze is taken away in some areas to achieve the effect. The fundamental consideration when using a subtracted finish is drying time. The longer the paint stays wet, the longer it will be workable, but the longer it will be vulnerable too. A small surface, such as a box or picture frame, will take several hours to dry. In a larger area, such as a room, it is essential for the wet edge (see page 16) to advance across the surface without drying. It is therefore standard practice to split the operation into two parts. Complete alternate surfaces and carefully wipe each adjacent area clean of any overlap with a rag. Having allowed the first application to dry, you can work on the remaining walls without fear of accidental damage. To increase the speed of application, it is a good idea to enlist the help of another person, particularly while you are gaining experience.

An applied finish, such as sponging, or ragging on, is usually unaffected by drying time. In general, the quicker-drying water-based mediums are better for these. The great advantage to applied finishes is that there is no pressure – the process can be halted at any point and continued at a later date without undue risk to the finished effect. You can therefore attempt a large project without help.

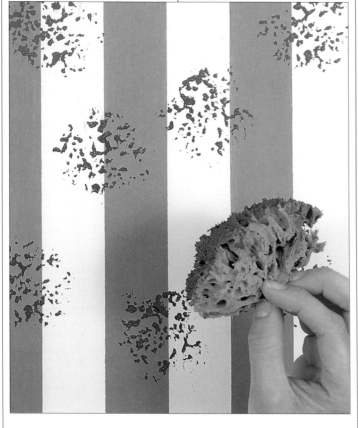

Applied finish – sponging on

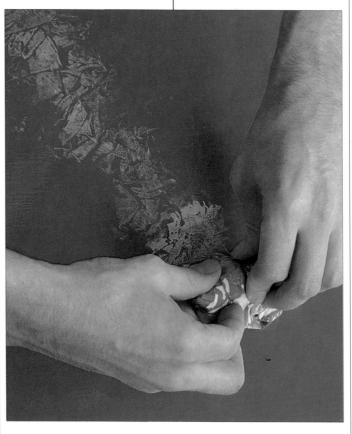

Subtractive finish – rag rolling

Applying paints

The finish of your walls or woodwork will largely depend on how you apply the paint. Applying paint is not difficult, but if you keep the following advice in mind, the results will look more professional.

Types of paint
Undercoat is an oil-based paint which makes an excellent base for over-decorating techniques, as well as oil-based finishing coats. Flat latexs have no sheen and are best suited to bumpy and old walls. Latex with a slight sheen is often called satin or semi-gloss. These do not absorb dirt so readily and are easier to sponge clean than flat latex, but they may reveal any flaws in the surface. Gloss paints are oil-based and usually applied to wood and metal.

Latex paint dries by evaporation of the water content, so keep the windows closed when applying it. Open the windows as soon as the work is completed. Most water-based paints can be given a further coat after approximately four hours, depending on the tempera-ture and humidity and the porosity of the surface.

Using a roller
When using a roller, make sure that it is evenly coated, then roll it in all directions, making your final strokes lighter in pressure to lessen the imprint of the roller pile. Use a 1 in. brush for edges and intricate areas.

Using a brush
When using a brush for latex, apply the paint in all directions with long sweeping strokes to give a full level coat. Use a smaller brush of about 1 in. to apply the paint behind pipes and other awkward areas. Begin at the top corner of a wall and work your way down in a patch width that you find comfortable. Do not stretch or reach while on a ladder – the time saved is not worth the danger.

When using a brush for gloss oil-based paint, lay on generously over a small section and distribute evenly with cross-strokes. Finish by removing any excess paint and tip off with firm, even strokes.

Tipping off
This term applies to the very last strokes of wet paint or varnish in any particular direction. Wipe your brush clean on the side of the can or on the strike wire across the can, then use long, even, extremely light strokes. If you are painting wood, the strokes should be in the direction of the grain. The aim of tipping off is to eliminate any brush marks or at least to reduce them to an absolute minimum.

PAINTING ORDER

The usual order when painting a room is ceiling, walls, woodwork. When painting ceilings or walls, begin with an edge and work in sections, trying not to overlap. Painting should always be done methodically, but quickly, keeping the wet edge moving, so that one section does not dry before the edges are blended with the next section.

Painting order is particularly important when it comes to windows and doors. The diagrams show the correct sequence.

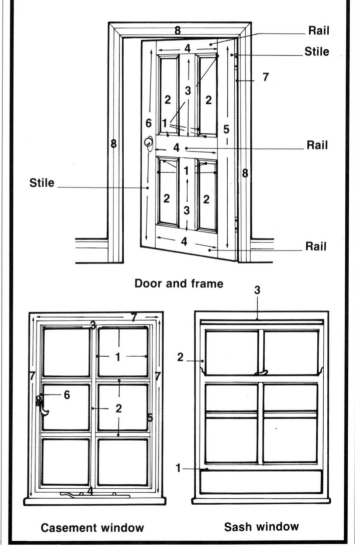

Door and frame

Casement window

Sash window

Preparation

Surfaces

Surfaces

◆

Sanding

New bare plaster
Ensure that new plaster is absolutely dry before applying paint to it. Water trapped in the plaster weakens the adhesion of the paint and may cause blistering. Some plasters have an alkaline nature, and when the plaster dries, white fluffy alkaline crystals may be deposited on the surface. These should be removed with a dry brush before painting. It is important to dry-brush the plaster anyway before painting to remove any surface dirt.

Fill any cracks or holes with a plaster-based filler, dampening the area slightly first with a little water. For the best results, overfill the hole or crack so that it is proud of the surface and overlaps the surrounding area. When it is thoroughly dry, level out the filler using a medium- and then fine-grit sandpaper and block. The sanding block is the best means of achieving an even surface. Always begin with a medium to coarse grit of sandpaper to remove most of the filler, and progress to a finer paper. Never use a paper coarser than the previous one. Only use sandpaper when cutting back filler, not on raw plaster walls: however fine the paper, it will make scratches. Remove nibs (rough flecks) and plaster splashes with a scraper, holding it flat against the surface and sliding it gently to avoid digging into the plaster.

Preparation should be compatible with the finished effect: oil-based for an oil-based finish and water-based for a water-based effect. For a finish using a water-based glaze or a wash, prepare the plaster with a coat of latex, thinned half and half with water. This thin coat seals the surface and creates a film which is absorbed by the plaster. Many modern paints tend to lie on top of the plaster rather than penetrating it. The sealer coat bridges the gap between plaster and paint, ensuring better adhesion throughout.

When the sealer coat is dry, any flaws in the surface will become apparent, and further filling will be necessary. This is best done with a fine-surface vinyl spackling. Use very fine sand paper to avoid breaking the paint surface, together with a sanding block for a true finish. Before recoating the wall with a full-strength latex, quickly cover the filled areas with the full-strength paint. This will save a complete coat to conceal them later.

Old plaster
If you have stripped off wallpaper, it is important to remove any trace of paste or size remaining on the surface, because these can cause the newly applied paint to flake. Wash the wall with warm water and a mild soap. Be sure to rinse off all the soap before leaving to dry, when a light sanding with a fine sandpaper will ensure your surface is clean. Fill the holes and cracks in the same way as for new plaster.

Sanding block with sandpaper

Now you need to assess the quality of the surface and make a choice. On a poor surface, it is often more economical to line the walls with heavy-duty lining paper (600 grade) than to spend hours laboriously filling and sanding. If you decide against paper, continue following the procedure for new plaster.

Lining paper should be butt-jointed, and not overlapped, to avoid a seam. The porous paper will act in a similar way to the raw plaster, so even if the end effect is to be oil-based, the paper should be sealed with a thinned latex or acrylic solution. The paper will soak this up and appear rather furry. When dry, it should be lightly sanded with a fine-grit sandpaper in readiness for the next coat. This will be water- or oil-based, depending on the base to be used for your final effect.

Painted plaster
The preparation in this instance is simply to make sure that the surface is clean, and that the paint to be applied will have some form of "key" to adhere to. Wash the area from top to bottom with a mild soap solution, taking care to rinse it clean. Treat any mold with a commercial fungicide. Key the surface by sanding with a medium-grit sandpaper or medium- to coarse-grit wet-and-dry paper, in conjunction with your sanding block.

As usual, the final effect will dictate which type of paint you now apply. If you plan to use oil glazes, apply two or three coats of an oil-based undercoat in the appropriate color, followed by a coat of oil-based eggshell. If the final effect is to be achieved with a water-based paint or glaze, apply unthinned latex directly onto the wall.

It is a temptation to apply paint too thickly in an effort to finish this boring part of the exercise. But it is far better to paint thinly, so that drying is quicker, and there is less time to wait between coats. In some cases the pigments used in paints are unstable and "bleed" through – red being the most common offender. One or two coats of BIN stain killer will act as a barrier and solve this problem.

Preparation over wallpaper
You might consider painting over wallpaper for one of two reasons. First, because

Sanding block with wet-and-dry paper

you wish to retain the paper's texture, or second, you fear that the plaster behind the paper is in such bad shape that most of it would be removed with the paper. Check that the paper is well stuck, with no peeling edges. Pull off any loose pieces, and fill all gaps and joints with vinyl spackling.

Don't be tempted to size old wallpaper, as any water-based solution will cause it to swell and create wrinkles and blisters. Apply an oil-based primer or thin undercoat and allow to dry.

Paint often causes color to bleed from wallpaper. This can be prevented by applying BIN or a thin coat of shellac, diluted with denatured alcohol to seal the color in. Continue with the application of the base coats as before.

Concrete floors
To prepare a concrete floor for finishing, first clean with a mild detergent and rinse. When dry, surface-fill with a fine-grade filler. Smooth the dried filler with a scraper,

Scraper

and apply a couple of coats of floor enamel to the floor, lightly sanding between coats.

Pottery and earthenware
Any pottery or earthenware which has not been glazed is extremely porous and requires sealing. Two coats of acrylic are therefore needed before you apply the ground or base coat.

Glass
This must be clean and free from any grease. To make sure of this, wash the glass in warm soapy water and rinse it thoroughly. Form a key by using wet-and-dry paper, together with a little water. The water acts as a lubricant and keeps the grit of the paper from getting clogged. Apply two or three coats of oil-based undercoat, followed by the appropriately colored eggshell. Latex or water-based paints and glazes are not recommended for use on glass and glazed ceramics. Being less durable, they are prone to chip and lose their grip on the surface.

Wire brushes

Metal surfaces

Old objects are often affected by rust. Never try to paint over even the smallest sign of rust, as this will merely recur and spoil the finish. Every trace of rust must be removed. For small areas use steel wool. For a large area you will need a wire brush or wire wheel attached to an electric drill. There are many ways to deal with rust, and the refinishing products sold for automobiles can be a great help. If the piece is damaged, you could patch holes with a fiberglass repair kit after all the rust has been removed.

Non-ferrous metals, such as aluminum or copper, should be washed with mineral spirits before priming.

New tin pieces should be washed in a half-and-half mixture of white vinegar and water to remove the greasy protective coating. Once the object has been cleaned, you can prime it with its appropriate primer. When this is dry, apply two coats of undercoat followed by two coats of eggshell. Latex, water-based paints and glazes are not recommended on this surface.

Raw wood

Raw wood must first be cleaned of grease and dust. Wipe it down with a mild detergent solution. Take care not to drench the wood, as this could lead to warping. Leave overnight to dry. The grain will rise due to the dampening and must now be sanded. Choose your grit carefully. If the wood is rough, a coarse paper is required. If the piece has been made by a cabinet maker, considerably finer paper will be needed. On flat areas use a sanding block, and remember to sand in the direction of the grain. Start at one side of the area and use long strokes of firm, balanced pressure. Overlap the sanding strips so that you do not miss anything. Use your sense of touch, and as you finish each area, wipe clean with a tack rag.

Treat all raw wood as if it still contained running sap. Any knot or crack that may bleed sap must be sealed with stain killer. This consists of shellac (a resin) in a denatured alcohol base, and dries very quickly indeed. Because of this it is prone to crack and therefore requires two or three coats over and just beyond the knot or crack. Any holes that need filling should be treated in the same way to prevent the filler drying out too quickly and becoming weak.

Next, apply a good-quality universal primer, making sure that the paint floods into any fault and seals the wood completely. Take extra care over the end grain, which will be more porous than the other areas. Once this coat is dry, you can fill any remaining cracks.

Once the filler has dried, sand it flush with the surface. Clean the work again with a tack rag before applying the undercoat.

Undercoat is normally put on with a brush. However, on especially large areas, it can be helpful to use a roller. Do not choose a foam roller for this – or for any oil-based paint – as it may be adversely affected by the mineral spirits in the paint. The aim when applying any base paint is to achieve a dense, even finish with the least amount of imperfections. As with latex, oil-based paints should be applied so as to limit the size of the wet edge (see page 16). On vertical surfaces it helps to tip off (see page 16) or lightly brush the paint in an upward direction.

Once the undercoat is dry, lightly wipe the area with a fine-grit sandpaper to remove any dust particles which have adhered to the paint and to create a key for the next coat. A second undercoat is normally necessary, followed by two coats of eggshell of your chosen color. After each coat dries, scuff the surface quickly with a fine sand paper to remove any particles and to key in the next coat.

Previously treated surfaces

As with any refinishing work, the previous treatment must be assessed. First, is the existing finish in good condition? And second, is it compatible with the intended effect? If the answers to these two questions are both positive, then all that is required is to clean and key the surface before going on with the base coats.

Wax is not compatible with paint, so if your surface has been polished with wax, this needs to be removed. For waxed wood, use denatured alcohol and a medium (00) steel wool. Remember to work with the grain of the wood and, when most of the wax has been removed, go over the surface again using a cloth in place of the steel wool. If you are dealing with a highly polished surface, use a finer steel wool – 000 or even 0000. Oiled wood should be treated in a similar way to waxed wood. Replace the denatured alcohol with mineral spirits and use a 00 steel wool. If

19

the surface has been varnished or shellacked and is in good condition, all you need to do is clean and key it in before applying the base coat.

If the surface is chipped or flaking, it should be removed. This can be done with abrasives such as sandpaper, or with a commercial stripper. Use abrasives if at all possible, because most strippers will remove oil from the wood, causing it to dry and weaken. A blow torch with a paint-stripper head can be effective. Be careful to play the flame from side to side to avoid charring the wood.

A French-polished (lustrous finish built up with thin coats of transparent or colored polish) surface should be treated in a similar way to waxed wood, with denatured alcohol and medium (00) and fine (0000)

▼ **Steel wool is available in fine and coarse grades.**

steel wool. Swab the surface with the denatured alcohol first, then rub it with medium-grade steel wool. The polish will soften quite quickly, and you will be able to wipe it off the surface. Once you have cleaned the object roughly in this way, go over it again with fine steel wool and alcohol, working with the grain.

Gesso

Gesso is a mixture of whiting, or powdered chalk, and glue (see recipe right). It is used to fill the grain of wood and to provide a smooth hard ground for gold leaf, marbling or japan work (a lacquer or varnish finish). A surface prepared with gesso will be smooth and cool to the touch like marble. Begin by giving the surface a coat of glue size or acrylic to prevent the glue in the gesso from being absorbed by the wood. Second, set and fill any pins or nails which may interfere with the adhesion of the gesso. Strengthen any joints by smoothing thin pieces of linen or silk soaked in gesso over them. These cloth reinforcements, which are called *intelaggio,* reduce the tendency of the gesso to crack and should be left to dry for at least two days.

Brush the gesso on smoothly and evenly to avoid bubbles. Most pieces will need six or seven coats. The first few coats will be relatively slow in drying; as the coats build up, they will dry faster. The correct time to apply the next coat of gesso is when its predecessor has become dull and is firm enough to be

brushed without being disturbed. If a coat is allowed to dry completely, the fusion between it and the next coat will be weakened and prone to chip. Once you start gessoing, you should continue until the piece is completed. Never increase the temperature of a room to reduce drying time, as this will make the gesso brittle. Remember when mixing your gesso always to overestimate quantities. It is far better to throw some away than to have to stop in the middle of application to make more. In fact, if the ratio of glue size to whiting varies much, adhesion may suffer. When the gesso has dried thoroughly, which normally takes two or three days, the surface will be ready for recutting and repolishing.

Recutting, which further smoothes and prepares the surface, is generally done with a cabinet scraper. This is a stiff, square-edged piece of steel, which has a slight burr on the edge. The scraper is held so that it leans slightly in the direction to which it is pushed or pulled. Work the area in a lattice pattern so that lines are not missed.

Water polishing makes the top surface of the gesso into a thin paste, which fills any superficial flaws. Dampen a clean cotton cloth and wring it out. Stretch the cloth over your fingers or over a sanding block and rub the surface. The porous gesso will soak up the water readily, and the cloth will require redampening frequently. Do not allow the

surface to become too wet, or the crispness achieved by recutting will be blurred. When the surface is smooth, leave the piece to dry for at least 24 hours.

A coat of shellac is normally sufficient to seal the gesso prior to applying of the ground coat.

Sanding

This is an essential task which is often overlooked. Many wonderful finishes are marred by lack of attention to touch. After all, a beautiful marble cries out to be touched, and if time and effort have been expended to achieve such an effect, it seems odd not to add the little extra effort that can turn a mediocre finish into a joy to view *and* touch. Sanding is probably the most important operation in preparation. It must be done to remove tool marks, and to smooth the surface and round the edges in readiness for paint. By using the correct procedures and selected grit of sandpaper, you can achieve an extremely high standard of finish. Sanding can be divided into three stages: using a coarse grit to create a new surface or shape; followed by a medium paper to smooth down the new surface; and using the finest grits to ready the surface for polish. In preparing wood, be careful to sand with the grain.

Wet-and-dry paper is black and, as the name implies, can be used wet or dry. The advantage of this is that a lubricant can be used to keep the paper sharp. With sandpaper the surface grit often becomes clogged and you have to change to a fresh piece. A lubricant (normally water) prevents clogging and therefore extends the life of the paper. When using wet-and-dry paper with a lubricant, rinse the surface regularly and make sure that all the sludge is removed. Only use wet-and-dry paper with a lubricant on a painted surface or metal – never on raw unsealed wood.

Silicon carbide paper is a crystalline abrasive that is very hard and sharp. It may be used on lacquers, plastics, wood, composition materials (for example, medium density fiberboard), plaster, and metal.

1 **Silicon carbide**
2 **Sandpaper**
3 **Garnet paper**

SANDPAPERS FOR SANDING

GARNET-PAPER	SILICON CARBIDE
–	12/0–600
–	11/0–500
10/0–400	10/0–400
9/0–320	9/0–320
8/0–280	8/0–280
7/0–240	7/0–240
6/0–220	6/0–220
4/0–150	4/0–150
3/0–120	3/0–120
2/0–100	2/0–100
1/0–80	1/0–80
½–60	½–60
1	1
1½	1½
2	2
2½	2½
3	3
3½	3½

More important than the type of sandpaper is the size of grit. This is graded by numbers which rise as the grit becomes finer. The paper most commonly found in hardware stores will be labeled coarse, medium, and fine. This is a good base from which to start. However, as you progress with your project, you will discover the need for a finer and maybe harder paper. By using the appropriate grit grade, you can obtain far more rewarding effects. The golden rule when sanding, however, is always to make a gradual transition from coarse to fine. Work with the same or a finer paper but never a coarser one, because this will cause scratches. The table (left) will help you choose the most suitable paper and grit.

Equipment

- *General equipment*
- ◆
- *Painting tools*
- ◆
- *Gilding tools*
- ◆
- *Plastering tools*

General equipment

In addition to paint, brushes and specialty items, you will find it useful to buy some general equipment.

Masking tape is ideal for securing stencils and masking off areas when you are using aerosols, but it should not be used to produce clean, straight lines; paint bleeds underneath it. Instead, use **clear cellophane tape**. Remove this by pulling the tape back on itself.

Masking tape

Clear cellophane tape

Level

Palette knives

A **level** and a **plumb line** are two of the most essential decorating tools, with uses ranging from checking that new plaster is level to making sure shelves are straight. A steel **tape measure** is used for a variety of purposes from measuring to providing a cutting edge.

Cutting mats, tracing paper, and **craft knives** are primarily useful for stencils or découpage.

Goggles and **dust masks** are both important safety items. Wear goggles whenever there is a danger of splashing paint, medium, or varnish into your eyes. Wear a dust mask when sanding or using powders.

Drop cloths are essential whenever you need to protect the floor or any other item. **Cotton rags** are useful for lifting off glazes, creating effects, and cleaning brushes, etc. **Cheesecloth** is a variable-weave cloth used for cleaning up and creating various paint effects. **Tack rags** are sticky open-weave rags, ideal for cleaning

Craft knives

Steel tape-measure

Tack rag

surfaces prior to painting or varnishing.

Many people paint out of the can, but a **paint pot** allows you to use a small amount of paint at one time, keeping the remainder clean and protected from air (which causes a skin to form). **Palette knives** are good for breaking up artists' oil color when mixing a glaze. A **corner painter** is extremely useful for painting corners or other adjacent surfaces.

Goggles

Cutting mat and tracing paper

Dust mask

Plumb line

Cotton rags

Drop cloth

Cheesecloth

Paint pot

Painting tools

There is a vast range of brushes available. The brushes listed here will cover most of your decorating needs. **Standard decorators' brushes** are part of any painter's kit. Sizes will vary depending on whether you are applying oil base or latex. **Radiator brushes** will make painting radiators a great deal easier.

Artist's brushes come in different shapes and are composed of different hair, ranging from the best and most expensive sable through squirrel and ring cat to more affordable hog hair. **Round** brushes have a fine point and should always be reshaped after cleaning. **Flats**, which have a square end, produce wide, thin imprints. **Filberts** are also flat but gently taper to a conical shape. **Fans** are just as they sound – splayed out like an open fan.

Badger-hair softeners are probably the most important members of a specialist collection. Badger-hair brushes are very expensive indeed, but once you have experienced using one for marbling or graining, you will find the

effect hard to equal. Nevertheless, it would be wise to learn how to soften using a **hog-hair softener** or dusting brush before trying a badger. This is because it is easy to produce an acceptable effect with a badger brush, and you will therefore have less incentive to improve your technique.

Dusting brushes are also known as jam dusters or, when a pale bristle is used, lily-bristle dusters. These brushes were originally designed to remove dust from an area prior to coating. They have been largely replaced for this purpose by the tack rag, except for removing deposits from moldings and intricate areas. More often they serve as softeners or for stippling in small- to medium-sized areas.

Fitches are the decorator's closest equivalent to an artist's brush and are used for small-scale work, such as cutting in the glazing bars of a window. They are available in hog hair or lily bristle, and in fan, oval, flat, or angled shapes. The angled fitch is often used for spattering because of its shape and its stiff bristles.

Floggers and **draggers** are used for graining. They come in various sizes. Draggers are primarily used for dragging and floggers for flicking against wet glaze.

Mops are soft brushes of squirrel or camel hair used when gilding, primarily to remove surplus gold or metal leaf, and to apply gold powder.

Mottlers or spalters are available in squirrel, hog

hair, and even sable. These are graining brushes, used for figuring or drawing the grain, normally after the undergraining is complete.

Stencil brushes are designed to achieve a fine effect when stippling over a stencil. They are made from hard-wearing bristle which has some spring, and are available in different sizes.

Sword brushes or sword liners were originally used just for lining. A sword brush has long soft hair and an angled face which enable it to travel long distances without having to be replenished. Now it is more often used for veining in marbling. Care must be taken to reshape it after washing.

Stippling brushes come in a variety of sizes. They are comparatively expensive and should be cleaned and stored carefully.

Dusting brush

Hog-hair softener

Dragger

Flogger

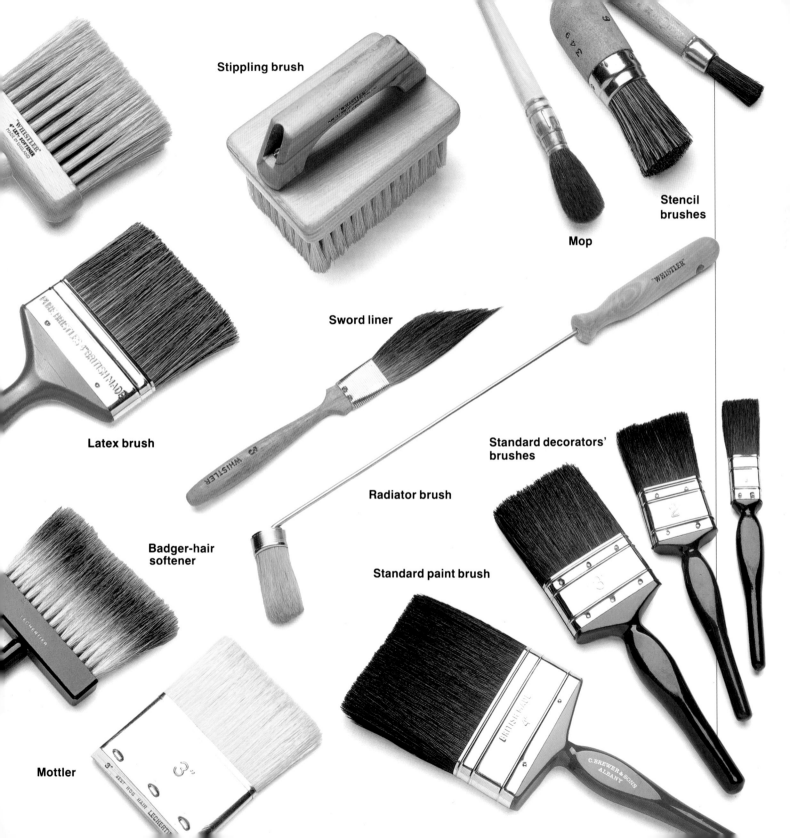

Stippling brush

Mop

Stencil brushes

Latex brush

Sword liner

Standard decorators' brushes

Badger-hair softener

Radiator brush

Standard paint brush

Mottler

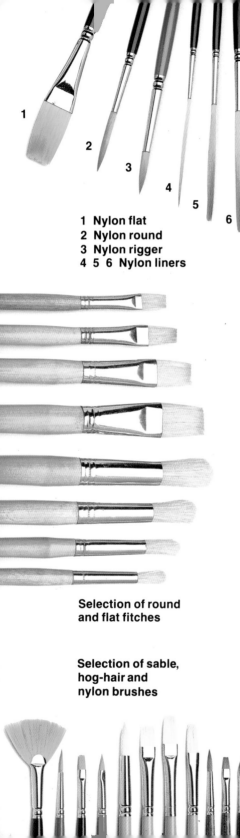

1 **Nylon flat**
2 **Nylon round**
3 **Nylon rigger**
4 5 6 **Nylon liners**

**Selection of round
and flat fitches**

**Selection of sable,
hog-hair and
nylon brushes**

BRUSH CARE

New brushes should be washed in warm water to remove loose bristles, and allowed to dry. This process should be repeated once or twice, or until no further bristles are lost. This is particularly important for varnish brushes. Remember that paint glaze or varnish dries on rollers and brushes just as easily as on walls. If you have to stop midway through and it is important not to let the equipment dry out. If you are using oil-based glazes and paints, stand the brushes and rollers in enough water to cover them, thereby preventing the air from reaching them. Shake the brushes and rollers clear of water before restarting work. When using latex glaze or paint, never soak the tools in water, because this will thin the paint or glaze that they contain. Depending on the length of your break, either wash the tools and leave them to dry, or wrap the brushes and rollers in plastic wrap.

CLEANING BRUSHES – OIL

First, remove the majority of paint or glaze from the brush with a rag or paper towel. When using brush cleaner or mineral spirits, rinse the brush, using an old steel comb or wire brush to loosen stubborn color. Always smooth or squeeze the bristles in a downward direction away from the handle. Once the brush appears to be clean of colour, it should be cleaned of solvent, but be sure that no paint remains on the brush before you do this. If you have used brush cleaner, rinse the brush clean in tepid water. Mineral spirits can be removed with normal soap and lukewarm water. Do not use detergents as these tend to deprive the bristles of their natural oils. Shake the brush in order to remove as much water as possible, and either lay it on its side or place it, bristles upward, in a jar to dry. If you find that the bristles are starting to splay out, wrap them, when damp, in a heavy paper secured with rubber band or masking tape.

CLEANING BRUSHES – WATER

A water-based glaze or latex paint is far more difficult to remove when dry than its oil-based counterparts. For this reason, try to wash the brushes and rollers used with this medium as soon as possible. A comb and a wire brush are useful tools when loosening thick, heavily clogged bristles, but these should be wielded with care, and plenty of water should be used to flush the paint or glaze away. Dry and store the brushes in the same way as those used with oil-based paints and glazes.

Other painting equipment
Paint trays and **rollers** are part of every painter's kit. Do not use a foam roller for oil-based paint as it may be adversely affected by the mineral spirits in the paint.

Feathers can be used in marbling, as an alternative to fine artist's brushes or sword liners. Any clean and reasonably sturdy feather will do.

Graining rollers or rocker combs are available in different widths and grades. They are normally made of rubber and pulled across the wet glaze with a gentle rocking motion to produce a heart grain wood effect.

Combs come in rubber, leather, and steel. A triangular rubber comb with differently graded teeth is a useful first choice.

It is important to choose the right **sponge** for your effect. Natural sponges are expensive, but will swell when immersed in water. Synthetic sponges have a regular shape but can be torn into more ragged and manageable pieces.

Swan and goose feathers

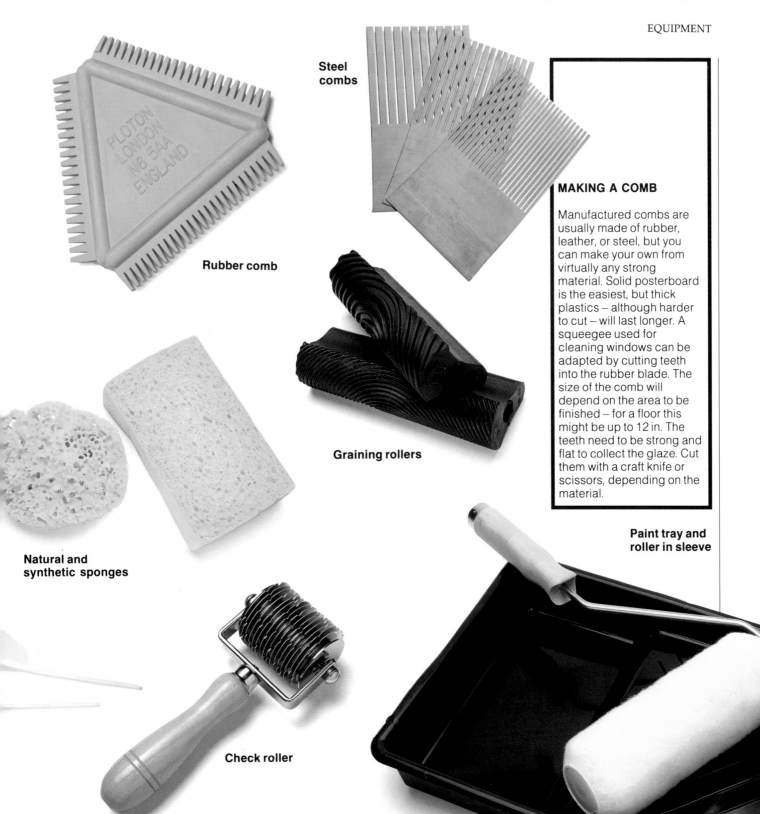

Rubber comb

Steel combs

Graining rollers

Natural and synthetic sponges

Check roller

Paint tray and roller in sleeve

MAKING A COMB

Manufactured combs are usually made of rubber, leather, or steel, but you can make your own from virtually any strong material. Solid posterboard is the easiest, but thick plastics – although harder to cut – will last longer. A squeegee used for cleaning windows can be adapted by cutting teeth into the rubber blade. The size of the comb will depend on the area to be finished – for a floor this might be up to 12 in. The teeth need to be strong and flat to collect the glaze. Cut them with a craft knife or scissors, depending on the material.

Gilding tools

Gilder's cushion, knife, and tip

Tools for plastering

Gold leaf is available from specialty suppliers and, like solid gold, its purity is measured in carat. The leaf most often used by professional gilders is 22 carat. This is available in different weights and thicknesses, referred to as standard or single, double and triple gold.

Silver leaf is sold in slightly larger leaves than gold. It is heavier and less expensive but, unlike gold, it tarnishes and must be varnished. The leaf needs to be kept tightly wrapped to protect it from the air, and it should be trimmed before application to prevent the joints from showing up as darker strips.

Aluminum leaf is cheap and is supplied in large leaves, which makes application much quicker. Although grayer than silver, it can be used to great effect.

Schlag, or **Dutch, leaf** is an alloy of copper and zinc and is available in shades of gold. It is far cheaper than gold, but needs varnishing to prevent it from tarnishing and, like silver leaf, should be kept wrapped.

Bronze powders, which range from pale gold to dark, or penny, bronze, can be used in their powdered form. Alternatively, you can mix them with a medium, such as gold size, to produce an effective paint.

Gold and other metal leaf is supplied in transfer or loose-leaf form. Transfer leaf is attached to thin tissue paper, so you can convey it to the surface easily without special tools.

Loose leaf is sold in books, as is transfer leaf, but because they are loose, you must take care to avoid the leaves falling out. As there is no backing to help you manipulate the leaf, you will need a **gilder's cushion**, a **knife** and a **tip** to convey it to the surface.

MAKING A POUNCE BAG

A pounce bag is a small cotton bag filled with whiting. It is used to dust the whiting over a surface in effects such as gilding, where it prevents unwanted adhesion of goldleaf, or graining, where it prepares an oil ground to receive a wash. To make the bag, take an old piece of thin cotton measuring about 8 in. square and spread it out flat. Carefully put a tablespoonful of whiting into the middle of the square, and gather up the four corners. Secure the ends with string as low down as possible to make a neat tight bag.

A **plywood board** is merely a strong clean board which is used to hold the mixed joint compound. It should be placed so that it overhangs a bench or stool enough for you to hold the hawk under the edge of it when collecting compound for use. The **hawk** is a small board, about 12 in square, with a short stick handle fixed to the underside. It is used to carry the compound from the plywood board to the surface, and to hold the compound as you work. Use the **taping knife** to apply the compound and to spread it over the area.

Plastering bucket, hawk, and taping knife.

Finishing

Varnishing

Varnishing

◆

Wax finishing

◀ **Better-quality varnish brushes hold more liquid and are therefore recommended for large surfaces. A good-quality new paintbrush can be used for small surfaces.**

There are three main reasons for contemplating varnishing: to protect a completed effect; to provide a barrier; and to add depth and tactility to a finish. There are situations, therefore, that do not require varnish. But when varnish is needed, it is important to select the right one. There are probably as many types of varnish as there are paint, and each is tailored to suit a particular application.

Oil varnish
It would be impossible to list all the available varnishes, as new products are constantly being made, but these will usually be improved versions of existing types. Probably the most robust – apart from industrial two-pack or acid catalyst lacquers – oil varnish is a higher build varnish than its water-based counterparts, but it does have a tendency to yellow. This needs to be taken into consideration when the effect to be covered is fairly pale.

The easiest oil varnish to use is polyurethane. It gives a slightly hard and clinical finish compared with more traditional varnishes, but this can be modified by polishing and is a small price to pay for its durability.

Oil varnishes can normally be purchased in three finishes: flat, which has almost no shine; satin, also called semi-gloss, which has a sheen; and gloss, which has a high sheen. Durability goes hand in hand with the finish: the higher the shine, the more protection offered.

If you want the protection but not the shine of a gloss finish, apply further coats of satin or flat varnish over the gloss. Be sure to key in by sanding before coating to ensure good adhesion. Several thin coats of varnish achieve a more even surface than one or two thick ones. Thinning the varnish with mineral spirits or turpentine will aid application of the first two coats.

Water-based varnishes and sealers
Acrylic and vinyl-based resins suspended in water do not yellow and offer some protection to the

Flat finish

Satin finish

Gloss finish

effect. PVA is probably best known as a glue, but also serves as a paint medium or size and makes a useful sealer and varnish. The varnish can be thinned with water and, although it is often opaque in liquid form, it will dry clear.

Sprays

Nitrocellulose lacquer in aerosol form can work well on latex or water-based finishes. Beware, however, of using it with oil-based mediums and colors. The nitrocellulose thinners which dilute the lacquer act like paint stripper on these. The finish must be entirely water-based – including the ground coat – to avoid damage. Be careful to read the advice given by the manufacturer and to follow all the necessary precautions. This type of lacquer is far more combustible than any other

and therefore demands greater respect. It takes far less time to dry than its counterparts and is much thinner. It offers only minimal protection, but will not yellow.

Varnish is sometimes found in aerosol form, but this is an expensive way of finishing a piece. The varnish will be much thinner than it would be out of a can, which will reduce its build and its protective qualities. Again, the manufacturer's advice should be followed to the letter, and the varnishing area must be well ventilated. When using aerosols it is always best to tilt the surface upward toward the spray so that you can keep the can vertical.

Preparation for varnishing

Varnish is highly vulnerable when wet. Not only will the shine be marred by a hair or

a piece of lint, but the decorative effect which requires protection may be weakened by any foreign body which becomes stuck in the varnish. Cleanliness is the answer. Wear clothes that are free from wool or lint, cover your hair, and prepare your working environment carefully by minimizing outside drafts and limiting movement in your chosen area. If the piece to be varnished is small, it is a good idea to shelter it underneath a cardboard box or similar screen. Remember to allow some air to enter the box or the varnish will remain wet longer.

The temperature and humidity of the room are also important. The varnish needs to be reasonably warm in order to flow correctly. In a humid atmosphere, there is a danger of blooming. This

can also happen to oil glaze and gives the surface a powdery look. It occurs as a result of already damp air entering into contact with the drying varnish or glaze, or when a drop in temperature causes condensation on the drying surface. The answer is to avoid humid conditions and to maintain as constant a temperature as possible.

The surface to be varnished should be smooth and free of nibs. Remove all grease by wiping with a cloth and a little mineral spirits. Take the tack rag straight from its sealed plastic bag and use it to clean the area meticulously, changing regularly to a clean fold.

Thoroughly mix the varnish with a clean stick or dowel – never shake it, as this will cause bubbles. Then decant the varnish into a pot with a "strike

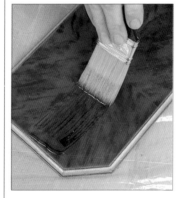 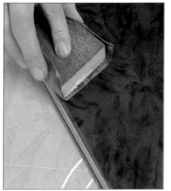 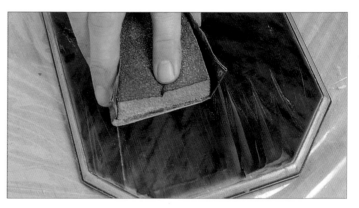

Varnishing
1 Brush on the varnish, gently tipping off so that the brush marks flow away.

2 After the varnish has dried for 24 hours, smooth down the surface with a block and fine-grade wet-and-dry paper, using water as a lubricant.

3 When the water becomes sludgy, wash the surface with clean water and a sponge.

wire'' attached. In cold weather the varnish may require warming before decanting. Varnish is inflammable so never use a naked flame for this. Take off the lid, and place the can in warm water for a few minutes. Remove the can and stir the varnish with a clean stick. If it is still too thick, repeat the exercise using hot water.

Load the prewashed brush with the decanted varnish and transfer this directly to a piece of brown paper without wiping the excess onto the strike wire. Work the brush over the paper, spreading the varnish. This expels air from the bristles and removes any last stray bristles. From now on, the brush should remain wet.

When varnishing is complete, the brush must be stored in keeper varnish. Make this by mixing two-thirds mineral spirits or turpentine with one-third varnish. Suspend the brush so that the solution covers the bristles completely, keeping them clean, supple, and free of air. You can buy a pot which has clips to hold the brushes in position and which is also equipped with a dust cover. Alternatively, use an old clean varnish can, drill a hole in the stock of the brush and pass a wire through it which will rest on the lip of the can.

Varnishing technique
Because varnish is transparent, it is advisable to have a strong light source behind the piece so that you can constantly check the surface for the glint which tells you which areas have been coated and which missed. On a limited area, such as a small table top, start at the center of the panel and work outward.

When the surface is extensive enough to require re-loading of the brush, apply the varnish in strips, using the technique of moving the wet edge. Try not to overload the surface with varnish, which could result in runs or sags. These build up slowly and then appear as if by magic. Practice will help you discover just how much varnish to apply and how thinly you can brush it out without its breaking. Remember that you can thin the early coats a little to make application easier. Wipe the excess from the brush by means of the strike wire and not the edge of the can. The wire forces the returning varnish to enter the container in a thin stream, helping to prevent bubbles. It also reduces the buildup of the drips often found hanging like stalactites around the inside lip of varnish cans. In time, these break and fall into the varnish, rendering it unusable.

Stone-effect finish
Oil varnish can be treated after application to impart a stone-like quality to the surface. Apply the varnish in the normal way, and while it is wet, scatter granulated sugar over the surface. This will sink into the varnish in varying degrees and must be allowed to dry hard. After about 24 hours, wash the surface with warm soapy water. The sugar will dissolve, and the pock-marked texture will become apparent.

Wax finishing

Wax finishing can be achieved over varnish, shellac, and lacquers. Prepare the surface by rubbing gently with 320 grit paper to remove nibs and flaws. Clean with a tack rag. Place a small amount of wax polish between several layers of cheesecloth, press it onto the surface, and apply it in a circular motion. Leave to dry for 10 minutes. Then rub the dried wax hard with a clean, soft cloth, first in a circular motion, and then along the grain. Leave for an hour and repeat the application.

Polishing with wax and steel wool
This is the most common way to polish marble effects, and a fine finish can only be achieved over at least two coats of varnish. The surface should be flattened off first, using fine wet-and-dry paper and a block with water as a lubricant. Using a 0000 steel wool and good-quality wax, rub the length of the surface in long, straight strokes. Finally buff the finish with a soft rag.

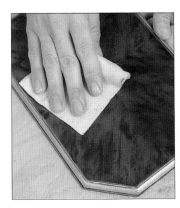

4 Clean with a tack rag to prepare the smoothed varnish for a further coat.

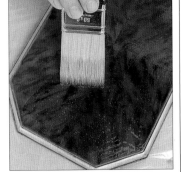

5 Apply the final coat of varnish using the same method as before.

Techniques

You need no prior knowledge of paint effects to achieve pleasing results. However, you will achieve more successful results if you have suitable equipment and, most important of all, if you have prepared your surface correctly and to a high standard. If you enjoy color and the interactions of colors, all you need to know is that most paint effects rely on the play between foreground and background. If the contrast between the two is great, the resulting effect will be loud or bold. Soft, subtle effects are achieved by using similar colors with similar strengths for ground and top coats.

The finishes described here have been simplified as much as possible to reduce decorating costs and increase ease of application. As you become more experienced, you may want to move on to more difficult and complicated techniques. One of the exciting aspects of decorative paint effects is that there are always different ways of achieving effects and, no matter how long you've been graining or marbling, there will always be new tricks and shortcuts to learn.

Antiquing

Over gold

◆

Color wash

◆

Craquelure on découpage

◆

Craquelure on stenciling

◆

Paint

◆

Drag

◆

Handles

◆

Ragged and dragged

◆

Rubbed

◆

Stipple

◆

Water staining

◆

Fleck spatter

Antiquing is a simulated ageing that can soothe a piece into its surroundings as well as creating an atmosphere of times gone by. The term applies to a myriad of techniques and effects, ranging from the pronounced distressing, or time-worn look, produced by a wire brush to the fine speckle of a spatter. Most effects achieved with a color can also serve in antiquing. They cover applications as diverse as staining black-and-white prints with tea to ageing a new brass handle with boot polish.

The key to successful antiquing is subtlety. Where other effects ask to be noticed – even if elegance is their second name – antiquing needs the delicate tones and refined textures that will make a piece look as if it has been in situ for years. The colors normally used in antiquing are, therefore, rich, soft earth tones: raw umber, burnt umber, raw sienna, burnt sienna, and ivory black.

Antiquing over gold

Gilding* is often antiqued, especially when applied to a classical design, where it may otherwise look too new and bright. First protect the gold with a thin tinted varnish* which will seal the piece and give some definition to carving. When the varnish is dry, use 000 or 0000 steel wool* to distress the piece. Concentrate on protruding surfaces, edges, and areas more prone to wear and tear. The gold will be removed in places, leaving the ground to show through. Once you have achieved a pleasing look choose a color for the antiquing glaze.

Gilding is usually antiqued with burnt umber or burnt sienna, because they impart a rich glow which is bold enough to reduce the gold's power but retain a warmth which enhances the piece. Oil glaze is the preferable medium, as metal leaf can sometimes react with water to cause tarnishing.

Mix your chosen shade with the glaze to form a strong color*. Apply the glaze liberally over the area and allow it a little time to adhere. Then stipple* or drag* the glaze with an open-weave cloth, such as cheesecloth*. This technique removes some of the glaze and ensures that all crevices and hollows have been thoroughly covered. Use a clean cotton rag, dampened with a little mineral spirits if necessary, to clean off the remaining glaze. Apply a varnish if you would like a sheen, but protection is not necessary, as natural wear and tear will merely add to the effect.

Equipment

Pale oak varnish
Steel wool 000 or 0000
Oil glaze colored with burnt umber or burnt sienna
Varnish brush
Glaze brush
Cheesecloth
Cotton cloth
Mineral spirits

✳ Further information

Gilding *p.122*
Varnishing *p.28*
Equipment *p.22*
Color mixing *p.13*
Stippling *p.104*
Dragging *p.54*

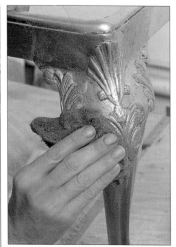

1 Having protected the gilded surface with a thin coat of pale oak varnish and allowed it to dry, rub over the surface with 000 or 0000 steel wool to give an impression of wear.

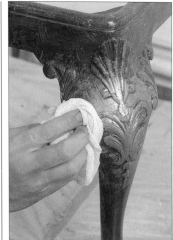

3 Using an open-weave cloth such as cheesecloth, stipple and rub the glaze over the entire surface.

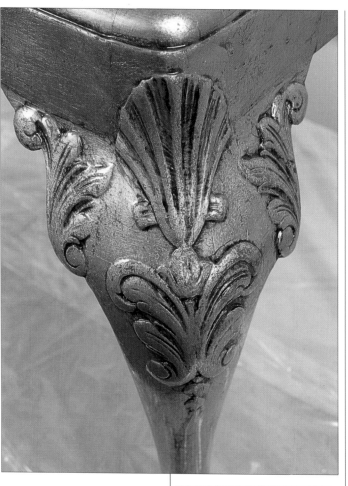

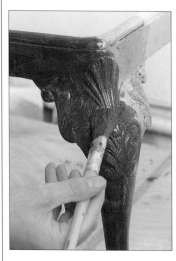

2 Mix the antiquing glaze – burnt sienna was the choice here – and apply it with a brush, taking care to penetrate all the details of the work.

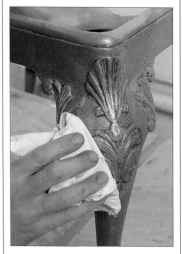

4 Gently clean over the area with a clean soft cloth. In some instances it may be necessary to use a little mineral spirits to produce highlights.

5 The antiqued effect warms and softens the gilding; the finished object glows rather than standing out brashly.

6 When a heavier antique finish is needed, drag the glaze over the moldings and carvings using cheesecloth and only the high points will appear as clean gold. The remainder will vary in tone according to its position.

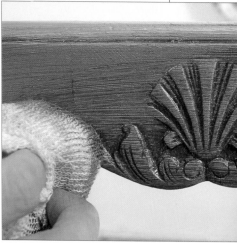

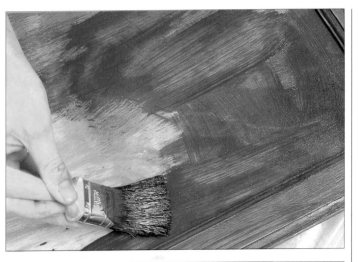

1 Apply the antiquing glaze to the unsealed wood. Brush the color into the pores of the wood, flooding all the flaws and crevices.

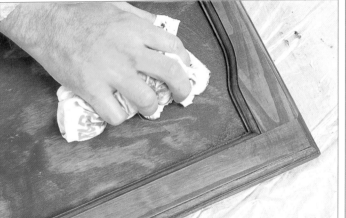

2 Use an absorbent cloth to wipe the surface of any glaze not taken in by the wood. Rub quite hard, especially over protruding areas such as moldings and edges.

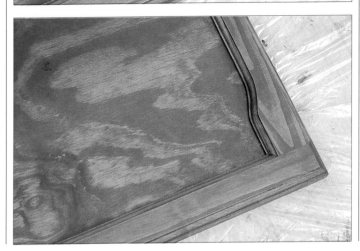

3 The antiquing knocks back the strong green of the color wash, giving an impression of age.

Antiquing color wash

Wood to be antiqued by the color wash method* must be porous. If the piece has been color washed and needs toning down, the technique can be continued without further ado. If the effect is to be applied to untreated wood, however, the surface must be cleaned with a mild detergent solution to remove any dirt or grease that may mar the finish. When choosing an antiquing color, bear in mind the color scheme of the surrounding area and the color of the piece. The example here uses burnt umber. Although less hot than sienna used with the gold, this color has the necessary warmth to counter the slight coldness of the green ground. The medium can be oil- or water-based. Oil gives more time for application and may, therefore, produce a less patchy effect.

Equipment

Oil- or water-based antiquing glaze with burnt umber
Brush
Rag

✱ Further information
Color washing *p.47*

Antiquing découpage with craquelure

Découpage* often needs an effect which will consolidate and bind it. It can be antiqued in many ways but craquelure is one of the most effective. Craquelure is the French name for the network of fine cracks which often cover the surface of old oil paintings. The cracks are formed by the gradual and unequal shrinkage of neighboring layers of paint under a varnish and have become one of the tests of authenticity in an old painting.

The paint effect is achieved with two coats of finish: a slow-drying oil-based varnish coat and a quick-drying gum arabic (used with watercolor*. The oil-based varnish is applied first and when it has formed a skin the quick-drying gum arabic is lightly put on top. This produces a kind of *crème brûlée* effect, with the still-drying oil-based varnish being the cream, and the gum arabic being the thin caramel topping. The base varnish moves as it continues drying, and because the dry top coat cannot follow suit, it cracks. The cracking cannot be predicted beyond the general guidelines that the thicker the base varnish the wider the cracks will be, and the thinner the first varnish, the finer the cracks. To speed the effect, you can play a hairdryer across the surface. Once the craquelure is complete, allow it to harden for about an hour. You can then rub color into the faulted surface to highlight the cracks. The mesh of cracks can aesthetically unite a piece of découpage and, with the help of an antiquing glaze, kindle an otherwise bland project.

Equipment
Oil-based antiquing varnish*
Water-based gum arabic*
Antiquing oil glaze colored with raw umber
Varnish brushes
Glaze brush
Rags

✷ Further information
Découpage p.120
Applied and subtracted finishes p.15
Varnishing p.29
Applying mediums p.18

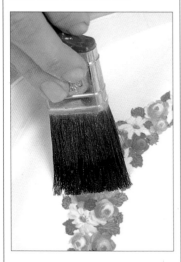

1 Apply the oil-based varnish evenly over the area, tipping off* in one direction. Remember to have a major light source on the opposite side of the surface so that you can see the glint of the wet varnish and spot any missed patches.

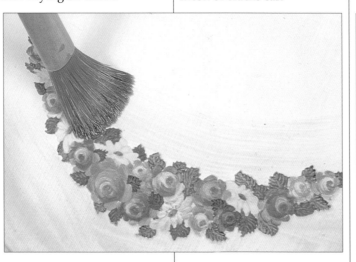

2 When the oil varnish is just dry enough for you to pass the back of your finger over the surface without sticking, apply the gum arabic evenly over the area. Leave in a warm atmosphere for cracking to develop as drying occurs.

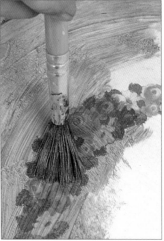

3 Allow the finish to harden for an hour after cracking. Then you can rub an oil-based antiquing glaze into the cracks to give them greater definition. Oil glaze must be used for this because the gum arabic would react with water and dissolve.

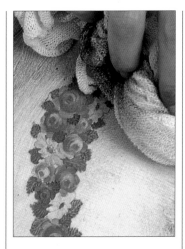

4 Using a circular motion, gently rub the colored surface with a rag. Change the rag occasionally and continue this procedure until all the excess color has been removed from the surface. Seal the finish with oil varnish when dry.

Craquelure

Gold stenciling* can often look a little new and brash, even over a black ground. Craquelure gives a wonderful time-worn look to the work and can be extensively used without fear of overplaying the effect. Apply the ground varnish slightly more thickly for this craquelure, and when it is dry enough to touch, coat it liberally with

gum arabic. Drying with a hairdryer will increase the effect and rubbing a tinted glaze, such as the vermilion hue used here, will emphasize the cracks and convey an impression of lacquer. When the work is dry, protect the effect with an oil-based varnish*.

Equipment

Oil-based varnish
Water-based gum arabic
Antiquing oil glaze colored with vermilion hue
Brushes for varnish and glaze
Hairdryer
Rags

✱ Further information

Stenciling *p.128*
Varnishing *p.29*

2 Let the surface harden for an hour. Rub in the red glaze which will be retained by some of the cracks.

5 The web of craquelure softens the découpage and gives the tray a feeling of age.

1 Brush the water-based gum arabic over a generous coat of oil varnish, which has dried sufficiently to touch. Speed drying with a hairdryer. Do not apply the heat too intensely and do not use a naked flame: these items are combustible and must be treated with care.

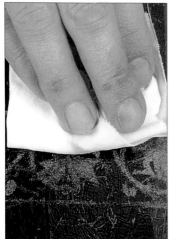

3 Wipe off the excess glaze with a rag.

Antiquing paint with craquelure

One antiquing technique is often complemented, enhanced or disguised with another. In this case the initial antiquing effect of rubbing or brushing has been carried out* and craquelure is to be an additional finish. The first finish used a raw umber glaze, and this color will be employed again in highlighting the cracks.

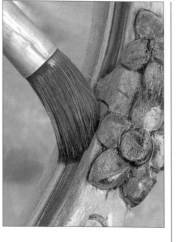

1 Apply the oil-based varnish, taking extra care with ornate parts where varnish may pool and therefore dry unevenly.

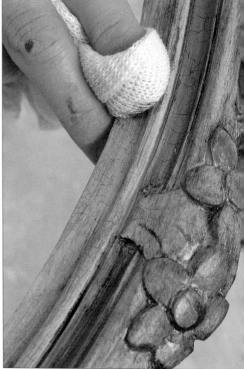

3 Give the craquelure one hour to dry before rubbing in the raw umber glaze. Remember that the gum arabic is vulnerable and would dissolve with water, so protect the surface with an oil-based varnish as soon as it is dry.

4 The finished effect has softened and aged the gold stenciling.

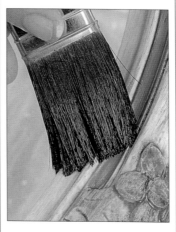

2 After the allotted time*, apply the coat of gum arabic.

Equipment

Oil-based antiquing varnish
Water-based gum arabic
Antiquing oil glaze colored
with raw umber
Varnish brushes
Glaze brush
Rags

❋ Further information

Antiquing (distressing) *p. 43*
Antiquing découpage *p.37*

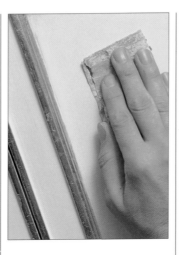

Antiquing drag

When the piece to be antiqued needs a direction or grain, antiquing drag is often the answer. This finish, achieved in a similar way to dragging*, is very subtle. The glaze is applied thinly and must be oil-based to maintain the slow drying necessary for a soft, graded result. The ground color used here is gardenia, and the glaze is raw umber. As in standard dragging, the glaze has to move over the surface, and therefore preparation* must be of a high quality.

Equipment

Antiquing glaze with raw umber
Glaze brush
*Very fine sandpaper**
Soft-textured rag
Dry paint brush

✱ Further information

Dragging *p.54*
Preparation *p.17*
Sanding *p.21*

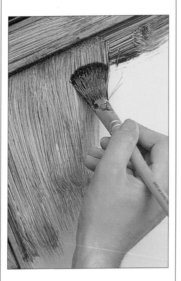

1 Scuff the surface with a very fine grit of sandpaper to make sure that the finish is smooth and without faults that could collect glaze. Remember to sand with the direction of the drag.

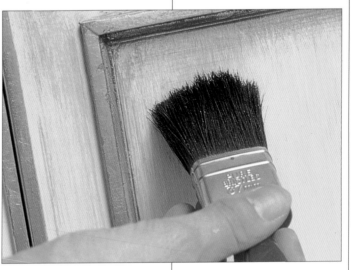

3 Gently wipe the surface back and forth along the line of the drag with a soft-textured rag.

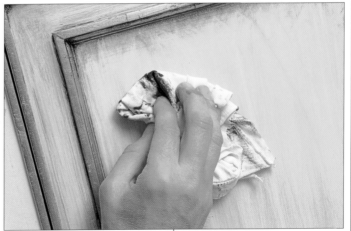

2 Apply the raw umber oil glaze, brushing out well and being careful to penetrate every nook and crevice.

4 Use a dry paint brush to feather out the glaze which has built up at the ends of the panels.

Antiquing handles and hardware

Probably one of the most common and most unnecessary sights is an antique piece of furniture with bright sparkling handles. Hardware can easily be subdued by applying a colored glaze, as with woodwork. Boot polish and oak varnish are time-honored treatments which can work to great effect. As a cabinet collects dust of a particular color over the years, the hardware is likely to be dirtied with a similar hue. Glaze can unify the overall task and suggest the effects of use as well as conveying a patina of age.

Equipment

Oil-based glaze with raw umber
Glaze brush
Rag
Dry paint brush

✷ Further information

Stippling *p.104*

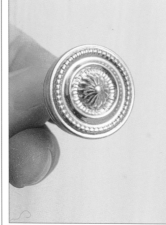

1 The pristine knob prior to its treatment. How inappropriate it would look on a piece which had been toned down.

2 Apply the glaze, making sure that it penetrates the details of the design.

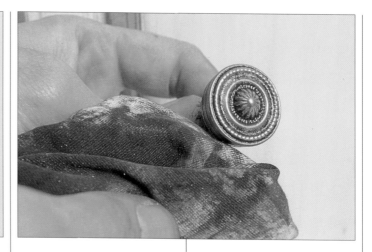

3 Wipe the excess glaze from the surface, leaving it in the recesses.

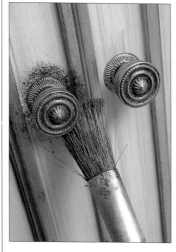

4 Attach the handles, not forgetting to treat the base roses separately. Stipple on* the mixed glaze around the roses, and use the rag and the dry brush to draw the color away from the handles.

5 The finished effect, suggesting a patina of age where use of the handles over the years has darkened the area around them.

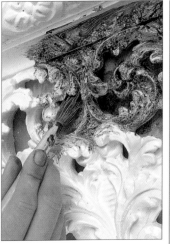

Ragged and dragged antiquing

When an intricate piece is to be antiqued, the effect must be as delicate as possible, so that the changing tone accentuates the play of light and dark and does not distract the attention. In this example a highly detailed cornice is antiqued using ragging* and dragging* techniques combined with raw umber glaze.

Equipment
Antiquing glaze tinted with raw umber
Application brush
Dry paint brush
Lint-free rags

* Further information
Ragging *p.104*
Dragging *p.88*
Stippling *p.54*

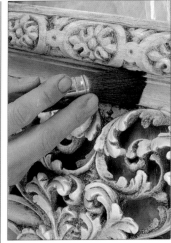

1 Apply the antiquing glaze, stippling* the areas that are hard to penetrate.

2 Using a soft lint-free rag, pounce over the surface* removing the majority of the glaze from the projecting elements of detail.

3 With the dry paint brush gently drag* any part of the piece which needs to indicate a direction of movement.

4 The finished effect accentuates the form of this ornate piece.

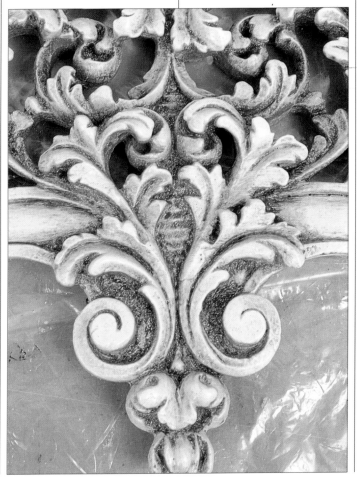

Rubbed antiquing

Although paint effects are normally either applied or subtracted*, rubbed antiquing falls into both categories. It consists of two stages: first the removal of paint, varnish, or another applied effect by wire brushing or sanding; and second, the rubbing of glaze into the surface to suggest grime from years gone by.

Equipment

Antiquing glaze tinted with raw umber
Glaze brush
Wire brush
*Coarse-grit sandpaper**
Rag

* Further information

Applied and subtracted finishes *p.15*
Sanding *p.21*

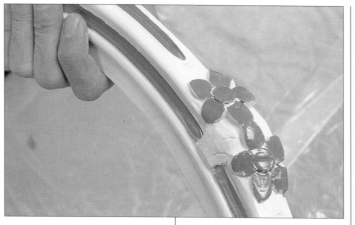

1 The rather gaudy freshly-painted detail of a chair back.

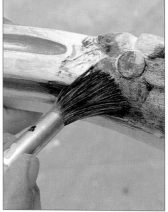

3 Apply the raw umber glaze over the entire surface. The exposed areas, being more absorbent, will color more deeply.

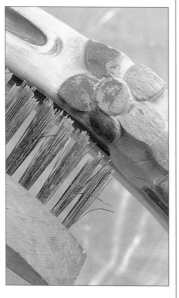

2 Brush the surface with the wire brush. Don't be too gentle – the odd prominent scar looks authentic. The surface can be scuffed equally well using coarse sandpaper.

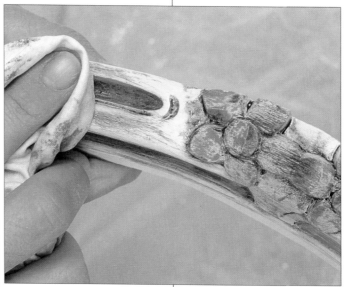

4 Rub the surface with the rag, allowing the glaze to remain in the hollows and niches of the piece.

Antiquing stipple

The aim of this effect is to reproduce that patina of age on pieces of furniture shown by a gradation of color from dark to light – like the ivory keys on an old piano whose pale centers darken as they near the neighboring keys. So the first step is to establish where the piece would be pale and where dark. For example, the majority of erosion on a table occurs in the middle, because it is easy to clean and because heavier items tend to be positioned there. If, however, the table has a large lamp at its center and this was rarely moved, the color grading is likely to be reversed. Like most skills, antiquing needs practice, but you can learn an enormous amount by examining old pieces to see how and where such lighter and darker areas occur.

The fine texture of stipple which lends itself especially well to the even application of glaze, makes it ideal for this kind of antiquing. The technique most often used is blended or tonal stippling*. Oil mediums are best, and you will need two glazes of a standard antiquing earth color*, such as raw umber – one a stronger tone than the other. Wipe the surface over with a slightly thinned untinted oil glaze to help the colors move. Then apply the paler glaze, around the outside or in the center, whichever is appropriate. The darker medium comes next, so you need only one application brush. Next, stipple the darker tone into the lighter, remembering to clean the brush before returning to the dark patch. The effect is very delicate and is best appreciated from a distance. Often it is complemented with a spatter*, or water stained – or both.

Equipment

Untinted oil glaze thinned with mineral spirits
Antiquing glaze medium tinted with raw umber
Antiquing glaze dark tinted with raw umber
Application brush
Decorator's dusting brush
Rag

❋ Further information

Stippling *p.104*
Antiquing colors *p.36*
Spattering *p.96*
Water-staining *p.45*

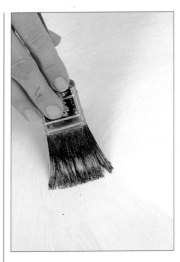

1 Wipe the surface with the thinned untinted glaze and then apply the paler of the two tinted glazes, leaving clear the area which is to be darker.

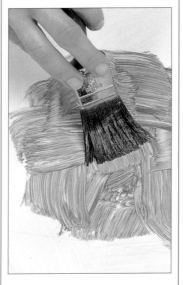

2 Apply the darker glaze.

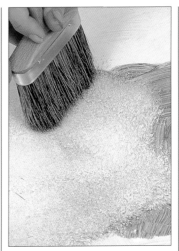

3 Using the decorator's dusting brush, stipple from dark to light, remembering to rub the brush clean with a rag each time before returning to the surface.

4 The finished effect shows the subtle color gradient to perfection.

Water staining

Like fleck spatter, this is a complementary finish, normally associated with antique stipple*. The effect is achieved by spattering* denatured alcohol over an oil-based glaze.

Equipment
Denatured alcohol
Oil-based antiquing glaze
*Spatter brush**

✽ Further information
Antiquing stipple *p.44*
Spattering *p.96*
Brushes *p.24*

1 Spatter the freshly worked oil-based glaze with denatured alcohol.

2 Pale rings appear which resemble water damage.

Antiquing fleck spatter

This effect is generally used over a drag*, or where a direction has been indicated. In graining* it is often used instead of a check roller* to imitate the pores of the wood. The effect is obtained by softly brushing over spatter* while it is still wet and is therefore best achieved with an oil glaze.

Equipment
Antiquing oil glaze tinted with raw umber
*Fitch**
Dry paint brush

✽ Further information
Dragging *p.54*
Graining *p.63*
Check rolling *p.46*
Spattering *p.96*
Brushes *p.24*

1 Using the fitch, spatter the surface with glaze.

2 Gently soften the spots of glaze in the direction of the ground coat drag.

Check rolling

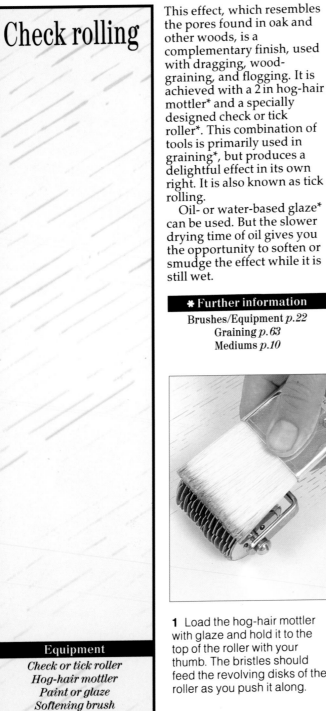

This effect, which resembles the pores found in oak and other woods, is a complementary finish, used with dragging, wood-graining, and flogging. It is achieved with a 2 in hog-hair mottler* and a specially designed check or tick roller*. This combination of tools is primarily used in graining*, but produces a delightful effect in its own right. It is also known as tick rolling.

Oil- or water-based glaze* can be used. But the slower drying time of oil gives you the opportunity to soften or smudge the effect while it is still wet.

＊ Further information

Brushes/Equipment *p.22*
Graining *p.63*
Mediums *p.10*

1 Load the hog-hair mottler with glaze and hold it to the top of the roller with your thumb. The bristles should feed the revolving disks of the roller as you push it along.

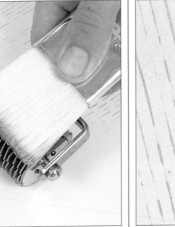

2 Make sure that the tracks remain roughly parallel and travel in the direction of the grain.

3 You can use a softening brush* to smooth the effect while the glaze is still wet.

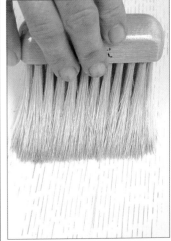

4 The finished effect looks smartly formal (especially when a pale top coat is used over a dark ground) when applied to boxes or occasional furniture.

Color washing

Many experts refer with fondness to the old-style distemper (made from water and pigment bound with casein, egg, or glue) that was originally used to produce this finish. However, although it was cheap and produced quick results, it did not cover or wear well. Modern decorators use either water-based or oil-based glazes to achieve this effect. The techniques are the same for both, apart from their drying times, but as this is an applied effect*, the water-based medium is recommended.

Color wash on wood
You can color wash wood with thinned-down latex*, which is slightly opaque, or use a true transparent wash,

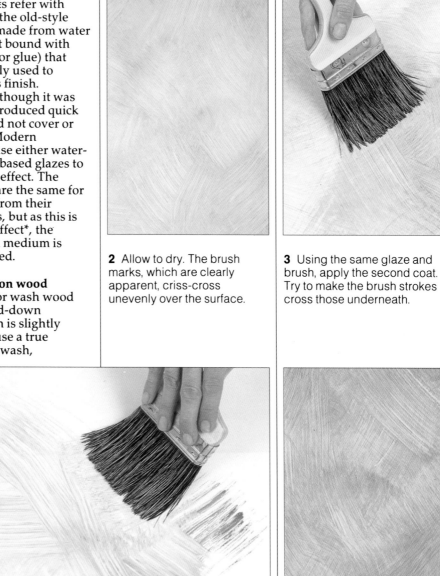

2 Allow to dry. The brush marks, which are clearly apparent, criss-cross unevenly over the surface.

3 Using the same glaze and brush, apply the second coat. Try to make the brush strokes cross those underneath.

Walls
1 Apply the glaze lightly with a standard decorating brush*. Vary the angle and direction of the brush, allowing the ground to show through.

4 The completed effect is an undulating finish with a refreshing crispness.

Equipment

Paint or glaze
Brush
2 cloths (1 damp)

watercolor, gouache, or a powder – suspended in water*. But you need to take certain precautions first.

When raw wood is dampened with a water-based medium, its sponge-like reactions lead to the rising of the grain. If you want a soft effect, it is wise to dampen the surface of the wood first with a clean, damp cloth. When the wood is dry, flatten the raised grain with fine sandpaper* and a block* before proceeding.

If you are color washing a piece of furniture that has been stripped to its raw state, neutralize the surface by washing it down with a mixture of one part vinegar to twenty parts water.

A piece made from raw new wood needs to be checked for any filled areas. These will not be porous and will therefore refuse to take the color. You can color in small, unobtrusive fillings later. But if the filling is extensive, you may have to consider a different effect.

✳ Further information

Applied and subtracted
finishes *p.15*
Brushes/Equipment *p.22*
Mediums *p.10*
Sanding *p.21*

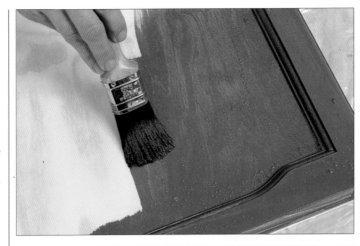

Wood
1 Apply the thinned color quickly to cover the area without patches.

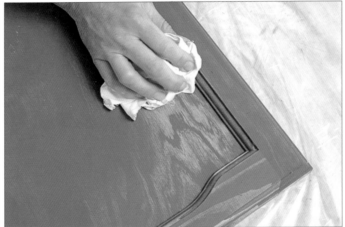

2 Rub the surface with an absorbent cloth to remove the excess wash.

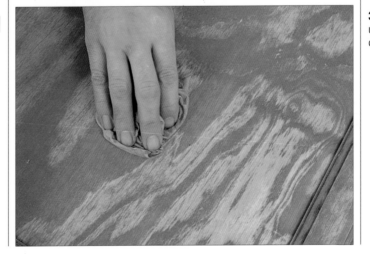

3 Use a damp cloth to clean up any remaining surface color.

Combing

There are endless possibilities for this simple finish, which is often seen in large scale on floors. Different combs and handling techniques can produce a multitude of effects ranging from the primitive to the luxurious. Combing was popular in the 1920s and 1930s, when it appeared in dull, somber colors. The combs were made of metal, poster board, and wood, and were drawn over the surface of wet paint to produce a constrasting textured effect. The combs had been developed far earlier for the more refined process of graining*, but by the beginning of the 20th century graining had gone out of fashion.

Combing can be tackled with water- or oil-based glaze. In fact, if the area is small enough, normal undercoat or latex can be used. Allow this to begin tacking up before you start combing; otherwise the paint will flow back into the marks made by the comb. If you use home-made combs* (see page 27), don't let the top coat get too tacky, or the poster board may not be strong enough to force its way through. Rubber, leather, and steel combs are available through craft supply stores.

Basketwork combing

This technique is primarily a floor application, but can be extremely effective on a smaller scale. Suited to subtle colors, such as soft grays and pale blues or yellows, the design can be applied in a chessboard pattern, or at a 45° angle for more of a basketwork effect.

Equipment
Paint or glaze
Brush
Comb
Rag

✳ Further information
Graining *p. 63*
Equipment *p. 22*

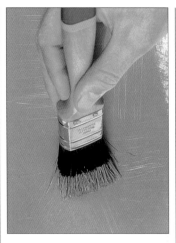

1 Apply the glaze.

2 Drag the comb (in this case a steel one) through the glaze, angling it slightly toward you. The drag should be roughly the same length as the width of the comb.

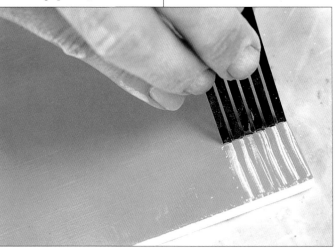

3 Comb at 90° to the first imprint, again angling the comb to produce a square imprint the same size as the first one.

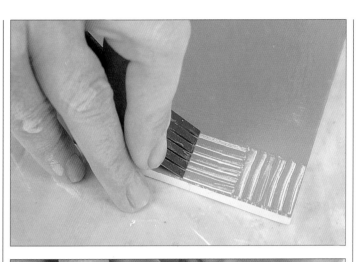

4 Continue to produce the repeated alternating print, remembering to keep the comb clean by wiping with a rag from time to time.

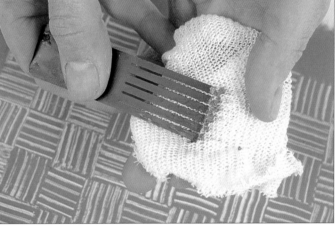

5 The finished effect. Some of the comb marks are bound to be a little skewed. This gives a softness and slight movement which adds to the effect.

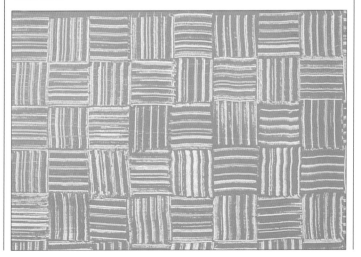

Weave

You can create a weave or plaid effect by introducing a second or even a third color, strategically applied over a wet ground coat. Combs of different grades and widths, dragged across the surface at right angles to each other, help enhance this effect.

Equipment
2 paints or glazes
2 brushes
2 combs (4in. fine and 11in. coarse)

❋ Further information
Applying mediums *p.16*

1 Apply the ground color and tip off*. Using a clean brush, paint on a further color in stripes. The brush of the second color will need to be well loaded as the ground is still wet.

2 Pull a 4in. wide fine-grade comb across the surface, along the lines of the second color.

3 Using a 1in. coarse-grade comb, drag equidistant strips across your first marks, about 2in. apart. The final effect has the appearance of a subtle, rich weave or a plaid.

Watered silk

This effect is much more luxurious than most combing techniques and is produced here using a triangular rubber comb. Steel combs will create a finer and more delicate look.

Equipment
Paint or glaze
Brush
Comb

✷ Further information
Applying mediums *p.16*

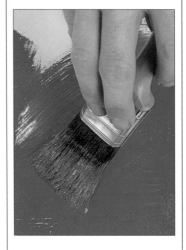

1 Apply the glaze and tip off* in the direction in which the effect will run.

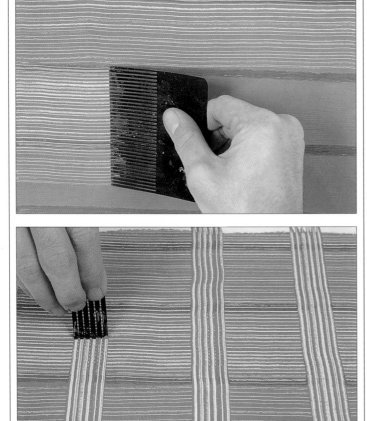

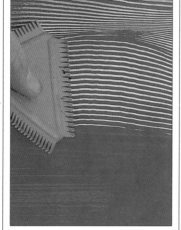

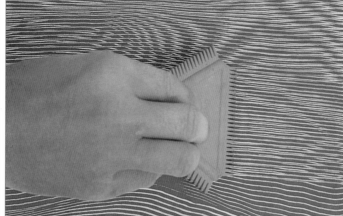

Moiré

2 Pull the comb through the glaze in a straight line, but smoothly change the angle of the comb to produce an alternately broadening and narrowing stripe.

4 When the area is completed and while the glaze is still wet, pull the comb in a straight line through the pattern. As if by magic, a watered silk effect appears.

This effect is a close cousin to that of watered silk. However, it is far less flowing and more mechanical. Patterns like the one shown here can be so pronounced that they produce an illusion of movement. This harsh color contrast has been chosen to demonstrate the optical effect of moiré and subtler combinations would normally be used.

Equipment

Paint or glaze
Brush
Comb

✱ Further information

Applying mediums *p.16*

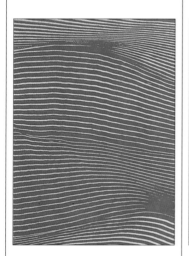

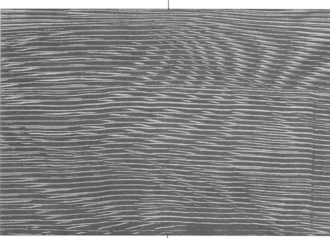

3 Create a second swirling stripe to fit snugly alongside the first. Each succeeding stripe should complement the one before: broad where the preceeding one was narrow, and narrow where it was broad.

5 The finished effect, with its rings of watered silk, is particularly effective on small items or when combined with an antique finish.

1 Apply the glaze and tip off* in the direction of the combing.

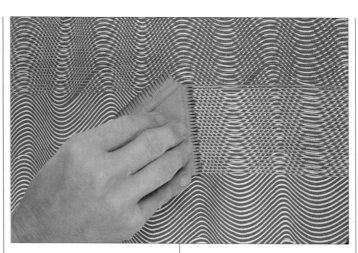

3 Cover the area using the same technique, filling in the undulations and maintaining the rhythm of the previous strip. Do not change the angle of the comb.

4 Drag the comb in a straight line through the pattern while the glaze is still wet. As with watered silk, the moiré will magically come to life.

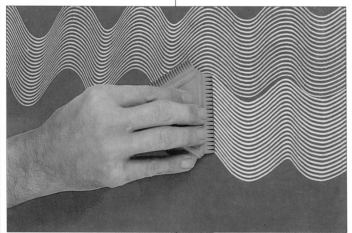

2 Pull the comb through the glaze, curving from side to side but keeping the face of the comb pointing directly toward you.

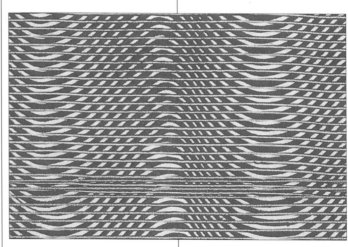

5 The finished effect is brash and would be difficult to look at for long periods. However, if you use pale colors with less contrast between base and top coats the finished effect can be very attractive.

Dragging

Dragging walls

◆

Dragging wood

Dragging is an underrated effect and easy to execute, providing it is well planned. As the name implies, the technique involves dragging a brush through an applied glaze coat, and it leaves fine brush marks where the ground smiles through. Because the top coat is pulled across the surface, high-quality preparation is important. All dents, spitz, and nibs must have been filled or removed before the glaze coat is applied, as these would otherwise catch the color and be high-lighted, thereby marring the effect. Just prior to top coating, check that the surface is smooth by lightly scuffing over it with a 320 grit paper*, remembering to move in the direction of the drag.

When choosing colors, bear in mind that this effect first became popular in the 1930s, thanks largely to designer John Fowler, whose work of the period in English country houses is renowned. The colors were restrained and often very subtle indeed. The base color would be tinted toward the glaze coat color to make only the slightest contrast between the two. Although strong colors have been used with great success, this effect usually benefits from delicate color. The finest examples of dragging on walls occur when its presence is hardly noticeable, but it lends the room an air of quality and elegance.

Dragging walls

Dragging is a subtracted finish*, and when the effect is to be achieved on a large area, a time-efficient technique must be employed. Oil-based glazes are normally used, but on small surfaces water-based glazes can give good results. Water-based drag will be matte, whereas oil-based drag dries to a sheen. The brush to use depends on the area which requires finishing. Walls need either a 6 in. flogger*, a 9 in. dragger*, or a doctored latex brush. Floggers and draggers are graining brushes with long bristles, which pick up glaze easily when pulled across the surface. You can doctor a latex brush, by cutting a line of bristles to thin them out. This will give the brush a better marking quality.

Glaze is normally applied by brush, but you can use a roller on walls. When using a brush apply the glaze thinly and evenly and tip off* in the direction of the proposed drag. The first dragging stroke will be guided by the adjacent wall. Subsequent strokes, which should be parallel to this, will be unguided and consequently more challenging for the inexperienced. Try to maintain a relaxed wrist and allow the brush to do the work. Hold the brush at an angle of approximately 30° to the surface and pull downward through the glaze. Where the situation allows, you might find it helpful to use a giant ruler made from a straight edge of wood with nails hammered through to keep it clear of the surface. But hand dragging is preferable. It is far quicker, and minor wiggles and deviations will not be as obvious as you might think. Remember to keep the dragging brush clean by wiping it occasionally with a rag. Turning the brush over to utilize both faces can also be helpful.

The most common problems when dragging walls are twofold. The first, known as curtaining, appears at the top of the wall where the dragging brush takes a grip of the glaze. If the glaze is applied too thickly, this effect will be unattractive, and the glaze will need to be feathered downward with a dry paint brush. The second problem also results from the amount of glaze applied. The bottom of the wall, where the dragging stroke finishes, will tend to be heavy with glaze. To combat this, pressure on the bristles should be lessened slightly so that less glaze is picked up by the brush on the lower part of the wall. Alternately, the brush can be dragged in a flicking stroke back up the wall. This must be done

with great care, and each stroke should end at a different point so as to stagger, and therefore blend, the effect with the rest of the wall.

If the wall is high enough to need a ladder, you will have to interrupt the dragging stroke to climb down. The brush must not be stopped while in contact with the surface. The travel must continue as the brush is lifted away. When you continue the drag, your stroke must begin its movement before the brush makes contact with the surface. The more smoothly you carry out these two operations, the less obvious the overlaps will be. It is wise to alternate the point on the wall where these breaks occur to make them less apparent.

Equipment
Paintbrush and/or roller
Paint or glaze
Dragger or flogger (6in.or 9in)
Rags

✳ Further information
Sanding/sand paper
chart *p.21*
Applied and subtractive
finishes *p.15*
Brushes/Equipment *p.22*
Applying mediums *p.16*
Painting order *p.16*

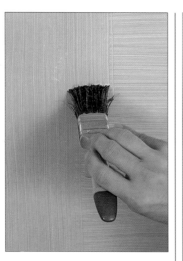

1 Apply the glaze thinly and evenly, making sure that it is tipped off in the direction of the intended drag.

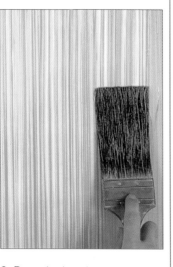

2 Drag the brush smoothly through the glaze, allowing the bristles to do the work. Hold the brush at an angle of about 30° to the surface.

3 Wipe the dragging brush regularly with a rag to keep it unclogged and therefore able to produce the same effect across the surface.

4 The finished effect. The overlaps should be almost imperceptible.

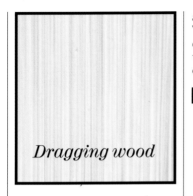

Dragging wood

Dragging has its origins in graining, and when dragging woodwork similarities of technique remain. The size of brush will depend on the piece that is to be dragged. For a large table top, a large brush will make the operation much easier. In general, however, woodwork finishing requires a smaller brush: a 3 in. flogger* or a 1½–2 in. dragger* would be ideal.

Woodwork must be dragged with the grain or, if particle board is used, the way the grain would run. If there is a choice of direction, always drag the length of the panel. The most important aspect of dragging woodwork is the order in which the piece is tackled. If a standard panel door is to be dragged, each section should be dealt with individually. If need be, you can mask each section off and allow it to dry before working on the next. When you become more proficient, you will be able to complete the entire door without stopping. But it is essential to apply glaze and drag the confined pieces of wood first in order to achieve a clean joint line*. The joints can be emphasized with a fine line when the glaze is dry to give extra sharpness.

Equipment

Paint or glaze
Paintbrush
Flogger (3in. or 1½–2in.)
Rags

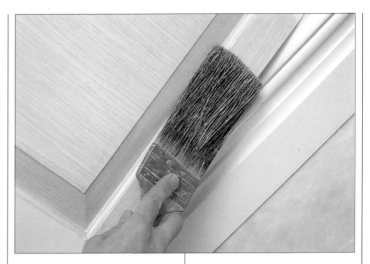

2 Apply the glaze to the rail* and drag. Note that the drag begins before the joint line. Complete the second rail in the same way.

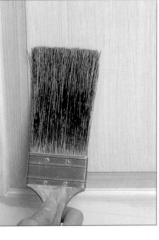

1 Apply the glaze and drag the panel, first ensuring that you tip off in the direction of the drag. If the panel is square, the drag is normally vertical. Wipe the surrounding area clean.

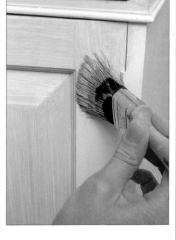

3 Apply the glaze to the stile*, carefully rubbing glaze up to the joint.

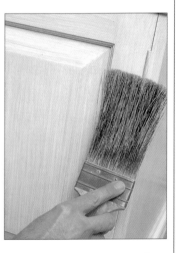

4 Drag the brush through the glaze. The dragging stroke should begin with the bristles overlapping the edge of the stile, so as to avoid a curtaining effect. The finished texture is very subtle, giving an impression of opulence.

Faux bamboo

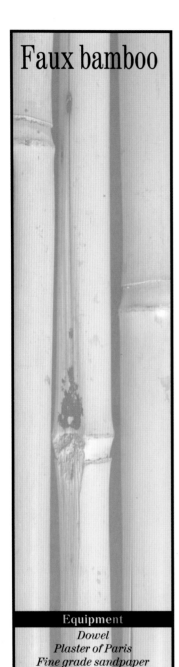

Bamboo has always been a popular material for the construction of buildings and furniture in the Far East. Its combined assets of lightness and strength have constantly meant that it has been used up to the present. Furniture made from this giant tropical grass was introduced to Europe during the 17th century when trade with China increased, and it became highly fashionable. But the expense of bringing furniture from Asia precluded many from owning it. So European craftworkers quickly began making and painting pieces of furniture to look as if they were constructed from bamboo. The fashion reached its peak in the 18th century, when the production of faux, or simulated, bamboo expanded to fantasy effects in brilliant colors.

To make faux bamboo, begin with a length of dowel. As bamboo varies in diameter, any size of dowel will do. Build up the "joints" with plaster of Paris, and smooth them down ready for paint. The ground color is a pale yellow, and the glaze coat a raw umber. Protect the finished piece with two coats of flat varnish and then polish with a clear wax.*

＊ Further information
Sanding/Sand paper chart *p.21*
Applying mediums *p.16*

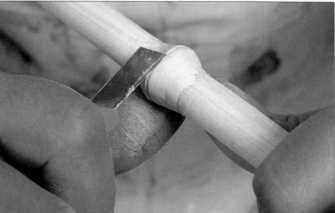

1 Slightly dampen the dowel before rolling on the plaster of Paris with a finger.

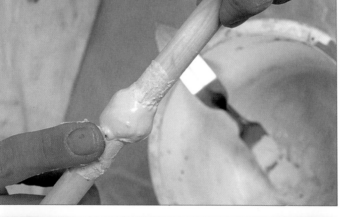

2 When the application is dry, sand it with a fine sand-grit paper*, carefully shaping the joint. Using a craft knife, gently cut a groove around the middle of the joint.

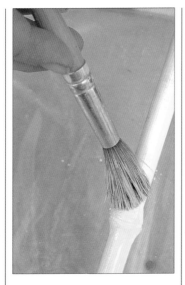

3 Apply the base coat of pale yellow, and tip off* the paint lengthwise.

4 When the ground coat is dry, sand with a fine-grit paper. Apply the raw umber glaze coat and lightly drag it along the stem.

6 The finished effect. Faux bamboo can be used instead of real bamboo (if this is unavailable) for furniture or picture frames.

5 Again using the raw umber glaze, paint on the joint groove, the spine, and the eyes.

Faux stone blocks

Equipment

Joint compound
Water
Heavy-duty bucket
Broom handle or other mixing stick
*Plywood board**
*Hawk**
*Taping knife**
Bucket with water
Old latex brush
Plumbline
Level
Straight-edge
Measuring tape
Finishing trowel

Faux stone blocks became fashionable in the 18th century, when the art of marbling* was extended to include granite and sandstone. The effect was popular because it lent an air of strength and durability to an interior, and was also much easier to achieve than marbling. Spattering* and sponging* were used to simulate texture, and the blocks were defined by a simple *trompe-l'oeil** line.

The technique of faux stone blocks is partly borrowed from stucco work which was often treated with a block-like effect. Stucco is a quick-setting plaster with an added strengthener such as ground marble. Stucco work, dates back to antiquity, but gained popularity in the 16th century in Italy, from where it spread throughout Europe. The British architect Inigo Jones is thought to have been the first to promote stucco in England when he used it in conjunction with Portland stone dressings on the Queen's House at Greenwich (1616-35) and the Queen's Chapel in London (1623-27). Faux stone blocks increasingly became an interior feature, and by the latter part of the 18th century the fashion had spread to North America, where some fine examples can be found in the hallways and reception rooms of Empire-style houses.

Creating stone-blocks

A simple stone-block effect can be produced by marking the selected wall area with a plumb line and level, and sponging and spattering the surface, which is then divided into blocks by painted lines. This is an effective way of achieving a sober, elegant look. The example shown combines the paint technique with a stucco-like texture and would be suitable when a more rustic effect is required. The surface must be plastered to help create the texture. There is no need to be deterred by this. It is true that plastering cannot be learned in a matter of hours, and professionals may take years to bring their skills to perfection, but the textured technique used here cuts out the real difficulty of plastering, that of smoothing off.

Prepare your wall in the same way as for any other effect*. You will need joint compound for this technique because it is an easy plaster to use and also offers a long enough drying time in which to complete the effect. Joint compound comes ready-mixed and in powder form. Always keep bags of powder in a dry place. If any water comes into contact with the joint compound before use, it will almost certainly be spoiled. Plastering can be very messy, especially if you have never done it before, so it is advisable to clear the room of furnishings and spread a drop cloth over everything that's left. The plaster dust will hang in the air and could scratch polished surfaces even hours later. Heavy-duty, lined trash cans are essential later for dropped or old plaster.

Mixing joint compound

When mixing joint compound use only fresh water, as impurities in rainwater may be detrimental to the plaster. Mix the compound in a heavy-duty plastic bucket, a little at a time. Mixing is the most tiring part of plastering, and the more mixture in the bucket, the harder the task. A third of a bucket is probably the most that should be attempted at one time. Put the water in first; otherwise the compound will clog and stick to the side of the bucket. Stir continuously as you add the powdered joint compound to the water, using a strong stick, such as a broom handle. Continue stirring until all the powder is incorporated, and when the consistency is stiff enough to support the mixing stick but still workable, pour the compound onto the plywood board. Clean the bucket and stick immediately with water, or any remaining compound will harden and be difficult to remove. The cleanliness of tools is one of the most important and under-recognized keys to success in plastering.

Applying the compound

Plastering is a homey procedure without mystique. The same basic tools have been doing the job successfully for countless years, and the task itself is not unlike frosting a gigantic cake.

Use an old latex brush and a bucket of water to dampen all the tools before use. Quickly dampen the wall also to retard the compound's drying time. Hold the hawk in your left hand if you are right-handed – the reverse for left-handers – and position it just under the edge of the plywood board, so that you can scrape a portion of compound onto it with the taping kinfe. The amount should be just enough to support comfortably on the knife. The action of loading the hawk should be like scooping crumbs from a table onto your hand.

Approach the wall as if you were going to paint it – probably from left to right, if you are right-handed and vice versa if left handed. Place the loaded hawk so that its edge is in contact with the wall. Unlike painting, you should begin by pushing in an upward arc from a point just above the baseboarding. Once you have got the compound on the wall in swirls, you can smooth it out and stretch it over a much greater area. Do this with a clean finishing trowel, freshly washed with a brush and water from the nearby bucket.

Spread the compound with the trowel as if you were spreading butter.

Angle the trowel like the knife so as to allow the correct amount of compound to be squeezed under the blade. If the angle is too small, the compound will slip under the trowel and remain in a lump. If the angle is too great, the trowel will scrape the compound so that it breaks, and the plaster on the trowel will probably become dislodged and fall off. Try to avoid this scraping which is similar to scraping a minimum of butter onto toast. Discard any compound which has been allowed to fall to the floor. When the wall is covered and spread to a thickness of approximately $3/16$ in, you will be ready to apply the texturing.

Texturing

The joint compound used in this example allows an hour's finishing time to complete the texturing. Begin by marking off the chosen depth of block from an adjacent wall. Then use the straight-edge in conjunction with the level to work your way across the surface, laying the straight-edge onto the wet compound. With these horizontal lines completed, you can mark the staggered vertical ones with the aid of the plumbline and trowel. You can then texture the faces of the outlined alternating blocks using all manner of implements. Sponges* give an excellent effect. A coarser texture, as in this example, is achieved with a stippler* and then smoothed over with a trowel.

1 Complete the final stage of the texturing coat, using the taping knife to smooth the surface. Leave to dry overnight.

✲ Further information

Marbling *p.75*
Spattering *p.96*
Sponging *p.98*
Trompe-l'oeil p.136
Preparation *p.17*
Equipment *p.22*
Plastering tools *p.28*
Coarse stippling *p.106*
Washes *p.12*
Mediums *p.10*

2 Thin the raw sienna color with water, and apply it liberally with a brush. Work small sections at a time, as the joint compound is very porous and will soak up the wash rapidly.

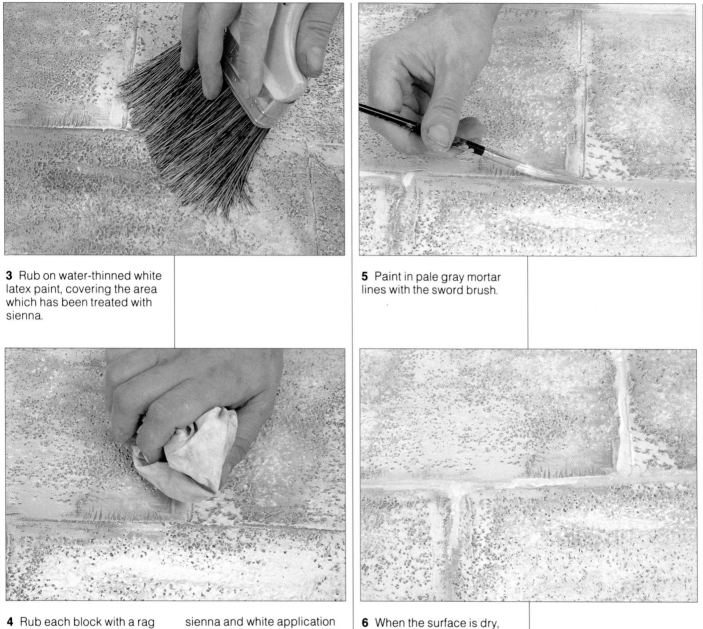

3 Rub on water-thinned white latex paint, covering the area which has been treated with sienna.

5 Paint in pale gray mortar lines with the sword brush.

4 Rub each block with a rag so that in some areas the sienna color fills the depressions and in others covers the white. Continue coloring sections with the sienna and white application and rubbing with the rag until the entire area is treated.

6 When the surface is dry, protect it with a water-based sealer, such as acrylic.

Flogging

Like dragging, flogging is a technique used in graining, and has only recently become an effect in its own right. More often seen on walls than on woodwork or furniture, this finish is usually most successful in subtle colors, but can look stunning in strong yellows, perhaps because of its resemblance to a cornfield. The effect is achieved in a subtracted manner*, and flogging refers to the action of slapping the brush against the wet glaze.

The glaze is applied with a brush or roller and tipped off* in the same direction as the flog. Unlike dragging, the effect is initiated at the bottom of the wall, and the work progresses upward. A flogger or dragger is the only suitable brush, as long bristles are essential to the effect. As the brush slaps the glaze, it is also pushed across the surface, causing the outer bristles to splay slightly. The glaze does not have to be pulled over the surface, so providing the preparation is reasonable, the finish will be successful. Keep wiping the brush with a rag to maintain a uniform overall effect.

Equipment

Paintbrush or roller
Paint or glaze
Flogger or dragger
Rags

✻ Further information

Applied and subtractive finishes *p.15*
Applying mediums *p.16*

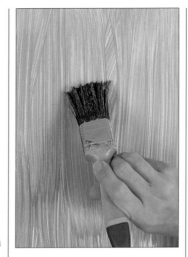

1 Apply the glaze, using either roller or brush, and tip off in the direction of the flog.

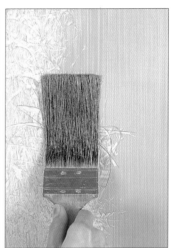

2 Start at the bottom of the area. Slap the glaze with the flogger, and at the same time move the brush in an upward direction over the surface.

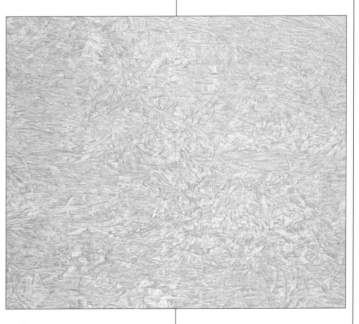

3 The completed effect has a more homey feel than that produced by dragging.

Graining

Clair bois

◆

*Bird's-eye
maple*

◆

Mahogany

◆

*Graining by
roller*

Graining is thought to date back to ancient Egypt where a shortage of wood stimulated the development of techniques to imitate wood grain. Similar faux, or imitation, wood finishes later emerged in Europe in response to demands for hard-to-obtain or exotic woods.

Although there are earlier examples, graining appears to have become popular in England in the latter part of the 17th century, possibly as an indirect consequence of the Great Fire of London in 1666. The oak needed to rebuild the city depleted stocks to such an extent that cabinetry had to be made from pine. This cheaper wood was disguised by graining.

In reality, however, the fire was probably only one among many contributory factors. The age of oak was nearing its end, and more decorative walnut furniture was in the ascendency. In paneling too, oak was gradually supplanted by basswood or pine, painted in a shade of yellowish-brown known as drab green, or grained.

It is difficult to ascertain just how widely graining was used, because, by its very nature, it was likely to be removed and redecorated with the passing of time. Quality improved, however, and by the 1850s an extremely high standard of work was being produced. Unfortunately this did not prevent graining from acquiring a bad reputation by the 1930s, when the most basic of techniques was employed together with a thick tar-like glaze which rendered surfaces anything but attractive.

Graining today
Today, techniques have again become highly sophisticated and capable of producing effects that are indistinguishable from the original. Some of these are very complex, but you can achieve effective finishes more simply (and it is advisable to stick to these in the early stages). Once you have mastered the basic graining techniques, you may decide to move on to more complicated variations.

The three types of graining shown here are an introductory effect called *clair bois* (meaning pale wood), a mahogany effect suitable for large areas such as doors and furniture, and a bird's-eye maple for small pieces like boxes or mirrors. All the techniques have been simplified as much as possible to give an attractive effect with the least amount of effort.

As with most faux finishes, a feeling of depth is achieved by layering the different colors. In most cases the medium is transparent oil glaze, sometimes in combination with a wash. The ground color should be a shade lighter than the palest part of the wood being copied, and the graining color, or top coat, should be a shade darker than the darkest part.

Clair bois

This pale wood graining effect is easy to achieve and can be extremely effective, especially when used in conjunction with black borders or lines, which will give a late French Empire or Biedermeier look to a piece.

Equipment
Raw sienna oil glaze mix *Application brush* *Flogger* *Rags*

✱ Further information
Mixing glazes *p.13* Mediums *p.10* Flogger *p.24* Applying mediums *p.16*

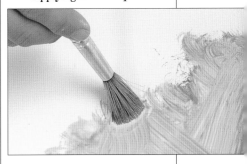

1 Brush on the oil glaze mixture, and tip off* in the direction in which the grain will run.

2 Use the flogger to pat the glaze in such a way that almost the entire length of the bristles is in contact with the surface. Work away from your body, lifting the flogger off the work before patting.

3 The finished effect closely simulates a pale wood.

Bird's-eye maple

The use of grained softwoods gained momentum in Europe at the time of the French Revolution, when harder wood was increasingly channeled toward military purposes. Locally grown beech and pine, or deal, were readily available but interest turned to more exotic woods in the desire for new effects. Bird's-eye maple was one example which grew in popularity until the mid-19th century, when graining was sneered at by the pundits of the day and went into decline.

Used in the past for large areas, such as paneling, a bird's-eye maple effect is extremely attractive for small pieces, such as boxes or mirror frames. The medium in this example is water-based, which gives a cleaner and finer finish. It is applied over a pale honey oil-based ground, and in order to allow the water-based wash to spread freely over the surface, all surface oil must be removed. Prepare the ground by rubbing it over with whiting*, using a rag or pounce bag*. Mix the wash* from powder color and water, using a 2:1 blend of raw sienna and raw umber. Apply the wash, tipping off* in the direction of the grain, and treat using a hog-hair mottler* in an action which combines dragging and walking the brush over the surface. Continue this in parallel bands until the surface is covered. Using a dampened fingertip, touch the wet surface to make a bird's-eye print. Repeat the marks in small groups over the entire area. Try to avoid making the prints too contrived or you may get a polka-dot effect. Use a badger brush* to soften the effect in all directions before allowing it to dry, when it should be varnished.

Equipment

Whiting
Wash of raw sienna and raw umber mixed 2:1
Application brush
Hog-hair mottler
Badger-hair softener
Rag or pounce bag

✱ Further information

Whiting *p.20*
Pounce bag *p.28*
Mixing washes *p.13*
Laying off *p.16*
Brushes *p.24*

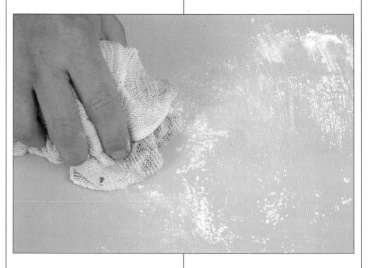

1 Rub over the oil-based ground coat with whiting, using a pounce bag or rag.

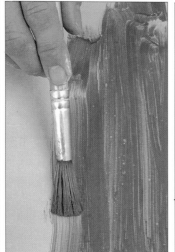

2 Apply the raw sienna/raw umber mix, and lay off* in the direction of the grain.

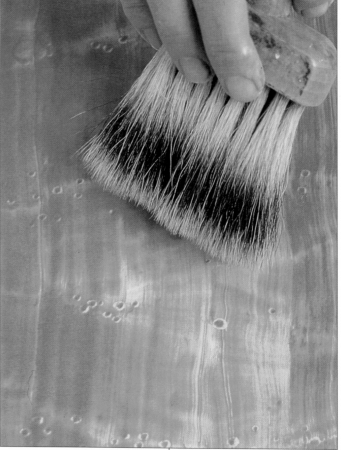

4 Dampen the tip of your finger and touch the wet wash to create the bird's-eye marks. These should be scattered over the area randomly but in vague groupings.

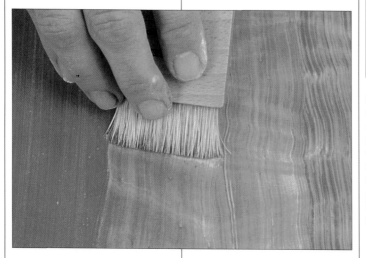

3 Drag a hog-hair mottler across the surface, moving one edge of the brush slightly in front of the other, and then the reverse, in an action like walking.

5 Soften the entire surface using a badger brush in all directions. This brush is so soft that it barely supports the weight of its stock. It should be used so delicately that the tips of the bristles barely touch the surface during the stroke, and it will gently blur the wash into a softer effect.

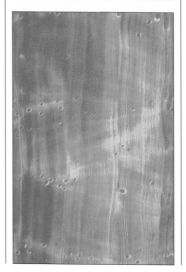

6 The pattern should not look repetitive. It helps to have a picture of the real wood as a visual reference while you work.

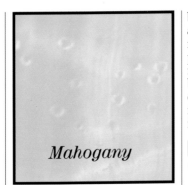

Mahogany

This finely figured wood was first used by Europeans to repair their ships while exploring the West Indies. One of its earliest documented uses in England was at Nottingham Castle in 1680, but over the next 50 years it became so popular that regular shipments from Central America could no longer meet demand, and an additional supplier had to be found. Mahogany began to be imported from Africa as well, and fine veneers were glued onto deal carcasses to reduce the cost.

The graining of this wood is more complicated than the two earlier examples. As with many graining techniques, there is more than one application. The undergrain is allowed to dry before first a figuring glaze and then the overgrain are applied on top. The undergrain is often oil-based, and the overgrain water-based to give a finer finish, but it is easier to practice the method with one medium at first, and in this example oil-based glazes are used throughout. The ground color for mahogany should be a brownish terracotta hue, but an exact match is not necessary. The color of a piece of wood depends on many factors, and it would be impossible to dictate a color that reflects all the individual variations found in nature.

Equipment

Undergrain glaze (one part raw umber, one part raw sienna, one part Vandyke brown)
Figuring glaze (one part burnt umber, one part Vandyke brown)
Overgrain glaze (burnt umber)
Application brushes for glazes
Hog-hair mottler
Badger-hair softener
Flogger
Cotton rag

✻ Further information

Mediums *p.10*
Mixing glazes *p.13*
Brushes *p.24*
Flogging *p.62*
Tipping off *p.16*
Dragging *p.54*
Clair bois *p.63*

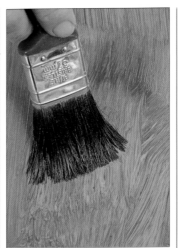

1 "Rub on" the thin undergrain glaze with the application brush. Tip off* in the direction of the grain.

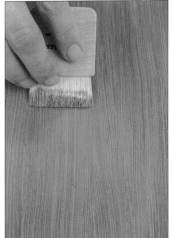

2 Using the mottler*, drag* with the proposed grain to produce even coloring and a faint drag.

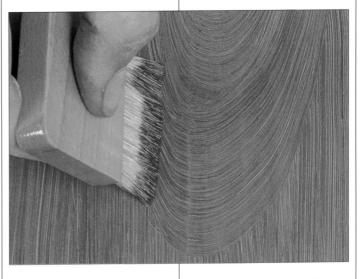

3 Continue with the mottler, this time used at a 90° angle to the previous strokes. Maintain this attitude as you etch in the annular rings, starting at the bottom with the smaller ring and building up. In this way, the bands get larger as they reach the summit of the figure and reduce as they fall level with the center.

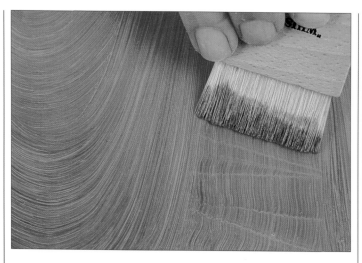

4 Once you have put in the main figure, gently drag in the remainder of the panel with the mottler returned to its original attitude. A slight movement of the hand similar to the technique used in bird's-eye maple will feather the edge. Leave to dry.

7 Apply the overgrain glaze, tipping it off in the direction of the grain.

9 The finished effect relies for its success on the pattern, depth of color and smooth surface.

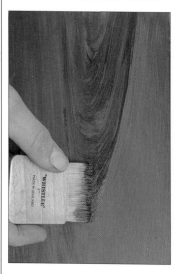

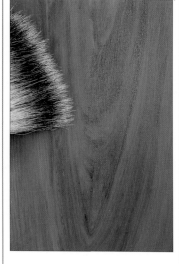

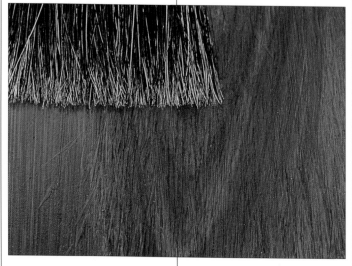

5 Using the hog-hair mottler and the figuring glaze, repeat the technique in step **3**. However, in this case the glaze is being applied instead of being removed.

6 Soften the figuring from the center outward with the badger-hair brush and allow to dry.

8 Flog* the panel with the flogging brush, working from the bottom upward, using a similar technique to that for clair bois*. Once dry, the panel should be varnished.

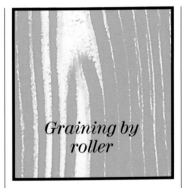

Graining by roller

Graining rollers offer a quick method of achieving a wood-like effect with a minimum of effort. Professional grainers are likely to pale at the thought of using them, because they need so little skill. There are many different sizes and grades of roller on the market. They can be used with oil- or water-based glazes but oil is the best choice for large areas, because it stays "live" longer, giving you more time to complete the technique. A soft color would be the most suitable counterpoint for the rough-hewn texture of this effect.

The term "roller" is slightly misleading, a key part of the action needed to use this device is more like rocking. This movement is made while you pull the roller across the surface. You will need to wipe the roller clean from time to time to prevent it from clogging with glaze.

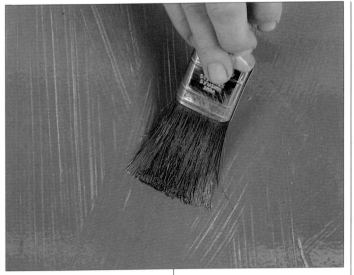

1 Apply the glaze with a brush or roller, and tip off* in the direction of the grain.

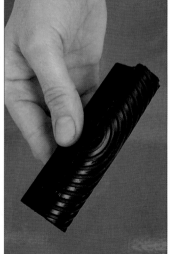

2 The open edge of the graining roller must be the leading edge when pulling through the glaze.

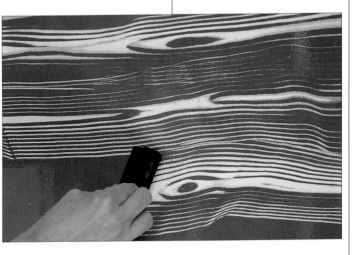

3 Hold the roller between fingers and thumb and drag it across the surface, rocking it gently at the same time. The rocking motion should be like turning a key in a lock. When beginning your drag, lean the roller so that the open edge is in contact with the surface. As you perfect the technique, keeping the roller at a constant angle, you can alter the attitude to its direction to achieve an undulating pattern, as in watered silk*.

Equipment

Paint or glaze
Brush or roller
Graining roller
Rags

✱ Further information

Applying mediums *p.16*
Combing: watered silk *p.51*

Lapis lazuli

A beautiful deep blue opaque stone with gold flecks, once dubbed "the heaven stone," lapis lazuli has always been valued highly. Originally found in Iran and Russia, it was ground down to create ultramarine blue. Highly expensive, ultramarine embellished many rich medieval paintings, where it was associated with purity and goodness. The Virgin Mary was nearly always depicted in this color. Today ultramarine is made from other pigments, and the only remaining supplies of lapis lazuli, from Chile and Afghanistan, lack the quality of depth and the number of gold flecks (iron pyrites) that were so distinctive in the earlier stones.

The following effect is a suggestive finish rather than an exact facsimile of lapis lazuli. In nature the gold would be less prevalent, and the veining less pronounced. However, this finish looks very effective on table insets, boxes, and lamp bases. You should apply a blue-gray ground in readiness for the effect, but as with any faux finish, such as marbling* or graining*, there can be no absolute color dictates, because natural substances vary so much.

The surface should be horizontal when the finish is applied. You can use a water- or oil-based medium* but, as always, the oil-based technique is easier to work because of its slower drying time, and it also tends to give a deeper effect. Mix the medium with a high ratio of color to reduce the yellowing of the glaze*. Apply ultramarine glaze first, and rag it over with a loosely crushed lint-free cotton rag*. While the ragged surface is still wet, paint on Prussian blue tinted glaze, in patches. Rag this in the same way as the first glaze, and then etch veins into the wet ground with a sword brush* fully loaded with mineral spirits. Pick up some bronze powder* on an artist's round brush* and add it to the veins. Use a larger brush to repeat the process adding gold or bronze powder especially where the blue is darkest. When the surface is completely dry, seal it with a latex glaze, and smooth it with wet-and-dry paper*, after which it can be finished with extra pale varnish* or latex glaze.

* Further information

Equipment

Ultramarine glaze and brush
Prussian blue glaze and brush
Bronze powder
Mineral spirits
Lint-free cotton rag
Sword brush
Artist's round brush

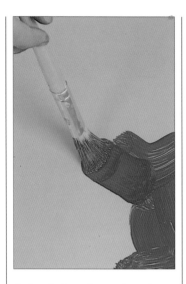

1 Apply the ultramarine glaze with a brush. The surface should be well covered and the glaze not tipped off*.

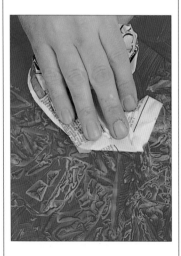

2 Break up the wet glaze by ragging with newspaper or paper, crushed into an open pad. Keep using the same part of the paper: the object of this technique is to displace the glaze rather than absorb it.

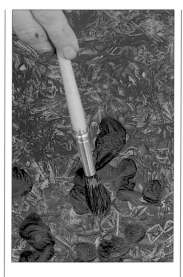

3 Apply the Prussian blue glaze strategically to give an undulating appearance.

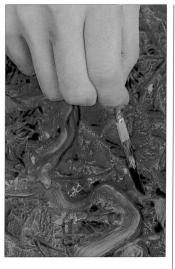

5 Load the sword brush with mineral spirits, and burn through the still wet glaze to create veins that meander and fracture.

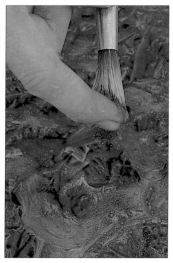

7 Mineral spirits can be spattered onto the darker patches to produce a more even effect.

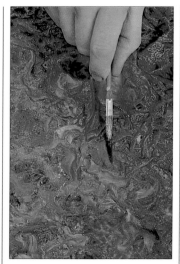

8 Picking up just bronze powder on the dampened sword brush, highlight the places where the veins meet.

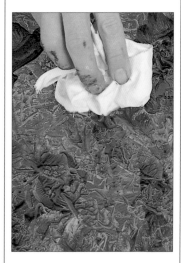

4 Using a cotton rag, break these areas up by ragging as before.

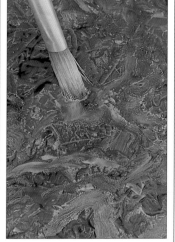

6 Use an artist's round brush, loaded with mineral spirits and bronze powder, to wander wider, gold-bearing veins through the ground.

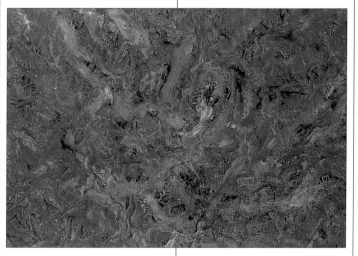

9 When the surface is completely dry (which could take several days) protect the finish by sealing, then varnishing or waxing.

Liming

Liming is a very similar effect to pickling*, but originates from a much earlier technique. Liming dates back to 16th-century Europe, when an unction containing the very corrosive slaked lime was applied to furniture and paneling to prevent worm and beetle infestation. Trapped in the pores of the open-grained wood, such as oak and elm, that was most widely used at the time, the white paste not only repelled the pests but also produced a pleasing visual effect. This became increasingly popular reaching its height in the 17th century.

Open-grained wood is still the best for this effect, and you will only need to give it a light brushing with a wire brush* prior to treatment. Close-grained woods will need more work with the brush. Once the grain has been readied in this way, you can apply a liming paste. Make liming paste by thickening white latex paint with a little plaster of Paris, as in the example here. Work the paste into the wood with a brush and then rub it off with a rag, leaving the wood to dry pale and ghostlike. Apply a sanding sealer*, and when this is dry, gently sand the surface with a fine paper*. Protect the effect with an extra pale varnish*. A splatter of black is sometimes added to suggest age.

✱ Further information

Equipment
White or latex
Plaster of Paris
Paint pot
Paste application brush
Wire brush
Sanding sealer
Sealer application brush
Fine sand paper
Rags
Varnish (extra pale)
Varnish brush
Black latex and spatter brush (optional)

1 Open the pores of the wood by brushing along the grain with a wire brush.

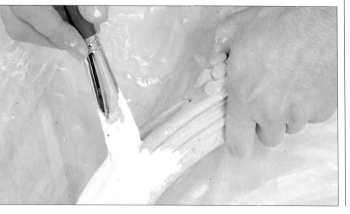

2 Apply a coat of liming paste mixed from white latex and plaster of Paris, working it well into the raw wood.

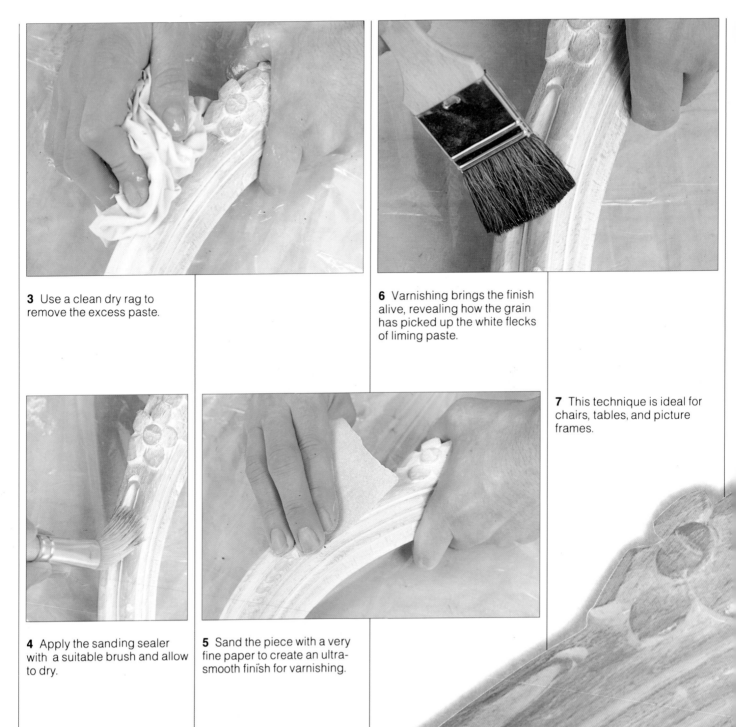

3 Use a clean dry rag to remove the excess paste.

6 Varnishing brings the finish alive, revealing how the grain has picked up the white flecks of liming paste.

7 This technique is ideal for chairs, tables, and picture frames.

4 Apply the sanding sealer with a suitable brush and allow to dry.

5 Sand the piece with a very fine paper to create an ultra-smooth finish for varnishing.

Malachite

Malachite is a rich green mineral formed of copper carbonate, named because its color resembles that of mallow leaves, and noted for its circular "bull's-eye" veining. Found in Eastern Europe, malachite has been used to great effect in Russian architecture, but is more often seen elsewhere as jewelry or as a decorative addition to furniture. Like all natural substances, malachite occurs in differing shades ranging from aqua green to emerald, and the bands of color which overlap to make its characteristic bull's-eyes vary from one stone to another. This effect has often been simulated in the past, using brushes and combs. The technique shown only employs brushes, in order to achieve a more muted result.

The ground color should be a pale blue-green. When this has dried hard, check the surface for faults and fine-sand it* before top coating. Apply a viridian oil glaze* and swirl it around with an artist's round brush*. Experiment with this swirling technique, overlapping the swirls until the entire surface is covered and the snaking patterns begin to build up into an overall design.

Next, introduce a second oil-based glaze tinted with darker monestial green. Work this into the still-wet viridian glaze to produce depths and shallows which begin to mix and blur. Form complete bull's-eyes by twisting the brush gently in a circle. Slight jittering is quite acceptable – in fact these circles should not be perfect. Now attack the glazes with mineral spirits, drawn carefully with a brush along one or two of the tracks already made in the glaze. The resulting patterns, which look like the contors on a map of some mythical land, should then be highlighted and strengthened with blue-black glaze and a spattering* of mineral spirits. This will suggest changing depths and bring into play a more natural figuring. The surface will now be very wet and must be allowed to dry thoroughly before varnishing.

❋ Further information

Sanding *p.21*
Mixing glazes *p.13*
Mediums *p.10*
Brushes *p.24*
Spattering *p.96*

Equipment

Oil glaze colored with viridian
Oil glaze colored with monestial green
Oil glaze colored with blue-black
Mineral spirits
Artist's round brush
Stencil brush

1 Apply the viridian glaze in a haphazard way, manipulating the brush to move the color about over the surface.

2 Using the artist's round brush, start to make the swirling marks. Hold the brush at the very tip, and roll it between finger and thumb to change direction. In this way, tight maneuvers can be made quite easily. This is a good time to play with the glaze and experiment with different shapes. There is no pressure of time. The glaze will take a while to begin tacking up. If it does, you can remove and re-apply it.

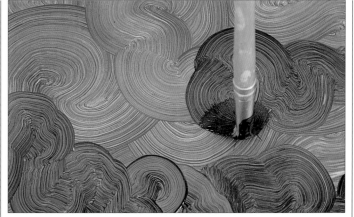

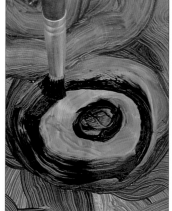

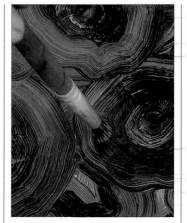

3 The monestial green glaze now comes into play, applied in a similar way to the viridian. At this point a vague scheme should be evolving. The monestial glaze should cover about 80 percent of the area, leaving the viridian to glow in shallows and highlight the figuring.

6 The blue-black will help to accentuate an impression of changing depths and mineral spirits spattered on with a stencil brush will give a less contrived feel to the effect.

7 Using a stencil brush loaded with mineral spirits, retrace some of the lines previously made. The glaze will dissolve and show the ground color through a veil of green. Introduce some blue-black glaze to the pattern, especially in the bull's-eyes.

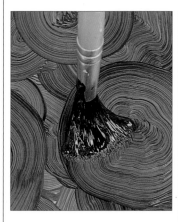

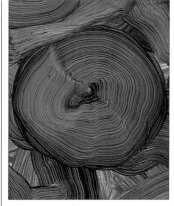

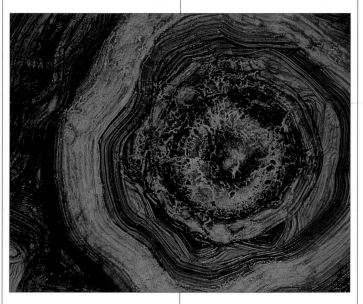

4 Create bull's-eyes of different sizes by twisting the brush between finger and thumb. Do not rush – a quick movement tends to introduce straight lines, which are disastrous to this finish.

5 The circular tracks, like mysterious contours on some undersea map, should meander around and under the bull's-eyes and each other.

8 The completed effect shows the degree of depth which can be achieved with this finish.

Marbling

Siena marble
◆
Black and gold marble
◆
Egyptian green marble

Marbling is the finishing of a surface in close imitation of real marble and will therefore be more successful if you study the figuring and veining of at least a few standard marbles.

Marbling dates back to ancient Egypt and is said to owe its evolution to the high cost of the genuine material and the difficulty of transporting it over large distances. However, the art spread, even in countries such as France and Italy where marble was readily available. The reason probably lies in the nature of marble itself. A strong, compacted stone, it is a safe building material when used in a block or column. But it cannot be used for beams and ceilings. These would therefore be decorated with a faux finish to complete a marble room scheme.

Similar techniques were also employed in a purely decorative way to create pleasing marble-like effects without regard for authenticity. This fantasy marbling, known today as marblizing, was used in harpsichord cases and other situations where it would obviously be impossible to use the true material. The techniques shown here have been passed down over many years specifically to produce imitations of real marble. But skills you acquire while practicing these effects can equally well be used with any color combination you like to produce a marblizing effect.

Siena marble

This marble is warm and delicately figured, and lends itself to use on walls and baseboards, or furniture. Prepare the surface well*, and apply a white oil-based ground coat*, which must dry hard before further coating. Add an even coat of flat white oil-based undercoat tinted with raw sienna artists' oil color.

Now mix three tinted oil glazes with the following artists' oil colors: raw sienna, burnt sienna and vermilion. Lay the three glazes onto the wet ground in fairly uneven patches. Blot the three colors with a crushed rag. Then use the hog-hair softening brush* to blend the colors into the wet ground. This is an important technique to practice, as it is employed in most marble effects, as well as in graining* and tortoise-shelling*.

Dampen the sword brush* with mineral spirits and load it with blue-black oil color to draw in the veins. When the main veins are in place, soften them with a badger-hair brush*. Distress* the ground here and there, using a natural sponge* and mineral spirits.

Then soften again, this time with a hog-hair brush*. Add the cloudy white deposits by softly applying thin white undercoat with a sword liner and softening with a hog-hair brush. Put in the fractured secondary veining using the sword liner and blue-black, softening from time to time. Add white veins and highlights without softening.

Allow the completed marble to dry. Varnish*, and then wet-and-dry* until flat. Color in any lost detail or highlights and varnish again using an extra pale varnish*.

Equipment

White undercoat
White undercoat tinted with raw sienna
Oil glaze mix tinted with raw sienna
Oil glaze mix tinted with burnt sienna
Oil glaze mix tinted with vermilion
Blue-black artists' oil color
Four application brushes
Hog-hair softening brush
Badger-hair softening brush
Sword brush (also called a liner or striper)
Natural sponge
Lint-free cotton rags
Mineral spirits

✱ Further information

Preparation *p.17*
Mediums *p.10*
Mixing colors *p.13*
Brushes *p.24*
Graining *p.63*
Tortoiseshell *p.111*
Distressing *p.43*
Natural sponges *p.26*
Sanding *p.21*
Finishing marble *p.80*
Varnishing *p.29*

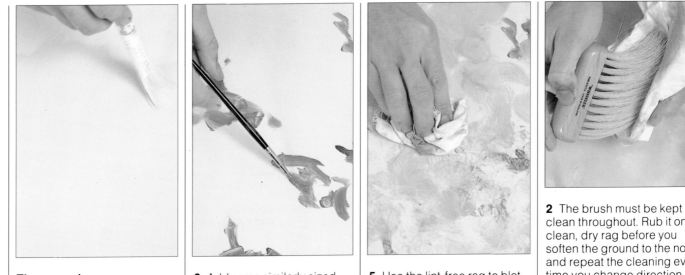

The ground
1 Evenly apply the white undercoat tinted with raw sienna.

3 Add some similarly sized patches of vermilion tinted glaze.

5 Use the lint-free rag to blot the wet surface.

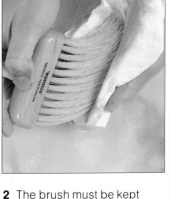

2 The brush must be kept clean throughout. Rub it onto a clean, dry rag before you soften the ground to the north, and repeat the cleaning every time you change direction.

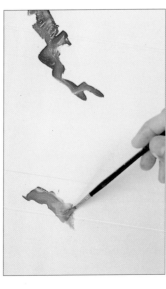

2 While the ground is wet, lay on patches of burnt sienna tinted glaze.

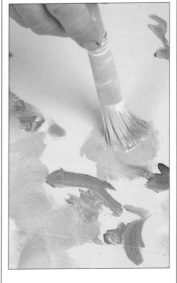

4 The raw sienna tinted glaze completes the tri-color combination.

Softening
1 Soften the ground colors with the hog-hair softener. This technique is worked in four directions – north, south, east and west. Here the brush is being gently drawn to the south. The bristles should barely touch the surface, and the brush should be angled slightly toward the direction in which it is traveling.

3 Soften in an easterly and then a westerly direction, remembering to clean the brush constantly.

4 If the brush is used too strongly brushmarks will appear. This can be put right by cleaning the brush and brushing lightly at right angles to the mark. Here the final softening strokes are being applied. Compare the appearance of the ground now to the way it looked at the start of softening.

2 Soften the veins in the same way as the ground colors, this time using a badger-hair softener. The finest of all brushes, this will soften so delicately that the subtleness achieved is breathtaking.

4 Soften the sponged areas following the same technique as before, brushing the slanted hog-haired softener gently to the north, south, east, and west.

6 Soften with the hog-hair brush, first along the vein, then gently away from it, and finally back toward the vein. In this way, the chalky deposits appear to be held back by the veins.

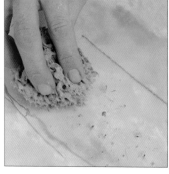

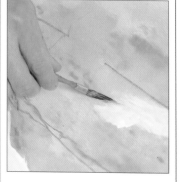

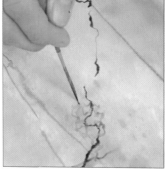

Veining
1 Using the sword brush dampened with mineral spirits, pick up some blue-black and draw the major veins quite quickly. Always pull the brush toward you, and change direction by twisting it between finger and thumb. Here a forking vein is drawn, broken by the kind of crack which is typical of marble.

3 Using a natural sponge slightly dampened in mineral spirits, gently dab over the ground. This technique causes the ground to burn through in places and create a freckled effect which contrasts well with the smoky softness of the other areas.

5 Use the sword brush to apply patches of white undercoat. These should be bounded by a vein as shown.

7 Draw in the finely cracked and splintered secondary veins, using the sword brush and blue-black.

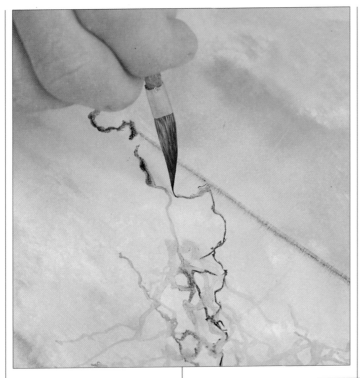

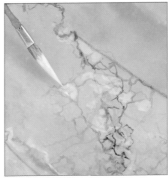

9 Use white undercoat for additional veining detail and to highlight veins and cracks.

10 The completed Siena marble should be varnished when dry to protect and enhance the delicacy of the effect.*

Black and gold marble

8 These cracks form on every bend of a vein and fracture forward as well as backward, creating a fine web-like network. The crack shown in the first veining pictures appears here in greater detail and has led to further crazing, which stops only when it joins the next main vein. This type of structure is common in marble, where veining results from enormous changes in temperature and pressure that crystalize color and fragment the limestone from which it is formed.

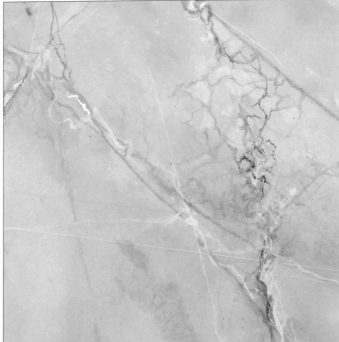

An exotic marble with fiery veins and speckles of gold and white, this has often been used for baseboards, especially in contrast to walls of a paler marble. It would make a good choice for lamps and table tops.

The ground must be black, dense and smooth, and the effect is achieved with brush, feather and sponge. Begin figuring with patches of yellow ochre oil glaze* and Venetian red* from which fibrous veins will extend. Apply them in a two-color brushing technique using a sword brush, or striper*. Load this with the yellow ochre glaze, but add a little Venetian red straight from the tube to the top part of the bristles, or heel of the brush, nearest the handle. In this way, you can put in touches of red when required simply by lowering the heel of the brush onto the surface. This may take a little practice, but adds greatly to the effect.

Apply fine white veins with a feather – any kind will do providing it's clean*. Use the wide edge, which will hold more paint and produce a finer line. Then soften the marble to north,

south, east and west with the badger-hair brush*, as for Siena marble*. Dampen the natural sponge* in a little mineral spirits, and bounce it gingerly over the veining to produce a freckled, slightly pitted effect. Work over this, using an artist's writing brush and the sword brush to fiddle in more veins and achieve a faintly honeycomb effect. Highlight this with white and an occasional hint of red before softening again. Put in the fine highlights with an artist's brush and leave the piece to dry. Finish the marbling by applying an extra pale varnish*.

Equipment

Oil glaze tinted with yellow ochre
Venetian red artists' oil color
White undercoat
Sword brush
Feather
Badger-hair softening brush
Artist's writing brush
Natural sponge
Mineral spirit
Fine wet-and-dry paper
Extra pale varnish and application brush
Clean rags

✱ Further information

Mixing glazes *p.13*
Mediums *p.10*
Brushes *p.24*
Feathers *p.26*
Softening technique *p.76*
Marine sponge *p.26*
Varnishing *p.29*
Sanding *p.21*
Preparation *p.17*

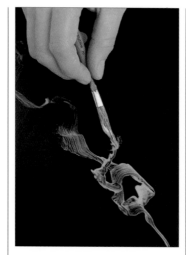

1 Apply the yellow ochre glaze with the sword brush, pulling and fidgeting the brush while twisting it between finger and thumb.

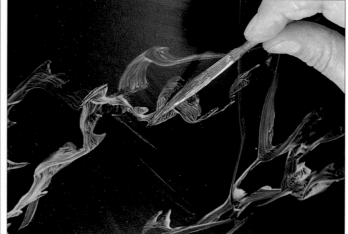

3 Dance the brush along and allow the heel to make gentle contact with the ground to deposit some red.

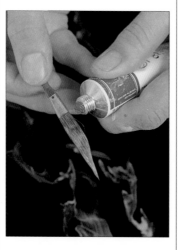

2 Dab Venetian red artists' oil color onto the heel of the brush so that from time to time during the figuring you can add a trace of red to enhance the fiery look characteristic of this marble.

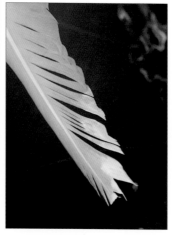

4 Use the feather (in this case, a goose feather) to draw in fine white veins running with and against the trend.

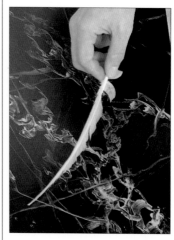

5 Add the white to the major veins, using the broader side of the feather, which will hold more paint and produce a thinner line.

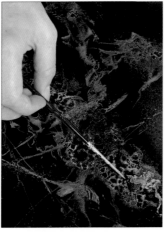

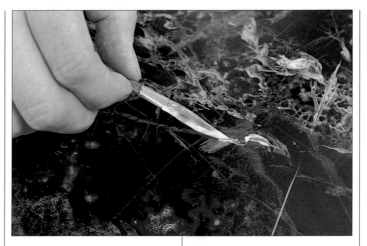

6 Soften the entire area with the badger brush, remembering to work in each of the four directions in turn and to keep the brush clean and dry by rubbing with a rag.

8 Strengthen the main figure using the yellow ochre on an artist's writing brush.

10 Use the sword brush to put white veins and highlights into the main figure. Add a few touches of red before softening again with the badger brush.

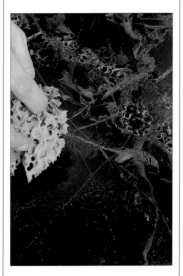

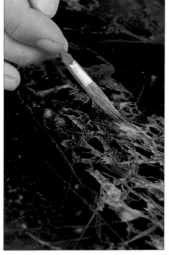

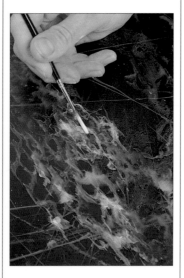

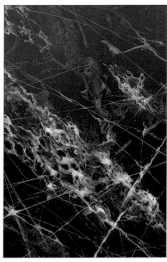

7 Dampen the natural sponge slightly with mineral spirits, and pounce it gently over the central figure. Holes will appear where the mineral spirits dissolves the glaze.

9 A honeycomb structure begins to evolve as the figuring continues.

11 When figuring is complete, add the final touches of white. Do not soften any further.

12 The finished effect has a powerful starkness warmed by the impression of inner fire.

FINISHING MARBLE

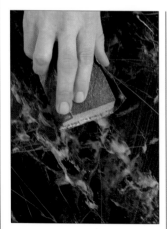

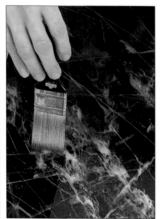

1 All marble effects must be varnished* to seal and enhance the finish. Allow the surface to dry completely – normally for 24 to 48 hours – before sealing with a first coat of oil varnish. Then use fine wet-and-dry paper and a block*, together with water, to smooth the surface*.

2 Apply a protective coating of extra pale varnish with a varnish brush*. Further coats can be added according to the degree of finish required.

3 The completed effect shows how the varnish brings the finish into focus and adds an important layer of depth.

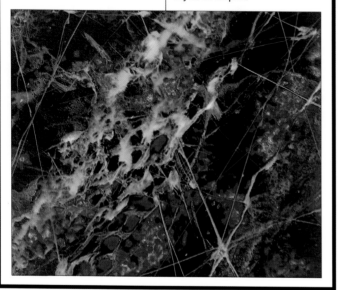

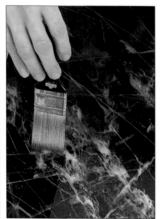

Egyptian green marble

This rich dark green marble is often used on pilasters and plinths, but its intricate detail and luxurious quality make it appropriate for smaller items such as table tops and inlays.

The effect begins with a black ground, which should be smooth and dense. Use a toothbrush or short-bristled brush to spatter* vermilion oil glaze* lightly over this surface. When this has tacked up roll on terre verte glaze with an artist's writing brush*. Twist the brush between the finger and thumb to roll the glaze off it. When about three-quarters of the area is covered with terre verte glaze, soften the effect with a crushed newspaper. Now fiddle in the white veins. These should be softened every so often using the badger-hair brush*. Gradually the dark green ground begins to break up beneath the fine web of veins. Touches of vermilion highlight some of the small plates surrounded by veining. Soften these, and allow the surface to dry before smoothing and varnishing with extra pale varnish*.

Equipment

Oil glaze mix tinted with vermilion
Oil glaze mix tinted with terre verte
White undercoat
Toothbrush or stencil brush
Artist's writing brush
Artist's 00 brush
Badger-hair softening brush
Sword brush
Newspaper
Cotton rags

✳ Further information

Spattering *p.96*
Mixing glazes *p.13*
Mediums *p.10*
Brushes *p.24*
Varnishing *p.29*
Sponging *p.98*
Ragging *p.88*
Softening technique *p.76*
Siena marble *p.75*

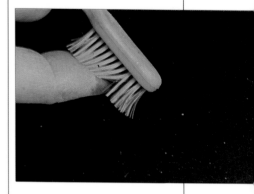

Initial effects
1 Using a toothbrush or stencil brush, spatter the vermilion glaze onto the black ground and allow to tack up.

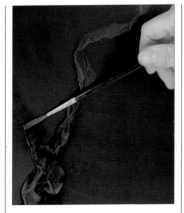

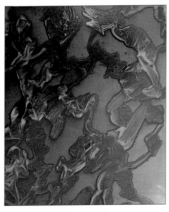

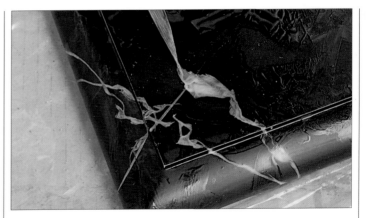

2 Twist the artist's writing brush between finger and thumb to roll the terre verte glaze onto the ground.

3 Roll the brush this way and that while drawing it over the surface until about three-quarters of the area is covered.

Veining

1 While the ground is still wet, apply the white undercoat thinned with mineral spirits or turpentine, using the sword brush.* Again, roll the brush between finger and thumb, and use its flat, tapered shape to produce wide and narrow vein lines. Make all your painting strokes toward the body, bringing the width and the heel of the brush into play when a broad vein is required and the tip and edge of the brush for a thin vein.

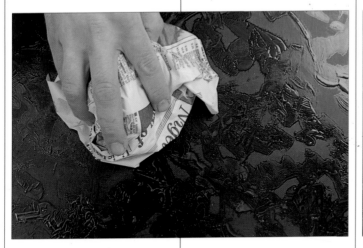

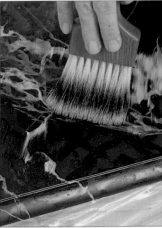

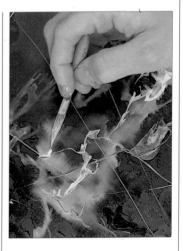

4 Soften the effect by crushing the newspaper into a pad and working over the surface as if you were sponging* or ragging.*

2 When the initial veins are in, soften them with the badger brush. The softening gives a smoky effect and creates the illusion that the vein is a little way under the surface.

3 Add more veins, like this one, sketched over the top of an earlier vein. The meandering veins of this marble differ quite strongly from the patterns found in the Siena marble*.

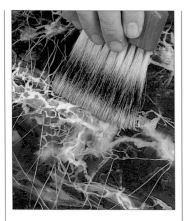

4 More softening follows, and you can see the gradual build-up of fine, straight crack veins which run at right angles to the original trend.

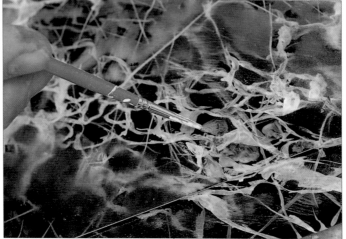

Softening
1 Some of the small plates created as the white veins break up the surface are picked up with vermilion from an artist's 00 brush.

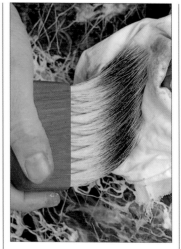

3 Only a clean brush will produce a good quality finish. Clean the bristles regularly with a dry rag.

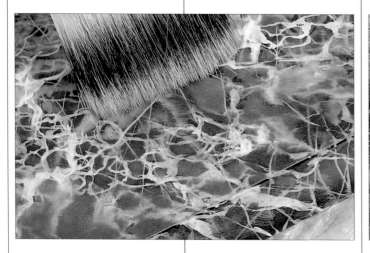

2 Soften the vermilion plates using the badger-hair brush. As always, softening is crucial to successful marbling. The bristles should hardly touch the surface.

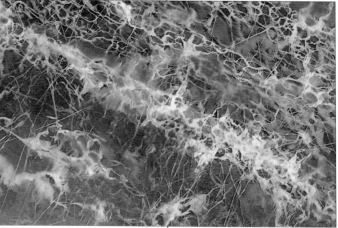

4 The completed surface showing the swirling, frothy network of veins intersected by fine lines. Allow this to dry before varnishing. Varnish enriches the shading and preserves the texture of the finished effect.

Pickling

This effect dates back to a finish called pickled pine, which evolved in the late 19th century. At the time, paint was commonly used to conceal the cheap construction of much of the pine, or deal, furniture to be found in servants' quarters and among the less well off. But the emergence of the Arts and Crafts movement fueled a fashion for natural wood, and stripping painted pine became increasingly popular. The stripping was a highly dangerous treatment undertaken with nitric acid. This left the wood looking aged and ashen, with white or gray remnants of paint and gesso clinging to the crevices. In some cases, the wood lost its color and resembled driftwood. In others, the color was darkened.

This "soft on the eye" effect (which came about by accident) was so admired that soon a technique was developed to apply it to new furniture. This involved bleaching and staining the wood, followed by filling the grain with a white or gray paint or paste. By the 1930s the effect was being used extensively, and cheap short-cuts were replacing the genuine technique for treating new wood. In a similar way to the evolution of graining*, the cheap, quick, and badly applied effects found their way into restaurants and bars, and out of favor.

Today the effect can be undertaken with little risk, as no acid is employed. And although purists may continue to view it with some disdain, its pale chalky demeanor and the ease with which it enables a piece to fit into a color scheme have guaranteed pickling, like liming*, a resurgence in popularity.

The piece to be finished should be in a raw state, and free of grease and grime. If the wood is very pale, you can stain it at this stage to provide some contrast with the top coat. Next you should seal with a sanding sealer. This is a clear shellac* with a denatured alcohol base, so it will soon be dry. Brush on a white latex* and remove it with a rag, leaving the surface relatively clean, except for crevices and corners, which naturally trap the paint. Work on one area at a time, or the latex will dry before it is wiped off. When wiping is complete, allow the piece to dry, sand it thoroughly, and protect it with one or two coats of extra pale varnish*.

❋ Further information

Graining *p. 63*
Liming *p. 71*
Mediums *p. 10*
Sanding sandpaper chart *p. 21*
Varnishing *p. 29*

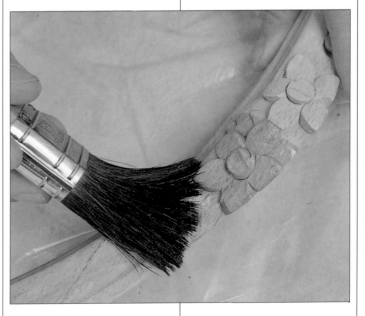

1 Clean the surface and apply sanding sealer with a brush. The sealer will quickly be absorbed by the wood.

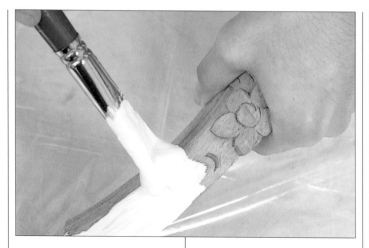

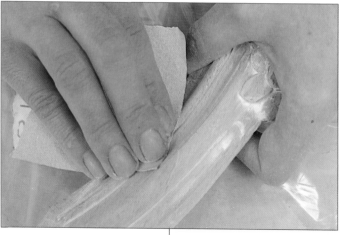

2 When the wood is dry, apply white latex* by brush, making sure that every nook and cranny is covered).

4 When the piece is dry, sand it with a fine-grit sandpaper*, remembering to go with the grain.

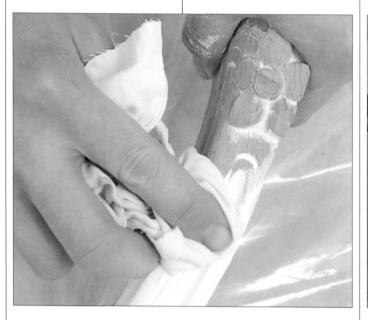

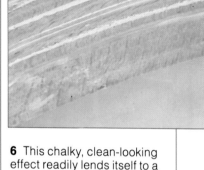

3 Wipe the latex off the majority of the surface – only the detailing will readily retain the paint. The latex will dry quite quickly, so work on small areas at a time, applying and wiping, rather than trying to cover the whole piece and then wiping it.

5 Apply one or two coats of extra pale varnish to protect and enhance the effect.

6 This chalky, clean-looking effect readily lends itself to a variety of wide-ranging decorating schemes and is justly popular with designers and decorators.

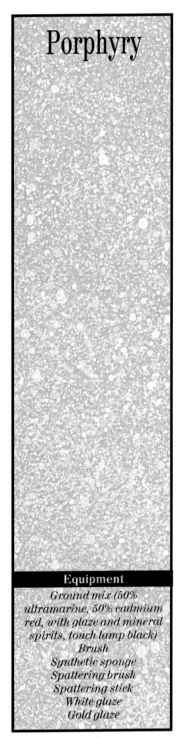

Porphyry

Equipment

Ground mix (50% ultramarine, 50% cadmium red, with glaze and mineral spirits, touch lamp black)
Brush
Synthetic sponge
Spattering brush
Spattering stick
White glaze
Gold glaze

Porphyry is a very hard variegated igneous rock with a granite-like texture, often containing fool's gold. Although it occurs in different colors, such as green and reddish brown, it is best known in its predominantly purple form, and its name means "purple stone." The Romans particularly enjoyed this exquisite color and dubbed the rock the "imperial purple porphyry" because its color betokened imperial rank. The effect is, therefore, a faux finish, for which it is advisable to look at an original beforehand, as in the case of marbling* or graining*. It is best used on plinths, columns, and anywhere suitable for genuine porphyry.

The technique involves two basic finishes: the ground coat, which is sponged off*; and the glaze or top coat, which is spattered*. Undertake the initial spattering by loading a long-haired brush with color that has been thinned to the consistency of milk. Tap the brush with the spatter stick, or vice versa. The stick has no other purpose, so almost any scrap of wood will do in its place. The impact between stick and brush will cause the bristles to flick strongly and discharge the color droplets.

Porphyry uses oil-based glazes and mediums*. The ground coat color is mixed using ultramarine, cadmium red, and a little lamp black, together with transparent oil glaze, thinned with mineral spirits. It is advisable to use artists' oils, which are of higher quality, and to mix a strong color, which will be more permanent. The ratio of color to glaze will dictate the strength of the color.

✱ Further information

Marbling *p.75*
Graining *p.63*
Sponging off *p.103*
Spattering *p.96*
Mediums *p.10*

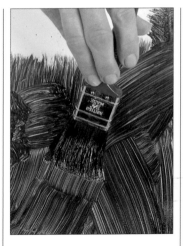

1 Apply the color-mixed glaze to the surface with a brush.

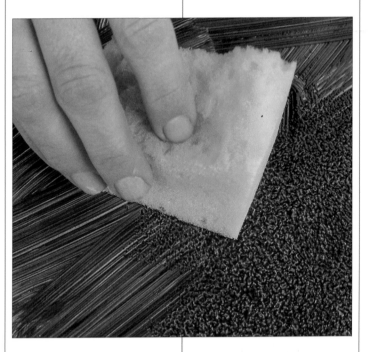

2 Using a clean, dry, synthetic sponge, even out the glaze and remove the brush marks. Pounce the sponge over the area*.

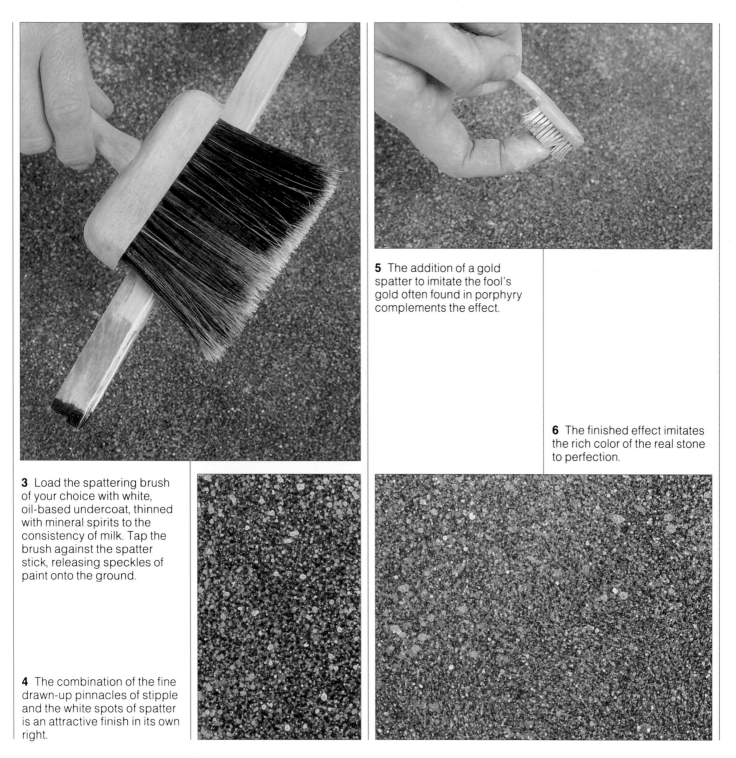

5 The addition of a gold spatter to imitate the fool's gold often found in porphyry complements the effect.

6 The finished effect imitates the rich color of the real stone to perfection.

3 Load the spattering brush of your choice with white, oil-based undercoat, thinned with mineral spirits to the consistency of milk. Tap the brush against the spatter stick, releasing speckles of paint onto the ground.

4 The combination of the fine drawn-up pinnacles of stipple and the white spots of spatter is an attractive finish in its own right.

Ragging

Rag rolling

◆

Bagging

◆

Ragging on and frosting

◆

Gold and silver fossil

Ragging covers a selection of finishes which rely on the contors of fabric. The fabrics used range from linen to plastic, and their effects are dramatic and diverse. Colors for this effect are normally soft, and the base color is nearly always the paler one. The obvious exception is frosting*, which is achieved with a white or off-white top coat. The majority of the effects are subtracted* and therefore require a certain amount of planning when large areas are to be finished.

The procedures needed for ragging, and their results, vary in two respects. First there is an enormous choice of materials, from paper to chamois leather, each of which will give a different texture. Second is the way in which the chosen material is manipulated – whether rolled across the surface or pounced in a similar way to stippling. The application of the top coat can be by brush or roller. If you use a brush be careful to tip off* the glaze and therefore lessen the brush marks. Some finished effects can be quite open and would be spoiled by such visible marks. The effect is one of the most dramatic and can be used for a wide variety of purposes. The crushed velvet texture can take on a marble-like appearance, especially when a gray or stone color is used as the base and paler mid-tone as a top coat. Many a coffee table has been improved with this technique.

Rag rolling

This effect is produced by rolling a lint-free rag over the wet surface of the glaze. Any material can be used, providing it is lint-free and clean, and unlikely to bleed color. Terrycloth will create a soft texture, while a non-absorbent plastic bag will leave a sharp, well-defined look. Most important when choosing your material is its quantity. If you are finishing a large room, you will need a plentiful supply of material, so that sodden rags can be replaced.

The preparation should be of good quality, but rag-rolling is kind to its surface. This makes it especially appropriate for a wall that is sound, but has undulated as old walls often do. Unlike dragging*, which would highlight the lumps and bumps, rag-rolling will make these less apparent.

Many techniques have been offered over the years to achieve this effect, but the original procedure has yet to be bettered. The technique is to crush the fabric several times by bunching it up and then unraveling it. This will give it some initial character. The material is then gathered into a loose

bunch and rolled in a diagonal course over the surface with the lightest of pressure. Avoid using the rag tightly rolled as this produces a repeated pattern and heightens the danger of skidding. Try to fill the area without rolling vertically or horizontally, as the eye will pick this up and the finish will be marred. Once you have covered an area, stand back and blur your eyes to check for dark patches. These can be blotted to keep the undulating effect even.

When you have completed the work or are taking a break, be sure to spread or hang out the used rags that have glaze mix on them, so that they dry thoroughly.

Equipment

Paint or glaze
Brush or roller
Rags

✳ Further information

Frosting *p.90*
Applied and subtracted finishes *p.15*
Applying mediums *p.16*
Dragging *p.54*
Ragging on *p.90*

WARNING

Never be tempted to throw rags away wet or leave them bunched up, because they are highly inflammable and can ignite spontaneously.

4 Blot darker areas and check the evenness of the finish by standing away from it and blurring your eyes. Lighter areas or bald patches may be remedied by ragging on* a little glaze with a wet rag.

1 Apply the glaze – in strips of about 24 in. wide for a large area.

2 Tip off* the glaze lightly, spreading it out and eliminating brush marks.

3 Roll the loosely bunched rag across the surface in a diagonal direction, applying only delicate pressure. Fill in, using angled runs, avoiding the vertical and the horizontal.

5 The completed rag-roll effect should tumble and twist across the surface. Viewed from a distance, the movement should be soft and not patchy.

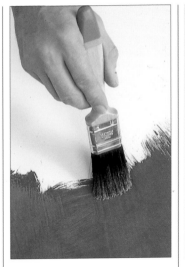

Bagging

Bagging, or bag stippling is one of the simplest subtracted* effects. The choice of medium is limited to a transparent oil glaze, because a solvent is sometimes required to break up the glazed surface. A brown paper bag dipped into mineral spirits or turpentine and scrunched up gives a crackled effect. Plastic bags are also used, and the thicker and more robust the bag the crisper the effect. A relatively soft supermarket bag was used in this example, which produced a subdued texture. Bagging is a soft, luxurious effect which, in some colors, can look like marble. It is best suited to smaller areas, woodwork, or on the walls of an opulent dining room.

Equipment
Glaze
Brush or roller
Paper or plastic bag

* Further information
Applied and subtracted finishes *p.15*
Applying mediums *p.16*

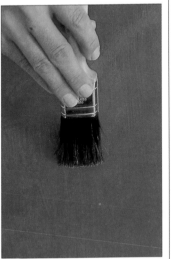

1 Apply the glaze with a brush or roller.

2 Spread out the medium, and tip off* to reduce brush marks.

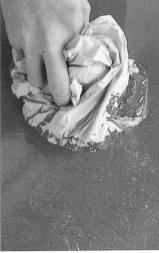

3 Pounce the bag over the surface. It is unlikely that more than one bag will be needed, because very little glaze is picked up by the plastic – it is merely redistributed.

4 The finished effect is luxurious, relying almost entirely on texture rather than the contrast between the ground and top coat.

Ragging on and frosting

Unlike the other rag effects, these are applied finishes*. The glaze is applied to the dry ground or base coat with a rag. The choice of rag is wide, but it must be reasonably porous in order to carry the glaze.

Ragging on
Ragging on probably evolved from rag rolling*, where it is often used to correct an error. Suitable colors are closely linked to those for sponging on*, as is the technique. The effect can be achieved with any glaze, but water-based glazes are most often chosen because of their quick drying. The only tools you need are those for preparation, together with a rag, some glaze, and posterboard for testing. Dip the rag into the glaze and test its print on the posterboard. Once you have an acceptable print, you are ready to approach your surface. The effect needs to be built up gradually, and because this is an applied effect, you can stop at any time and resume at a later date. The technique is the same as for sponging on*, with the rag taking the place

of the sponge. As an applied finish, ragging on has obvious advantages. In addition, it provides a sharp, more aggressive contrast between the ground and the top coats. The finish is often used on walls, but with very soft colors to make the overall effect easier on the eye.

Frosting

Frosting is a finish that works to great effect over many different grounds. It is achieved by either sponging on or ragging on, and is frequently used to refinish a decorative scheme quickly and inexpensively. It is often applied over paint effects that need lifting because they have become too heavy. A white or off-white top coat, put on by rag or sponge, is gradually built up, as described in sponging on*, until it almost conceals the original surface. Although technically a color reversal of two other effects, frosting is widely regarded by decorators as a finish in its own right.

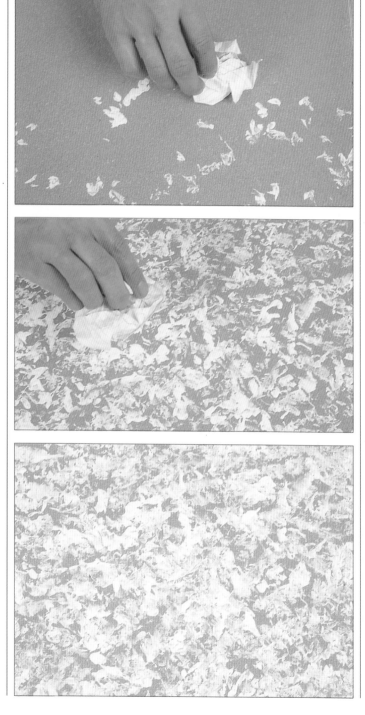

1 The white glaze is here applied with crumpled paper.

2 You should cover the whole area and gradually build it up, taking time to step back regularly and check the patches.

3 The completed effect is crisp, reminiscent of a frosty morning.

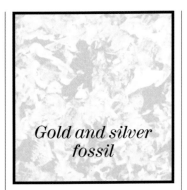

Gold and silver fossil

These effects, named for their appearance, are very much part of the rag finishes. The technique is the same as that for ragging' and rag rolling*, but the glazes are different. The effect is luxurious and should, therefore, be used sparingly. It is normally confined to furniture and accessories. Latex glaze* is used for both finishes, mixed with bronze powder for the gold effect or aluminum powder for the silver, and thinned slightly. The base coat should be a dead flat black and good preparation is important. The surface must be very smooth.

Gold
Lay the gold glaze on the ground coat with a brush. Roll a piece of cheesecloth across the surface but press firmly. The fine powder will adhere to the ground, and the medium will be absorbed by the rag. As you roll make sure you push or pull the gold mixture into a pleasing effect. The holes in the cheesecloth will contribute to this, and the bits of lint left on the surface can be removed when dry.

A spattered effect can be added to the damp glaze with the aid of denatured alcohol (see silver glaze).

Silver
Aluminum powder is mixed into the latex glaze in the same way as the bronze powder, but needs a slightly thinner mix, produced by adding more water. The application – again only by brush – should be quickly followed by the ragging technique. Use a cotton cloth, twisting it slightly while it is pounced to produce a good print. At this point, you can create a further effect by spattering denatured alcohol over the area. This releases the glaze in spots and pools, an effect that can also be achieved with the bronze glaze.

Equipment
Latex glazes
Paint pot
Water
Bronze powder (Rich pale gold) or
Aluminium powder
Brush
Cheese cloth
Toothbrush
Rag
Denatured alcohol
Stick

✱ Further information
Ragging p.88
Rag rolling p.88
Mediums p.10
Equipment p.22
Varnishing p.29

Gold
1 Pour the latex glaze into a paint pot and add a little bronze powder.

3 Do not allow the mixture to become thicker than light cream.

2 Mix the powder and glaze with a little water and continue adding bronze powder a small amount at a time.

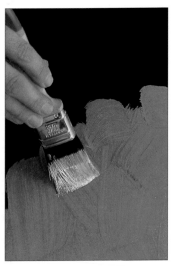

4 Apply the glaze with a brush. Do not spread too thinly.

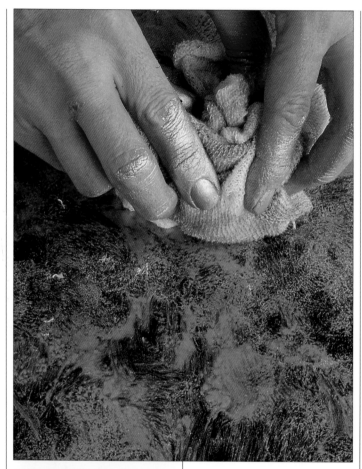

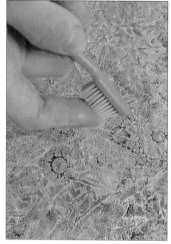

Silver
1 Use a brush to apply the glaze, which should be slightly thinner than its gold counterpart.

3 Use an old toothbrush to spatter the still-wet surface with denatured alcohol.

5 Ragroll the area with cheesecloth, exerting firm pressure to move the glaze.

6 When the surface is dry, the lint from the cheesecloth can be rubbed off, leaving an undulating, luxurious finish, which should be protected with a gloss or satin varnish*.

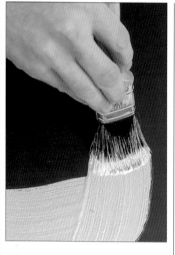

2 Rag the glaze in a pouncing movement, using a lightly bunched-up piece of cotton. Apply some pressure to the rag and slightly skid or twist it if it becomes difficult to acquire a good print.

4 The finished effect is almost molten in texture, ideal for an art deco-style interior.

Sandstone and Lichen

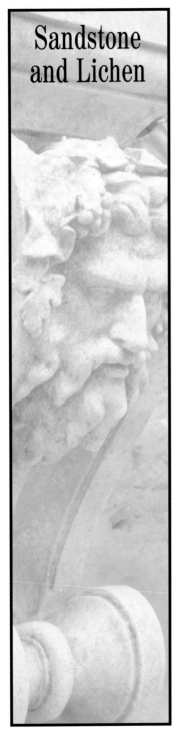

While faux stone blocks* have moved from being an exterior finish to grace many a fine entrance hall or stairway, the related sandstone and lichen effect finds its natural environment outside in the oramentation of backyard or decks and sheds. Lichen can be encouraged to grow on new stonework by painting it with live yogurt, but this takes time. An instant effect using paint can be remarkably effective. The example here is a Bacchus corbel (a decorative masonry support) made of polyurethane foam. It is first painted with a dull ochre oil-based ground*. When this is dry, a thin white latex glaze is scumbled (scrubbing dry paint with a dry brush over another dry layer) over the piece, which is then stippled* with a raw sienna wash while still wet*. The surface is gently ragged* to leave the yellow ground in some areas, and the white or sienna in others. The white glaze is then reapplied using a natural sponge*. This sponging* must be done delicately, allowing the sponge* merely to settle on the surface rather than pushing it into the hollows. The lichen is applied by spattering* yellow ochre and opaque oxide of chromium* onto the wet surface. The effect should be sealed with a flat water-based sealer*, as any sheen would be inconsistent with sandstone.

Equipment

White latex glaze and coarse application brush
Raw sienna wash and application brush
Yellow ochre and opaque oxide of chromium (acrylic colors)
Flat water-based sealer and brush
Natural sponge
Spatter brush
Cotton rag

✱ Further information

Faux stone blocks *p.59*
Mediums *p.10*
Mixing glazes *p.13*
Stippling *p.104*
Color washes *p.47*
Ragging *p.88*
Natural sponges *p.26*
Sponging *p.98*
Spattering *p.96*
Mediums chart *p.10*
Varnishing *p.29*

1 When the dull yellow ground is dry, apply the thin white latex glaze using a coarse latex brush to produce a patchy undulating coat.

2 Stipple the raw sienna wash into all the crevices, and haphazardly over the surface, missing some areas altogether.

5 Simulate the lichen by spattering yellow ochre and opaque oxide of chromium onto the wet surface.

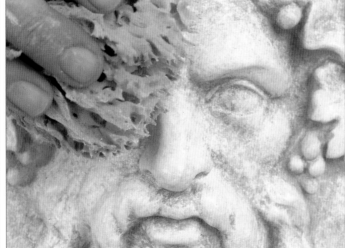

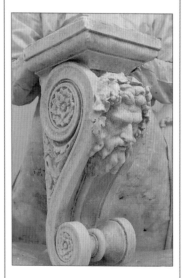

3 Rag the surface with a crumpled piece of cotton. This softens the two colors and allows the ground to show through in some areas.

4 Reapply the white very gently, using the natural sponge. Treat the entire piece, allowing the undulations to dictate the areas coated.

6 Protect the completed piece with a flat water-based sealer to preserve the natural appearance of the effect.

Spattering

This effect has a subtlety that enables it to be used in practically all aspects of paint finishing – from marbling* to antiquing*, from sharpening a dull effect to calming a vivid color. The tools and brushes needed to execute the effect are cheap and easy to acquire, and all mediums mentioned in this book, including varnish and ink, can be used with great success.

Spattering gets its name from the way in which the medium is conveyed onto the chosen surface. The resulting spots of color call to mind the work of artists like Seurat. Before deciding on a color combination for your spatter, take time to look at some pointillist paintings to see how colors in dot form work when placed next to one another.

Glaze and brushes

Success of application relies on the thickness of the paint or glaze. Thin down your chosen pre-tinted medium with a relevant thinner to the consistency of milk. The choice of brushes is enormous – from a toothbrush to a dusting brush. The most commonly used brushes are stencil brushes* and worn fitches*.

Spatter can be applied to a dry or a wet ground, using a short-bristled brush, as described here, or a long-haired brush and a spatter stick (see Porphyry*). For the short-bristled method, you can use a toothbrush, stencil brush, or any short-bristled brush. Load the brush with thinned color and draw your finger or a knife-blade over the bristles so that they flick fine spots of color onto the surface. If the glaze is too thick, the brush will not release it. If it is too thin, or the brush overloaded, the spots will run down the surface and will need to be removed. It

Multicolored spatter on a dry ground
1 Mix the color with the appropriate thinner to the consistency of milk.

2 Lightly load the brush and hold it so that the color runs to the ends of the bristles and not toward the handle. Slowly pull your finger over the ends of the bristles, so that small spots of color are propelled onto the surface.

3 Once the spatter is dry, you can apply a second color, in this case gold.

is a wise precaution to try out the effect on a test posterboard first, as in sponging on*. Spatter the surface in an overall manner. Do not hold the brush too near the surface, as this will lead to patches and heighten the danger of runs.

The short-bristled method will give a finely speckled effect, the size of spots depending to some extent on your distance from the surface and your particular way of handling the brush. If you work on a dry ground, there will be no pressure to finish the spatter quickly, and when one layer

is dry, you can add another. A wet ground offers you a more dynamic look with less likelihood of runs.

The disadvantage of this effect – whether you are finishing a room or a small piece – is that the spatter tends to go everywhere. So drop clothing is essential. If you wear glasses, cover the lenses with plastic wrap.

Spatter on a wet ground
This finish changes the fine salt-and-pepper texture of dry ground spatter into a more effervescent effect. Whereas the spots of color on a dry ground remain in their concentrated state on the surface, a wet ground allows the color particles to infiltrate. Because a wet ground is being used, the finish now becomes a subtracted effect, and all the rules for subtracted finishes* apply. Oil-based glaze is recommended due to its slower drying.

✻ Further information
Marbling *p.75*
Antiquing *p.34*
Brushes/Equipment *p.22*
Porphyry *p.86*
Sponging on *p.98*
Applied and subtracted finishes *p.16*

4 The completed effect has a feeling of depth, and the gold dots glint like tiny sequins.

Spatter on a wet ground
1 Apply the ground coat by brush or roller.

3 The finished effect, showing how the spatter has soaked into the wet ground coat. Compare this with the totally different effect created on a dry ground.

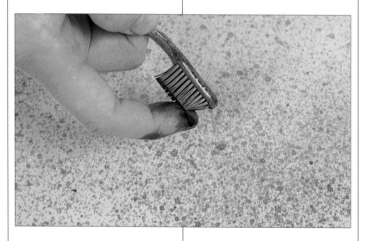

2 Spatter the thinned glaze, following the same method as for the dry ground. Because the ground is wet, the spatter is less likely to run.

Sponging

Sponging on
◆
Sponging on a multicolored ground
◆
Sponging onto a wet ground
◆
Sponging off

Equipment

Paint or glaze
Natural sponge
Paint tray
Plasterboard
*Cardboard**
Paper towels
Artist's brush

Sponging on

Sponging on is probably the simplest of all the paint effects, in that paint or glaze is applied to the surface rather than removed from it. Except in blended finishes*, drying time has no bearing on the final effect. This means you do not have to rush. Sponging techniques are straightforward and it is relatively easy to achieve an extremely effective finish. It is important to select a good natural sponge. This will have a large proportion of frills, rather than consisting mainly of holes. Natural sponges are not cheap, so ask to inspect a number of them before making your choice. Bear in mind the area you wish to finish: the bigger the sponge, the less time it will take to cover a large surface. Make sure that you have all your equipment at hand before you start.

Sponging can be done with oil- or water-based mediums. An oil-based glaze will produce an opulent, marble-like effect; a water-based glaze will be softer and chalkier. A water-based medium was chosen for the example shown below. Because it dries more quickly, it is less likely to be smudged by accident.

First, dampen your sponge with water. This will allow it to expand to its natural shape and also reduce its absorbency. Only the sponge's contours are required for this effect, not its ability to absorb the medium. In fact, the more it absorbs, the sooner it will need to be cleaned. Decant the medium (latex) into the paint tray. Tip the tray so that a wave of paint or glaze runs up onto the ramp of the tray and back, leaving a film of paint or glaze. Load the sponge and test it by printing onto the posterboard. When a pleasing print has been achieved, apply in a haphazard fashion over the area. Cover the area roughly at first, then fill in.

To avoid smudges, refrain from working on adjacent walls. Allow one wall to dry

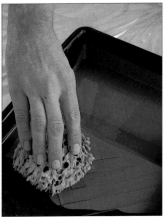

1 Take the dampened sponge and load the frilly side with color by dabbing it onto the ramp.

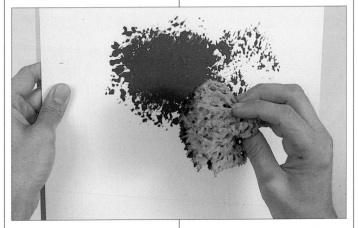

2 Test the print of the sponge on the posterboard. If only fine specks are apparent, more paint or glaze is needed. If a muddy wet print is left, too much paint or glaze has been picked up, and you should dab off the excess before starting.

before going on to its neighbor, and leave a random edge on either side of every internal corner.

Rectifying errors
When an error occurs, such as a blob where too much paint or glaze has been applied, or a twist where the sponge has been turned while still in contact with the surface, blot the excess with a paper towel and allow to dry. Carefully color in the ground or base color over any top colour that has extended too far, or that appears pale and smudged. When the ground color is dry, you can apply the top color again.

✱ **Further information**
Equipment *p.22*

4 Change the angle of the sponge frequently to avoid a potato-print effect. Always test your sponge on the posterboard after reloading with medium.

6 The completed effect should be as uniform as you can make it, naturally gaining a movement which should have no direction.

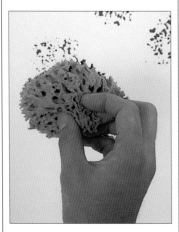

3 Once a crisp, open print has been achieved, apply this in a haphazard fashion over the area. Do not work from one side to the other, or the overall effect will be patchy.

5 Step away from the surface occasionally and remove your glasses, or blur your vision. This will enable you to spot lighter areas where extra prints are needed.

7 The two-color sponge-on effect is achieved by repeating the process, in this case with a softer color, which breaks up the strong color into a more fractured effect.

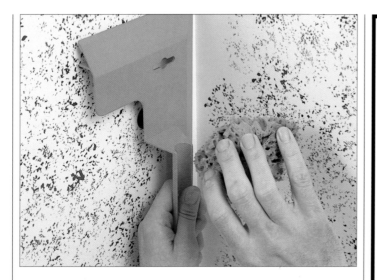

Corners

1 When sponging walls, leave a random edge on either side of corners, using cardboard to shield the neighboring surface as you work. Leave the area to dry.

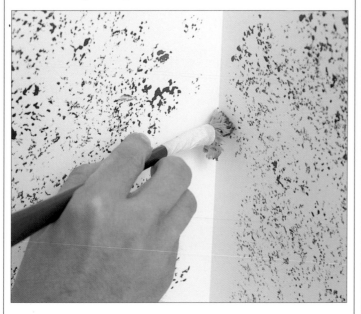

2 Use a piece of sponge taped to the end of a stick or long-handled artist's brush to sponge in the corner. Make sure that the sponge is not overloaded. Apply the initial prints randomly and then fill in.

ERRORS

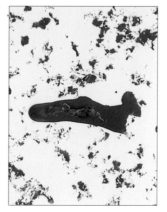

Beware of errors, such as blobs caused by not removing the excess on the posterboard, or swirls from over-enthusiastic twirling of the sponge while it is still in contact with the surface.

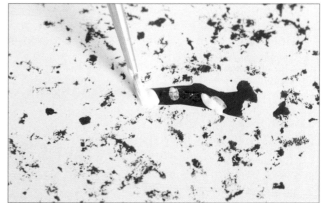

If the error is made early and has no neighbors, it can be wiped off with the appropriate solvent. However, this is not often the case, and wiping can lead to smudging, which endangers the whole effect. If in doubt, blot the offending print with a paper towel. When it is dry, rebuild through the base or ground color using an artist's brush and short, staccato movements.

Sponging on a multicolored ground

Sponging on a multicolored ground is often used to introduce a direction of influence, rather as striped wallpaper gives a feeling of height, and bands of color across a wall can give a sensation of width. This technique can be employed subtly to lift or widen a room.

1 Apply stripes or bands of color to the surface with a brush or roller. Low-tack masking tape will help keep the borders neat. Allow to dry.

2 Using a dampened natural sponge loaded with glaze, cover the surface with prints. The color should link with one of those used for the background. Here, the dark blue is allied to the gray and therefore "attacks" the white stripes.

3 The second color to be sponged on is a pale blue. More closely allied to the white, it breaks up the gray stripes.

4 The finished effect, although similar to that of sponging on a plain ground, conveys an almost subliminal sense of direction which can enhance the proportions of a room.

Sponging onto a wet ground

The merging of two wet colors creates softer effects. Unlike other sponging, it is achieved by printing over a wet ground coat. This base is a mix of one part oil glaze to two parts oil-based undercoat or eggshell of the chosen color, thinned by 10 percent with mineral spirits. It can be applied by brush or roller. If a large area, such as the wall of a room, is to be finished in this way, drying of the ground coat will need to be borne in mind. If possible, work with another person, one of you applying the ground coat from ceiling to floor in sections 3 ft. wide, the other sponging on the glaze or top coat. The application of the base coat should be controlled to allow time for the sponging to be completed on each strip. The dual application, which is common when glaze is first applied and then manipulated, allows enough time for the complete novice to achieve a good-quality finish over a large surface.

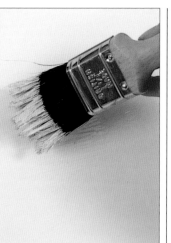

1 Apply the ground coat, a mixture of one part glaze to two parts paint, thinned by 10 percent with mineral spirits or turpentine.

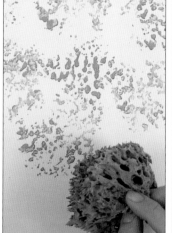

2 Sponge on the glaze coat. The technique is the same as for sponging on a dry ground, but you will need to load the sponge with a greater amount of glaze.

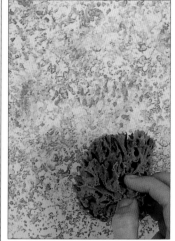

3 Fill in, remembering to use the sponge at different angles to achieve a non-repetitious effect.

Equipment

Ground paint or glaze mixture
Paintbrush or roller
Natural sponge
Paint or glaze
Paint tray

✳ Further information

Equipment *p.22*

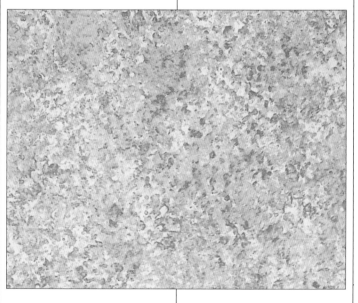

4 The finished effect is a softer version of sponging on with a fossil-stone quality.

Sponging off

This is a subtracted effect*, normally achieved with oil, although water-based glazes can be used over small areas. The glaze is applied with a roller or brush in the usual way and then lifted off with a dry synthetic sponge, leaving a subtle effect similar to that of stipple*. You will need a number of sponges to apply the finish to a large surface. Tear the sponges into manageable sizes, and use the rough surface to produce the effect. For a bolder result, wring the sponges out in mineral spirits before use – but only if you are using an oil glaze. The completed effect should be a fine undulating finish with subtle movement and depth.

Equipment
Paint or glaze
Brush or roller
Dry, synthetic sponge
Mineral spirits

✱ Further information
Applied and subtracted
finishes *p.15*
Stippling *p.104*
Applying Mediums *p.16*

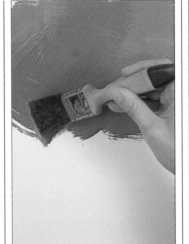

1 Apply the glaze without too much attention to brush marks. No tipping off* is necessary.

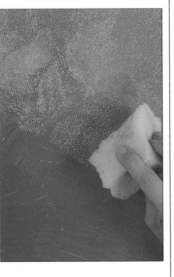

2 Place the rough face of the sponge onto the surface to remove the glaze. Sponge the area roughly, using a similar technique to sponging on.

3 To fill in, lift the darker areas of glaze which were missed in the initial sponging.

4 Sponging off results in a softer more overall effect than sponging on.

Stippling

Standard fine stipple

◆

Coarse stippling

◆

Multicolored stippling

◆

Blended or tonal stippling

Originally stippling was a way of distributing paint or glaze as evenly as possible. Many original paint effects involved stippling the ground or glaze color prior to finishing. Authentic standard stipple is only achievable with transparent oil glaze, because the effect is so fine that the medium must possess enough hold to preserve its texture without flowing back. The subtlety and finish of this effect are also enhanced by the glowing transparency of an oil glaze. The glaze is applied with a brush or roller and tipped off in the usual way for subtracted finishes*. A brush is then bounced across the surface with a pouncing movement, producing a fine pepper-like orange-peel finish.

Stippling is not an effect to undertake lightly. The physical effort required is greater than with any other finish. You will have to bounce the brush over the entire surface, so the bigger the brush the better when decorating a room. For such sizeable areas, it may be advisable to purchase a large stippling brush*. These are extremely expensive, however, and it's worth experimenting with some alternatives beforehand. A lily bristle decorator's dusting brush*, a broom head, a soft-bristle hairbrush, a shoe brush – all have been used with success.

Standard fine stipple

A standard stipple requires top-quality preparation*: the effect is so finely textured that any flaw stands out like a sore thumb. After applying the glaze, bounce the brush across the surface, letting the bristles act like springs. Hold the brush at right angles to the surface to prevent skidding. Angle the attitude of the brush to ensure that any lines caused by the brush shape are not as obvious as they would be if they were horizontal or vertical. Wipe the brush clean regularly with a rag to maintain a uniform effect.

When working on a large surface and following the recommendations for subtractive finishes, it is advisable to step away from the area to check the overall look and to jab the brush lightly at any dark patches. This effect needs extreme caution because of its fine texture. Any accidental damage will be very evident. If damage occurs and the surface is still wet, reapply glaze quickly to the affected area and restipple. If, however, the glaze has begun to dry, or tack up, a renewed application of

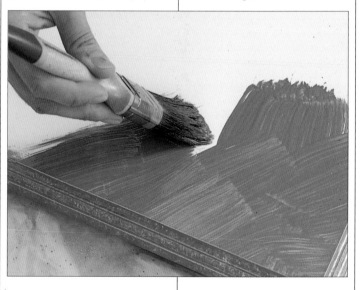

1 When finishing an edged surface, such as this table top, apply the glaze first to the edge and then to the larger top.

glaze will react against the tacky glaze and worsen the fault. If you can live with the fault, leave it. If not, remove the glaze with rags and mineral spirits, and allow the surface to dry for at least two hours before reapplication.

Equipment

Brush or roller
Glaze
Stipple brush
Rags
Cheese cloth

*** Further information**

Applied and subtracted
finishes *p.15*
Brushes/Equipment *p.22*
Preparation *p.17*
Applying mediums *p.16*

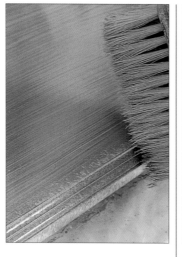

3 Stipple the edge first, because this cannot be done without overlapping the top.

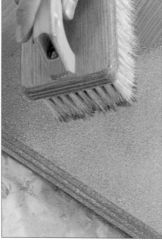

4 Stipple the top, holding the brush at right angles and allowing the bristles to act like springs. Remember to wipe the brush occasionally with a rag to remove the glaze.

5 Use a piece of cheese-cloth* wrapped around your finger to achieve a wiped, dragged look over the molding.

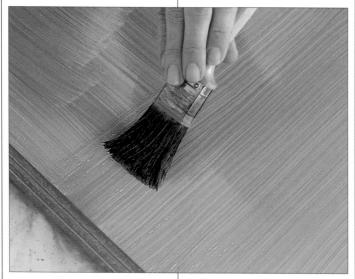

2 Tip off* the glaze lightly with an unloaded brush.

6 The finished piece demonstrates the subtlety of this technique.

Coarse stippling

This effect was achieved in a similar way to the standard fine stipple (see p. 104), but substituting a plastic stippler for the bristled stippling brush. This much coarser stipple can be useful when there is a danger of the standard fine stipple being too subtle and you want a non-directional effect that looks more stone-like and will have greater impact. However, using a plastic stippler is much more tiring than using a stippling brush, so think carefully before you decide to apply this finish to a large area.

Equipment

Brush or roller
Paint or glaze
Artex stippler
Rags

✱ Further information

Applying mediums *p.16*

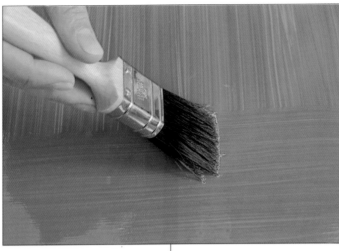

1 Apply the glaze and tip off* with an unloaded brush.

2 Bounce the stippler over the surface. Very little spring is offered by the stippler, so it helps to relax the wrist a little to gain a certain rhythm. Stipple the complete glazed area, occasionally cleaning the stippler with a rag.

3 Return to the surface using a lighter touch. Alter the brush angle while maintaining a parallel stippler-to-surface attitude to remove patches and lines.

4 Coarse stippling is particularly useful for giving a stone-like finish on wainscotings and baseboards.

Multicolored stippling

This stippling technique dates back to the 1930s, when it was popular in movie theaters and cocktail bars. As the name implies, a number of colors are employed and give a smoky, cloud-like effect, which also makes a good ground for marbling. Up to three or four colors may be used together, and these should all be roughly the same strength. Patches or bands of the chosen colors are applied to the ground coat while it is still wet. The colors are then blended together by stippling. It is important to apply the ground coat thinly and evenly, and because of the amount of wet glaze on the surface, the stippling brush will need wiping frequently.

Equipment
White or colored ground mix
Brush or roller
2 or 3 glaze colors of
similar strength
2 or 3 brushes
Dusting or stipple brush
Rags

1 Apply a white or colored ground, mixed from one part glaze to two parts paint and thinned up to 10 percent with mineral spirits.

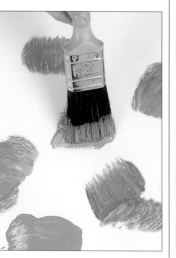

2 Add the colors separately, using a different brush for each color. Load the brush a little more than normal to aid application onto the wet ground.

3 A dusting brush is a good choice for this effect. Use it to stipple outward from one color to another, remembering to clean it regularly with a rag. Do not pick up the stippler when it is loaded with one color and begin stippling on another. This will muddy the effect.

4 Once the colors have made an initial mix, go over the area again using a lighter touch and a newly wiped brush to complete the overall blend.

5 This smoky, floating effect seems to drift over the surface, shifting from one color to the next.

Blended or tonal stippling

Unlike standard stippling, this effect was originally achieved without the addition of oil glaze. However, its use has expanded the boundaries of this mood-changing finish, which is nearly always used on walls to lend atmosphere.

The base coat for blended or tonal stippling is a mixture of two parts boiled linseed oil* and one part mineral spirits* mixed with three parts of the chosen color undercoat. Apply this by brush or roller and allow to dry. The dried surface will be extra-shiny and slippery and will allow the top coat more movement than normal. Divide the wall into three horizontal bands, marking them every so often with a dash of chalk. Mix three glazes for the top coat. These could be tints of the same color but of different strengths, or two colors that mix to form an attractive third color. Using transparent oil glaze in conjunction with pure color adds a luminous quality to the effect. However, the original method involved the use of normal, slightly thinned oil-based paint and relied on the oil quality of the base coat to achieve the effect.

Apply the bands of color in the marked areas, in patches of about 3 feet, stippling each patch before coating a further section of wall with the three glazes. Pounce the stippling brush through the glaze, starting in the lightest glaze and working through to the darkest. At this point it is essential to rub the stippler clean with a rag. If you return the brush to the pale glaze without this cleaning, the effect will be ruined.

When finishing a sizeable area, it is advisable to utilize two stippling brushes, one for the upper half of the wall and one for the lower half. These should still be kept clean with a rag, although there will be less of a problem with color contrast on the brushes.

Equipment

Ground mix
Brush or roller
Chalk
Measuring tape
3 glaze colors or tones
3 brushes
Large stipple brush
Rags

✱ Further information

Mediums *p.10*
Applying mediums *p.16*

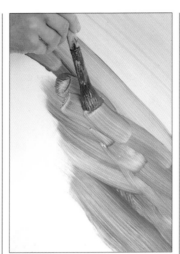

1 The oil-containing ground mix has dried, and the first pale band of glaze has been applied to the top part of the wall. Here the second, mid-tone glaze is being applied.

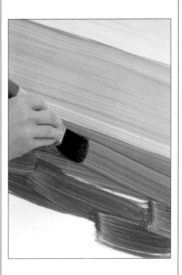

2 The third and darkest glaze is applied and tipped off* horizontally.

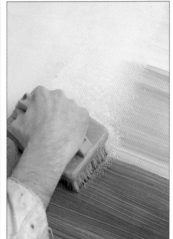

3 The stipple brush is pounced over the surface, traveling from the pale band through the mid-tone to finish at the bottom of the wall, where it is rubbed clean with a rag before returning to the pale area.

4 The completed finish, showing the soft graded effect.

Sugi

Equipment

Black oil-based stain
Brush
Rag
Paste-wood filler
Medium-fine silicon
carbide paper
Scraper
Damp rag
Varnish brush
Clear varnish
Spatter brush and black latex
(optional)

This charred wood effect dates back to the 15th century, when Eastern craftsworkers used it to mellow and lend the impression of age to a piece. Their technique, which is still employed today, involves the skillful playing of a flame over the surface of the wood. However, this alternative paint effect can produce a similar effect without the danger of using a naked flame. The piece being treated should be made of wood, or at least veneered with wood. The surface should be clean of any other finish and may require stripping.

The first stage is to stain the wood using a black, oil-based dye stain. An oil-based dye stain is easier to apply than a quick-drying alcohol stain and penetrates the wood less. Put the stain on thinly with a brush, and don't worry about a patchy covering. When the wood is dry (which normally means the next day), fill the grain with a paste-wood filler*. When this has hardened, sand the piece with a medium- to fine-grit silicon carbide sand-paper*. The sanding will cut back the filler and the surface of the piece to expose in places the color of the wood and thus give an attractive patina of age.

✽ Further information

Preparation p.17
Sanding/Sand
paper chart p.21
Brushes/Equipment p.22
Varnishing p.29

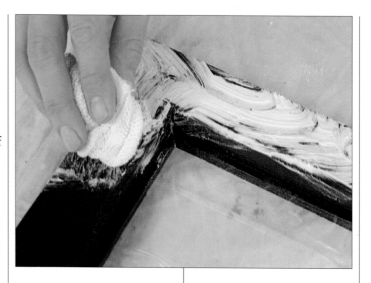

1 Rub the paste-wood filler into the grain of the previously stained wood, using a circular motion.

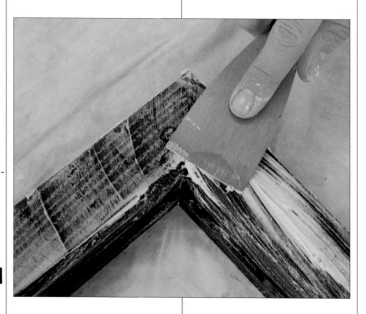

2 Pull the filler across the grain with a scraper, allowing it to fall into the pores of the wood. Leave to dry.

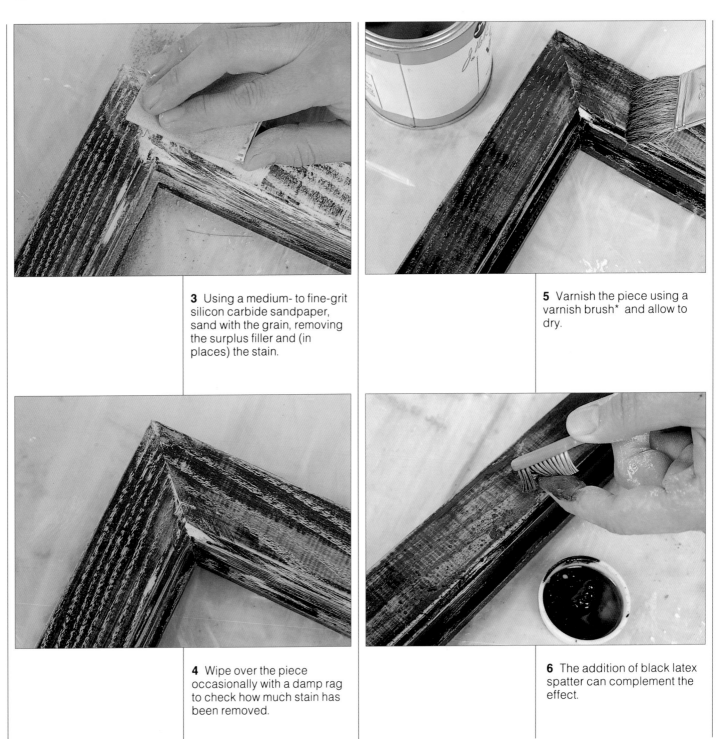

3 Using a medium- to fine-grit silicon carbide sandpaper, sand with the grain, removing the surplus filler and (in places) the stain.

5 Varnish the piece using a varnish brush* and allow to dry.

4 Wipe over the piece occasionally with a damp rag to check how much stain has been removed.

6 The addition of black latex spatter can complement the effect.

Tortoiseshell

Brown tortoiseshell

♦

Quartered red tortoiseshell

♦

Blonde tortoiseshell

A number of paint effects which evolved in Europe were prompted by the desire to compete with imports from the Far East. Bamboo is one such example*, and tortoiseshell is another. Tortoiseshell was brought to Europe along with fine silks and other Oriental merchandise as early as the 15th century. The shell, which comes from the hawksbill turtle, is yellow with a mottling of reddish-brown, but because it is translucent, it needs light to pass through it to be fully appreciated. By the 16th century, Italian craftworkers had found a way of overcoming this difficulty by inlaying the shell using a ground of pewter. The pewter acted like a mirror, reflecting light through the shell to reveal its fine patterning. This technique was taken to new heights by the French cabinetmaker Charles André Boulle, known as Buhl (1642–1732), whose name became synonymous with elaborate marquetry combining metal and tortoiseshell. Buhl was in the service of Louis XIV and supplied his furniture to the great palace of Versailles, but today any piece in this style may be known as buhl.

There is evidence of tortoiseshell being copied during the latter part of the 18th century, when the effect was used in the Hamburg school of German harpsichord casemakers. This early example was completed over a vermilion ground, and has Oriental-style borders of gold leaf.

Brown tortoiseshell

The techniques that produced it have hardly altered since. A varnish was applied and color laid on in overlapping patches to give depth and simulate the appearance of the shell. Today decorators use a pre-tinted varnish as the medium, applying it randomly over the surface. Color is then rolled onto the wet varnish and blurred with a brush to soften the effect.

Equipment

Yellow eggshell undercoat
Dark oak varnish
Burnt umber, artists' oil color
Ivory black, artists' oil color
Varnish brush
Artist's brush 0 or 00
Softening brush
Lint-free rag

❋ Further information

Faux bamboo *p.57*
Varnishes *p.29*
Mediums *p.10*
Brushes *p.24*
Dragging *p.54*
Marbling *p.75*

1 Prepare the surface to the same high quality as for marble* or dragging,* and apply a yellow eggshell ground coat. When this is dry, paint on the dark oak varnish without worrying too much about its evenness.

2 Roll tadpole-sized wriggles of burnt umber onto the now wet ground, making sure that they form a definite pattern.

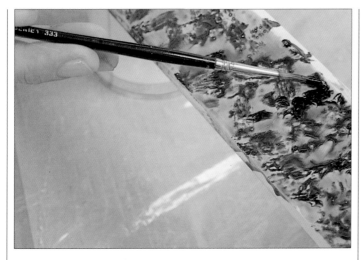

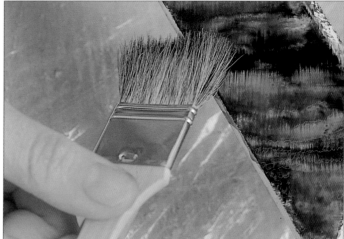

3 Apply the ivory black in the same way, but to a much lesser extent. Take great care throughout to create an uncontrived finish.

5 Use the same technique to complete the softening, but this time in an east to west and west to east direction. Be sure to keep the brush clean at all times by wiping it with a lint-free rag.

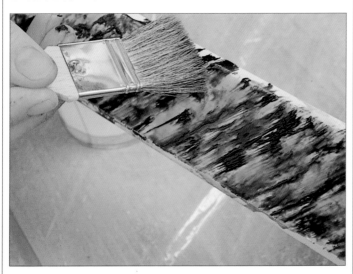

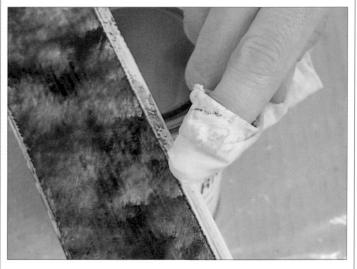

4 Using a soft-haired brush and barely touching the surface, blend the color into the varnish. Maintain the softening stroke at a constant angle until the whole surface has been treated. The brush should slant toward the direction in which it is moved, so as to lessen the force of the bristles on the surface. Soften the surface in both directions following the same line – for example, from north to south and south to north.

6 The finished panel is here being cleaned so that the edges may be gilded.

Quartered red tortoiseshell

This technique is a more elaborate version of the last, using a different color design. Tortoiseshell was often inlaid in very thin veneers, which lend themselves to a quartered effect. The design is here made more effective by the choice of a bright red ground, which echoes the vermilion used long ago by harpsichord casemakers.

After applying the red pre-mixed paint, measure the surface to be finished and find its center. You can complete the diagonally opposing quarters simultaneously, but you must mask the remaining areas with clear cellophane tape, as masking tape will allow the varnish to bleed through. Dark oak varnish is again the medium, but only black is used in the figuring. When the effect is completed and dry, smooth it with wet-and-dry sandpaper* and finish it with two or three coats of varnish*.

Equipment
Red ground coat and application brush
Clear cellophane tape
Dark oak varnish and application brush
Ivory black, artists' oil color
Artist's brush 0 or 00
Softening brush, such as a soft-haired cutter
Lint-free rag

✳ Further information
Sanding *p.21*
Varnishes *p.19*
Mediums *p.10*
Brushes *p.24*

2 Work the black oil color onto the wet surface with the artist's brush using short, staccato movements. The paint marks should generally lie along one diagonal.

3 Use a soft-haired brush – here a graining brush called a cutter* – to soften the color in both directions along the diagonal already established. Keep the brush clean and dry by wiping it on a lint-free rag.

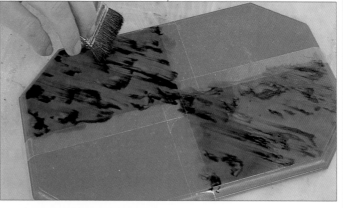

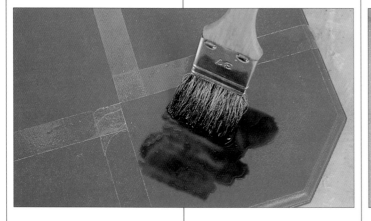

1 Having masked the appropriate areas with clear cellophane tape, apply the dark oak varnish.

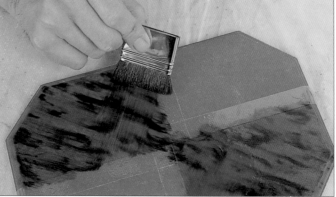

4 Blend the effect further by changing the line of softening to one at 90° to your original diagonal.

Clean the brush, and finally soften in the original directions again.

5 Gently remove the tape, and allow the two quarters to dry.

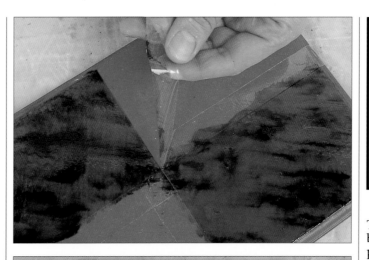

Blonde tortoiseshell

6 After drying, mask the treated areas and repeat the operation for the other two quarters.

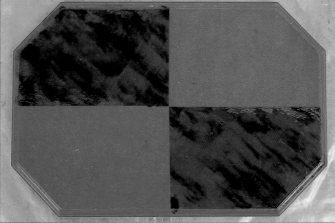

This effect uses the same blending technique as the previous tortoiseshell finishes, but the ground is more exotic. Metal leaf* – in this case gold – replaces flat color, recalling the pewter grounds used for tortoise-shell by Renaissance craftsworkers. This time the varnish is untinted, and burnt umber is the only oil color. A tinted varnish gives a dark but still rich effect known as brunette tortoiseshell.

Equipment

*Clear varnish and
application brush
Burnt umber artist's oil color
Artist's brush 0 or 00
Softening brush
Lint-free rag*

*** Further information**

Gold and metal leaf *p.28*
Loose-leaf gilding *p.123*
Varnishes *p.29*
Mediums *p.10*
Brushes *p.24*

7 When all four quarters are finished and dry, use a sanding block and a fine-grit wet-and-dry sandpaper to prepare the surface for varnishing. Any specks of color removed along with the debris can be replaced with pure black oil color.

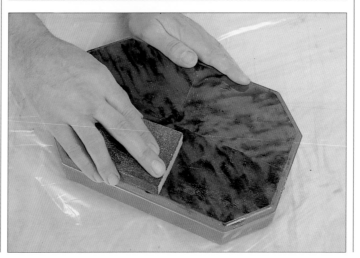

1 Apply the varnish over the completely dried gold leaf.

3 Using a soft brush, soften diagonally in both directions, pulling out the color.

2 While the varnish is wet, apply the burnt umber with the artist's brush in the normal way (page 111).

4 As with the other tortoise-shell effects, soften at right angles to the first diagonal, remembering to clean the brush with a rag, and finally soften in the original diagonal direction again.

Verdigris

The name verdigris comes from the French *vert de Grèce* (green of Greece) and denotes the color of age. Verdigris is actually a coating of cupric carbonate, formed by atmospheric action on copper, brass and bronze. Its wonderful blue-green color, which graces historic domes and spires and lends an ancient soft and chalky aspect to decorative metalwork, is often imitated. Professional metalworkers use acids and very high temperatures to reproduce this patina of age. But the effect can be simulated using paint, thereby allowing pieces which are not made or coated in metal access to this elegant effect.

✱ Further information

Bronze powder *p.28*
Gold size *p.122*
Mixing gold paint *p.127*
Mixing tinted glazes *p.13*
Mediums *p.10*
Brushes *p.24*
Pounce bag *p.28*
Whiting *p.20*
Preparation of metal *p.19*

Equipment

Bronze powder and gold size* mix, and brush*
*Latex glaze tinted with viridian**
Light aqua blue latex and brush
Light green latex and brush
Yellow ochre acrylic paint
*Whiting**
Acrylic
Artist's brush
Spatter brush
*Pounce bag**

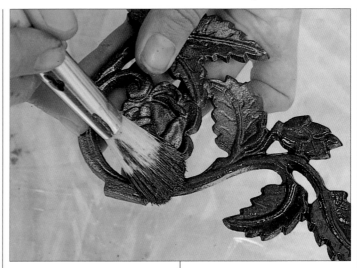

1 Clean your chosen surface – here a cast-iron bracket – and coat it with dark bronze paint mix. Allow to dry.

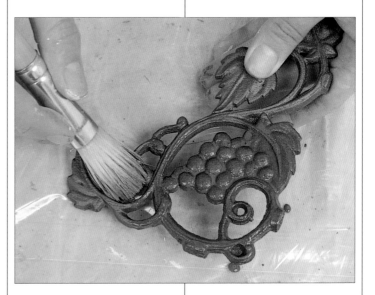

2 Liberally apply the dark green latex glaze, using an artist's brush.

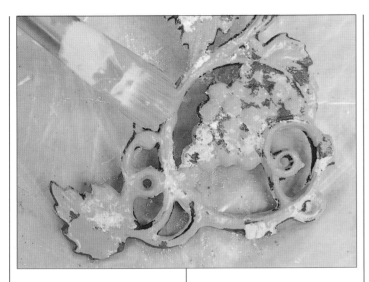

3 When the glaze is dry, haphazardly apply the light blue and the light green latex.

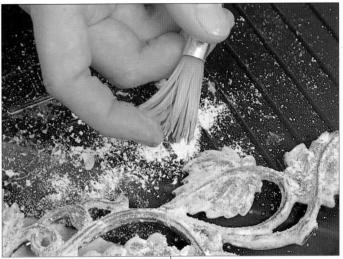

5 Wipe over the piece to remove any excess whiting and spatter with water-thinned yellow ochre acrylic.

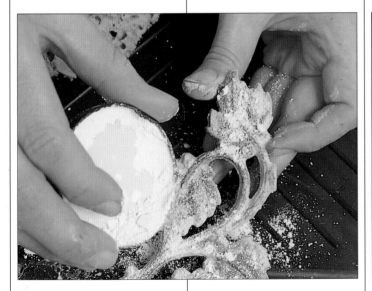

4 While the surface is still wet, sprinkle on the whiting and press it into the design with the pounce bag.

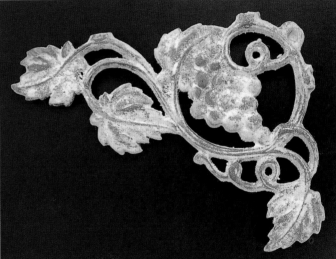

6 Protect the finished effect with diluted acrylic.

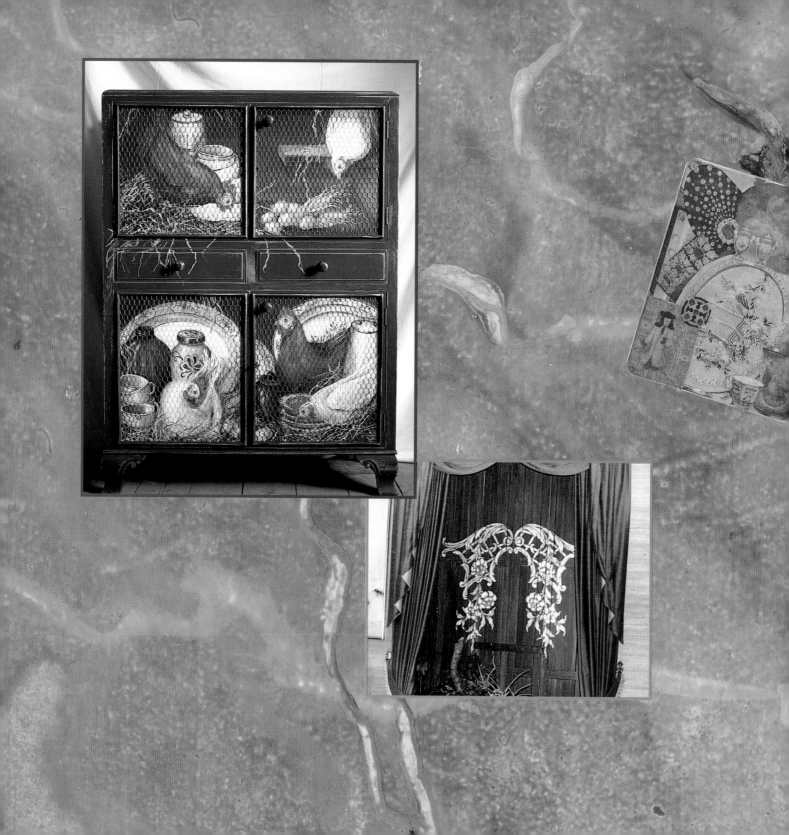

Artistic effects

This section deals with special techniques that are not, strictly speaking, paint effects, but are nevertheless used decoratively on both walls and furniture. All the effects included in this section can be tackled by the amateur with a degree of success. This is particularly true of stenciling and découpage. However, if you want to progress to a high level of achievement, particularly with *trompe l'oeil*, you will need to have some artistic ability and be prepared to practice; the examples included in the gallery required a high degree of skill and training. The *trompe l'oeil* technique included here is designed to get you started and, perhaps, to inspire you to pursue it further. Gilding, on the other hand, although one of the more demanding techniques, requires no special skills and can transform picture frames, furniture, fire mantels and ornamental pillars.

Découpage

The technique of mounting and varnishing cutout designs is thought to have developed in 17th century Italy alongside japanning (high gloss lacquering in the Japanese style), and in competition with Far-eastern imports of lacquered work. When hand-colored engravings were first used, they were sealed with many coats of lacquer. The Victorians loved this effect and often went overboard with heavy finishes, especially on firescreens and trays.

An attractive découpage can be created with a minimum of technical skill. The art of this effect lies not so much in the selection, cutting out and gluing of the designs but in the way they are arranged on the surface and the choice and application of the finishing varnish. A period or rural look is appropriate, and it is important to avoid an over-symmetrical pattern. Material is not hard to find, and it is a good idea to amass a file of pictures that catch your eye from magazines, calendars, catalogs and old wrapping paper. There are even stores who will supply printed designs intended for this effect. The inclusion of metal leaf can add an extra dimension to the composition. A photocopier can be a great help in reproducing, enlarging or reducing a design to fit an overall scheme. Test a spare patch of your chosen paper with a little varnish to check that it does not turn transparent and reveal print from its other side. You can use any painted suface as a base, providing it is spotlessly clean.

Map out your design on a sheet of paper the same size as the surface, and don't begin gluing until you are completely happy with the composition. Cut out the pieces using a craft knife and cutting board, and spray them on the print side with a fixative spray to ensure that the colors will not run when the varnish is applied. Use a white glue to attach the pieces onto the surface, making sure that they do not overlap. Meeting edges must be butt-jointed and not over-lapped. Ensure that all edges are coated with glue and glued down flat. A tiny artist's brush* can be used to apply glue to small pieces, and a little wallpaper roller will help to expel any air bubbles when flattening. Leave the piece to dry at room temperature before applying any coats of varnish. The varnish can be tinted* to give an impression of age or treated with a craquelure effect*.

Equipment

Pictures for mounting
Scissors
Craft knife
Cutting board
Color fixative spray
White glue and application brush
Small wallpaper roller
Varnish and application brush

* Further information

Brushes *p.24*
Varnishing *p.29*
Craquelure *p.37*

1 Cut out a suitable printed design with a pair of scissors, and decide which parts of it to use. Where there is more than one element, you will need to plan your composition on a sheet of paper the same size as your surface.

2 Carry out further cutting with a knife and cutting board. When you are satisfied with your planned layout, spray the pieces on the print side with a fixative spray.

3 Apply white glue to the back of the pieces with an appropriately sized artist's brush, ensuring that all edges are coated.

4 Press the pieces carefully onto the surface, making sure that they are flat, especially around the edges. Any adjoining pieces need to be butt-jointed.

Gilding

Loose leaf gilding

◆

Transfer gilding

◆

Gilding with powder

Gilding has been used as a form of decoration for thousands of years throughout the world, from the jewelry of the Incas to the ancient Egyptians' lavish ornaments of death. And perhaps even more astounding, the methods used have barely changed. Although some types of gilding require much skill and practice, the method described here should prove relatively easy.

The term gilding does not only refer to gold, but encompasses the application of all metal leaves and powders, from silver and platinum to bronze, aluminum, and gold-colored alloys.

The ancient process of gilding can be thought of as one of the earliest faux finishes because the intention was to convey the impression of solid gold in a less costly structure covered with only a thin skin of precious metal. The problem, therefore, is how to glue this fine sheet of gold or other metal to the surface, having previously ensured that the surface is exquisitely prepared, often with the use of gesso*.

Oil- and water-based

Traditionally there are two varieties of true gilding. As with many paint effects, these are water-based and oil-based. Water gilding is highly delicate and can be ruined by dampness. It is also a far more difficult technique than oil, involving only water with a minute addition of glue as an adhesive, and it cannot be used with transfer leaf.

Oil gilding – also known as mordant gilding – is therefore recommended here. Apart from being easier to undertake, it is much more adaptable and less vulnerable.

Gold size

The glue used in oil gilding is called gold size. This is a special mixture containing linseed oil, a drier such as cobalt, and copal varnish. Turpentine is often added as a thinner to ease application. Sizes are often quoted in terms of their drying time: four-hour, eight-hour, or sixteen-hour size, for example. Drying time is important because the quicker the surface dries the less danger there is from dust or other pollution, but the slower it dries the more time you have to work and the better the gleam. "Quick japan size," which dries exceptionally fast – in one to two hours – is useful where the atmosphere cannot be controlled and dust particles may fall in the wet size, but it is correspondingly fragile and more prone to cracking.

As always, a balance must be found but above all it is essential to keep the atmosphere as clean as possible. Pieces which are small enough can be covered. Do not wear wool, and keep drafts to a minimum. Paint the size on evenly, or drying will be patchy and affect the adhesion of the leaf.

When gilding over gesso* it is wise to coat the ground with one or two coats of thinned shellac*. This seals the porous gesso and reduces the risk of a patchy gold size coat. If you use acrylic gesso*, you may not need a shellac coat.

Applying gold size

The area to be sized must dictate the shape and dimensions of the brush. Flat brushes are suitable for large areas and moldings; round brushes are better for carvings and intricate details*. The brush should be of good quality, with long bristles to hold the size, yet firm enough to lay out the size evenly. Do not apply the size directly from the can. It must be decanted into a clean paint pot* or other container with a wire or string tightly strung across the top. This strike wire will cause the size that is wiped clear of the brush to drain back into the container without forming bubbles. Only decant the amount of size needed for the job. More can be added if need be, but once the size has been decanted it should never be returned to the original can, which is still clean and dust-free. Before any application, tack rag* the surface to remove any remaining dust.

When to gild

Once the size has been applied, the temptation to begin gilding is very great. However, if the gold or metal leaf is applied too early, it remains vulnerable to marks because the size underneath is still soft. What's more, the leaf will be dull and lifeless. The correct time to gild is when the size is practically dry. It is often suggested that you test this by drawing the back of your

hand or finger gently over the surface to produce a squeak, and this can be useful, but if you try it too early, you may cause serious damage. Another sign used by some is that the size begins to lose its glossy texture when it is ready for gilding. However, the surest results come from testing trial patches of size, applying the leaves at timed intervals. That way, the weather conditions and the size mix, which are as important as the thickness of the size, can be involved, and a more accurate decision made.

The technique for applying transfer leaf is straightforward*, but if you want to use loose leaf, you will need some special equipment* available from gold leaf suppliers, consisting of a gilder's cushion, knife and tip, and some gilder's whiting. A soft-haired brush known as a mop* is also useful for pressing the leaf into awkward areas, repairing problems and removing excess leaf.

Loose leaf oil gilding

Before gilding, lightly dust your gilder's cushion, knife and tip with gilder's whiting (using a pounce bag*) to prevent the metal leaf from sticking. The leaves can be individually deposited onto the cushion as required, or en masse, whichever is more convenient to the

1 Apply the gold size smoothly and evenly so that the whole area is ready for gilding at roughly the same time. Allow the size to tack up, having previously established its tacking time on a spare board.

particular job. Cut the leaf with the gilder's knife, which should be kept in its loop underneath the cushion when not in use. The size of the leaf depends on the surface to be gilded, but you should allow a reasonable overlap. Hold the knife blade flat against the leaf, so that it maintains an even contact with the surface, and draw it once across the leaf to cut it. The next step is to flatten the leaf. Use the knife to pick up the leaf and turn it, and take time to play with the leaf on the cushion. Experiment with sliding the knife under the leaf and gently twisting it, while blowing delicately to remove wrinkles. There are no rules and no magical secrets. The object is simply

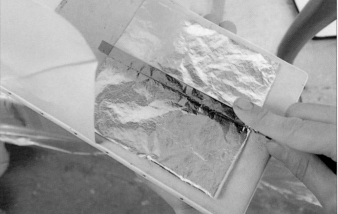

2 Cut the leaf to size using the gilder's knife on the cushion. Note how the knife blade is flat and the cut made with one pull. A sawing action would tear the leaf.

to smooth the leaf out in the best way you can.

When the cut leaves lie flat and unwrinkled on the cushion, prepare the tip to transfer them to the sized surface. Make sure your tip is smaller than the cut leaves, so that you will be able to position them accurately. Brush the tip over your cheek, so that it acquires enough oil from your skin to enable it to pick up the leaf. If this technique fails at first, rub a little moisturising cream on your cheek and try again. The leaf should be deposited onto the surface in one smooth action. If you make any movement when tip, leaf and size are together, the leaf will tear.

Continue applying the

leaves in this way, each overlapping its neighbor by approximately ³⁄₁₆ in. When you have applied six leaves press them against the surface with a cotton ball. Be careful to press the overlaps flat rather than lifting them upward. Wrinkles will appear, but this is normal and will be rectified when the surface is brushed clean. Once the leaf has been pressed flat, begin gently brushing the excess loose leaf off the surface. These bits of leaf are called skewings and should be kept for future patching. As you progress across the area, odd gaps will become apparent. Mending, or repairing, is achieved by pressing the skewings onto these areas. A mop or other

soft-haired brush* can be employed to press down the gold and remove the excess leaf at the same time. However, this technique requires some practice.

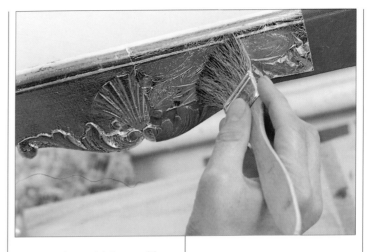

5 Press the gold down with cotton or a lightly used mop.

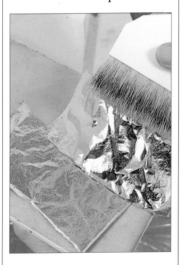

3 Brush the gilder's tip over your cheek to pick up oil for adhesion and use it to lift the leaf from the cushion.

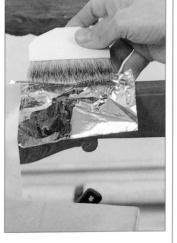

4 Apply the leaf to the sized ground in a gentle down-up movement. Any wavering at this point will cause the leaf to tear.

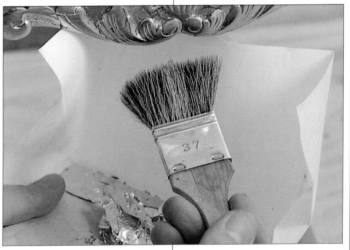

6 Brush the skewings off the surface, catching them in a pot or on the cushion for use in repairing or on later work. Carry out repair by pressing the unused leaf onto any area missed by the initial gilding.

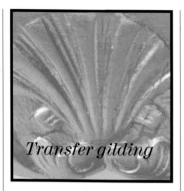

Transfer gilding

This technique was originally used by gilders when working outdoors, where loose leaf can be terribly difficult to control. The advantages of transfer leaf are obvious, in that manipulation can be undertaken by hand rather than by knife and tip. Transfer metal leaf can only be used in conjunction with gold size*. Apply the size coat in the same way as for loose leaf, and allow it to achieve its tack. If the leaf needs cutting, use long-bladed scissors or a craft knife and straight-edge. Cut the leaf with one snip or a single stroke of the craft knife to avoid tearing. Make sure that your working position gives support to your elbow or wrist to prevent undue movement as you apply the leaf to the sized surface. The transparent tissue backing will allow you to position it accurately. Place the leaf on the surface, and steady it with your spare hand as you stroke it into position with your fingers to ensure overall contact. Gently remove the backing to expose the newly gilded surface. The next leaf should overlap by approximately ³/₁₆ in. When you have completed the area, use the discarded tissues which still have leaf attached to carry out repairing*. Brush the surface clean with a mop* in the same way as with loose leaf.

Equipment

Gold size and application brush
Transfer gold or metal leaf
Mop
*Burnt umber antiquing glaze**
Rag

✱ Further information

Gold size *p.122*
Repairing *p.124*
Brushes *p.24*
Antiquing over gold *p.34*

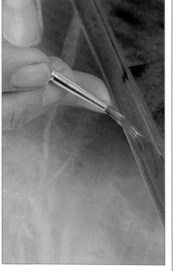

1 Apply the gold size using a suitable brush, and allow to tack up.

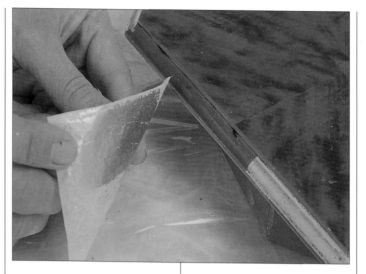

2 Hold the transparent backing sheet with both hands and approach the surface with the leaf.

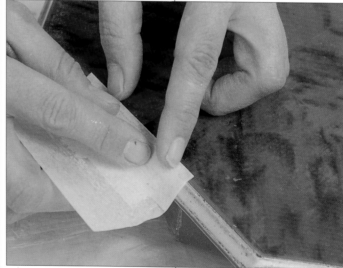

3 Steady your hands by leaning your elbow or wrist on a support, and hold the leaf with one hand as you calmly smooth it into place with the other, taking care not to move it once it has made contact with the size. Remember to overlap each leaf by about ³/₁₆ in.

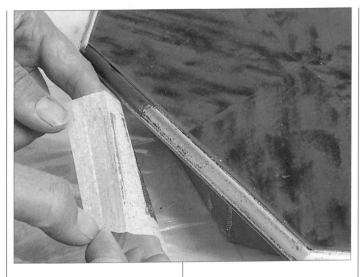

4 Having pressed the leaf onto the surface with your fingers, carefully peel away the tissue backing.

5 When the application is complete, remove unwanted debris with a mop, and fault where necessary.

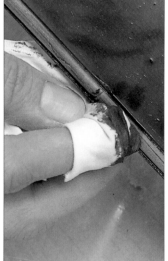

6 The gold can be complemented with the addition of antiquing glaze – in this case burnt umber.

Gilding with powder

Metal powders range from rich pale gold to dark bronze. Aluminum powder is also available. Their application is best achieved in a draft-free environment. When working with any fine-ground powders, it is advisable to wear a mask. This protects the lungs and lessens the possibility of breathing on, and therefore dispersing, the powder. Apply the gold size* in the same way as loose leaf* or transfer leaf*, and allow it to tack up. Use a camel-hair or squirrel-hair mop* to work the powder over the size and into any crevices. Allow the surface to dry for at least an hour before removing the excess powder with a soft cloth. Powder effects are liable to tarnish, so protect the surface with a coat of oil-based varnish.

Equipment

Gold size and application brush
Gold or bronze powder
Oil-based varnish and brush
Squirrel – or camel-hair mop
Soft duster or rag
Mask

✱ Further information

Gold size *p.122*
Gold fossil *p.92*
Loose-leaf gilding *p.123*
Transfer gilding *p.125*
Brushes *p.24*
Varnishing *p.29*

1 Apply the gold size and allow it to become tacky.

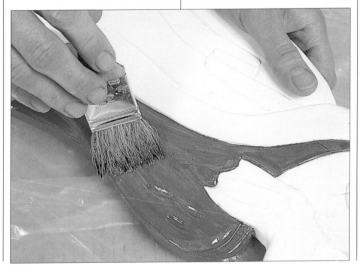

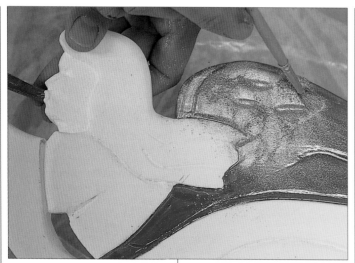

2 Cover the sticky size with the dry powder, using the soft-haired mop to work it into all the details.

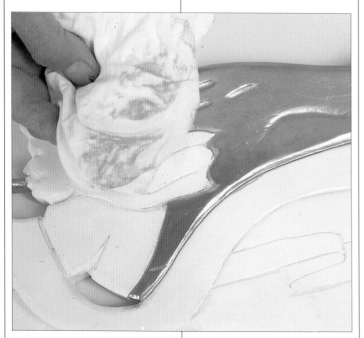

3 When the size has dried for at least an hour, gently remove the loose powder using a soft duster or rag.

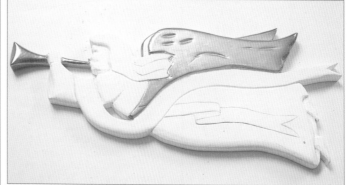

4 It is advisable to varnish gold or bronze powder, because it tends to tarnish.

GILDING WITH GOLD PAINT

This technique is often used to add details to a piece, such as stringing or a small hand-painted design. The gold paint can be bought or you can mix your own using bronze or gold powder and either gold size* or a water-based glaze (as for gold fossil*). Whether your medium is oil- or water-based, you will need to make a smooth, free-flowing but strong solution. If the mixture is weak, the gilding will be dull and lack definition. Apply it by brush.

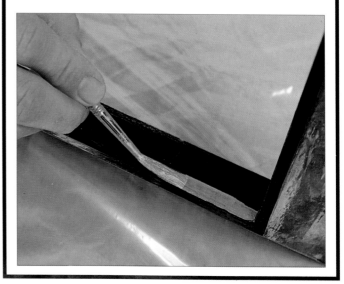

Stenciling

*Standard
stenciling*

◆

*Stenciling with a
sponge*

◆

*Stenciling with
netting*

◆

*Stenciling with
sprays*

◆

*Old gold
stenciling*

◆

*Stenciling with
an atomizer*

Stencils are known to have been used as far back as 3000 BC in China, where silks and paper were decorated. Since that time, many civilizations have employed this efficient decorative effect to enhance churches, tombs, floors, walls, textiles, furniture, books, trays, and boxes. And no great artistic talent is required to achieve a very pleasing result. To some extent stenciling has suffered through its own success. The recent fashion for stencils has tended to pigeonhole the effect. The mere mention of a stencil can conjure up images of the folk-style birds, fruit and flowers which, although attractive, have recently been overplayed.

In fact, an enormously varied style can be achieved with stencils, from Chinese or Egyptian designs to the patterns of Tudor wall hangings. Regency interiors were often edged with a design that was either stenciled or painted by hand. Stencils were popular in Victorian England, where they ranged from the austere to the frivolous. William Morris made extensive use of the method, as did many decorators of the Art Nouveau period. Charles Rennie Mackintosh included the technique in producing his unmistakable style. Louis Comfort Tiffany used stenciling in his famous commissions for the White House and Mark Twain's residence, thereby adding to the technique's standing.

Stencils can look ancient or modern, sharp or faded, and have the very useful ability to lend detail to an otherwise plain surface. Once a stencil has been cut, many different colors and textures can be used to vary the effect. Precut stencils are readily available from art and craft stores. If you want a quick and inexpensive effect, these can be a good, no-hassle choice. However, there is also much enjoyment to be had from cutting your own designs.

Choosing a design

First decide on the overall style of the piece or room. Often you can echo a motif from a fabric or plasterwork which will complement the scheme. Next, consider how you might reinforce or modify the physical aspects of your subject area. Do walls present too large an expanse that needs cutting into panels? Is the ceiling too high, and might the room benefit from a chair rail or wainscot? A picture rail frieze could expand the ceiling area, or perhaps the cornice needs strengthening. Try to see the room or piece as a whole with a clear idea of what you would like to achieve. Some rough sketches of your ideas may help. With an overall plan in mind, you can try out promising styles and sizes of stencil with paper cutouts pinned or taped to your chosen surface. These could be cut to the pattern of a ready-made stencil, traced from an existing source, or be an entirely new design. You can enlarge or reduce the design with the aid of a photocopier.

A key factor in stencil design is the arrangement of ties. The ties are the parts of the stencil which have to remain in place to support the open internal areas. For example, the letter O would require ties to prevent the center from falling out. The ties should be allowed for prior to tracing out the design, and should be wide and numerous enough to support the design with ease. When stenciling is complete, they can be colored in as desired.

Even a simple stencil should have little notches or penciled marks, known as registration marks, to enable you to line up each successive print in a frieze or border. If you are combining two or three different-colored stencils, the registration marks are even more critical to placing the stencils in the correct position. Registration marks are established when the stencil is cut.

Equipment
Tracing paper
Stencil cardboard
Cutting mat
Hard pencil
Stencil knife or craft knife

CUTTING A STENCIL

1 Trace out the design, leaving the ties in position.

2 Turn the completed tracing over onto the stencil cardboard, and re-trace.

3 Place the cardboard on the cutting mat, and use the stencil knife or craft knife to cut the stencil out, always working toward the body.

4 Registration marks should be made on the original tracings. This is especially important in the case of a double stencil, so that the design can be aligned on the surface.

5 Transfer the registration marks to the stencils by overlaying the tracings and remarking the points. Make these into a small hole or notch through which you can make a pencil mark to line up the cut stencils.

Standard stenciling

A standard stencil is normally applied with a stubby stencil brush* of the appropriate size, loaded with thick water- or oil-based color. Test the print first on a spare piece of posterboard. The drier the print, the less danger there is of seepage. Steady the stencil plate with low-tack masking tape to ensure a clean print.

Equipment

Stencil
Low-tack masking tape
Stencil brush
Thick oil- or water-based paint (two colors)
Posterboard
Soft pencil

✻ Further information

Brushes *p.24*

1 Secure the stencil in position on the surface, with low-tack masking tape.

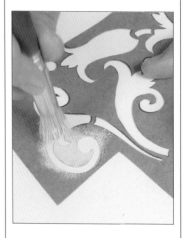

2 Load the brush with color, and check the print on some posterboard or a spare area of stencil. Pounce the brush onto the perforated portions of the stencil, angling the brush to make sure all exposed areas are covered. Occasionally a bristle may creep under the stencil, but this merely adds to the charm of the effect.

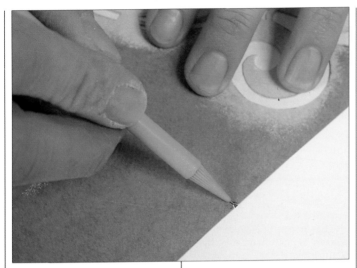

3 Use a soft pencil to mark the surface through the registration notch or hole.

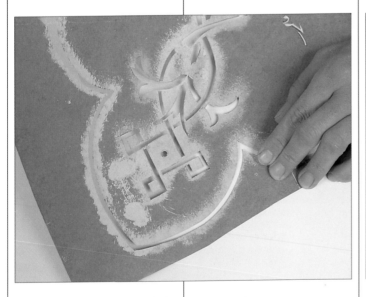

4 When the first stencil print is dry, use the registration marks to place the second stencil in position, and secure it with tape.

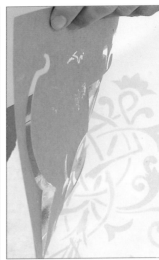

5 Apply the second color through the stencil as before.

6 A more detailed view of the completed two-color stencil shows how the color can sometimes overlap.

Stenciling with a sponge

A sponge produces a cleaner print than a brush. The flat side of a synthetic sponge* will provide a uniform mark, and a more dappled undulating print will be obtained from a natural sponge* or the torn face of a synthetic sponge. Sponges need a thinner paint or glaze than brushes to allow for some absorption. Greater care must therefore be taken to prevent this thinner color from bleeding under the edge of the stencil and spoiling the effect.

Equipment
Stencil
Low-tack masking tape
Sponge
Thin paint or glaze

✳ Further information
Sponges *p.26*

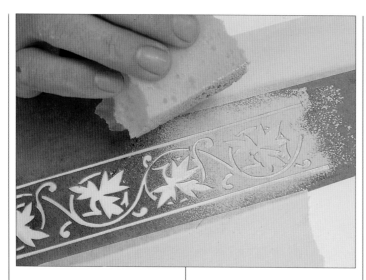

1 Tape the stencil in position and gently sponge the color over it. Having covered the area once, go back over it again to ensure that small details are not missed.

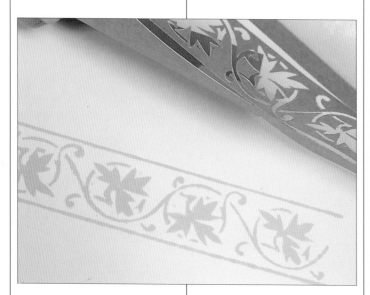

2 Compare the cleaner outlines of the sponged stencil with the previous brushed effect.

Stenciling with netting

Stenciling can be done with a huge variety of materials. The inhabitants of Fiji sometimes stenciled through banana and bamboo leaves which had been perforated by insects. Such ready-made natural or adapted stencils have been somewhat overlooked in the recent resurgence of the effect. This example is merely the tip of the iceberg but it may set you thinking about more inventive stenciling.

Lay the netting over the surface, either neatly and flat to produce an even effect, or in a slightly undulating arrangement. Use a nitrocellulose or enamel spray paint, but be sure to take all the precautions recommended by the manufacturer. When using any paint that is atomized under pressure, you should wear a mask and ventilate the area. You must extinguish all naked flames, including cigarettes, before beginning application. Paints in aerosol cans are very thin and will normally require shaking prior to use. A ball-bearing inside the can helps to mix the paint and thinner as you shake. You can reduce the noise by removing the cap from the can before shaking. When the paint has been well mixed, hold the aerosol in a vertical or nearly vertical position so that the feed pipe inside the can is not starved of paint. Hold the spray about 9 in. from the surface and move it along at a steady rate. Apply an initial dusting coat, followed by a slightly heavier one. This reduces the likelihood of runs.

Equipment
Netting
Spray paint, nitrocellulose or enamel
Mask

1 Lay the netting over the area. In this instance the fabric is allowed to undulate slightly. Shake up the aerosol paint, and apply it from a distance of approximately 9 in. Spray on a light, even coat, followed by another which is slightly denser.

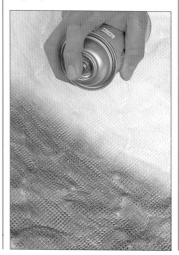

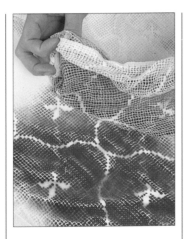

2 The undulating stencil produces a negative but still undulating effect. Where the fabric rested close to the surface, the print is sharp. Where it ballooned away, a softer, smoky effect is produced.

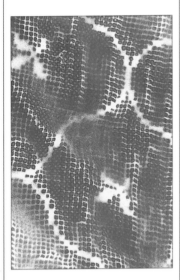

3 A closer look at the finished effect may prompt other ideas for this under-used type of stenciling.

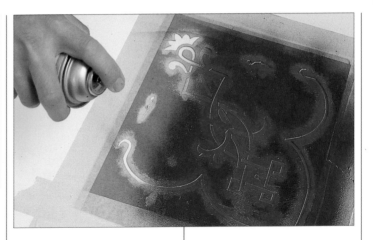

Stenciling with sprays

Spray paint is well suited to the technique of stenciling, because the airborne droplets that are propelled toward the surface are less likely to penetrate the stencil shield than paint applied by a mechanical method, such as the brush. The main problem that may arise with sprays is when a fine dust-like color strays underneath the stencil. This shadow effect can be attractive in softening an otherwise bold print and may be deliberately sought. It can be avoided, however, by using an adhesive spray on the reverse of the stencil to seal it in place during spraying. The adhesive prevents paint incursion but is slow-drying enough to allow removal of the stencil after the application of color. You will need to mask a much greater area around your work when using spray paint than would be necessary for other techniques, and you must observe the safety precautions on the can*.

Spray mist and gold paint
The effect known as off-spray, which originated as a by-product of stenciling with spray paint*, can be exploited in its own right by bouncing the spray off a piece of cardboard in a spray mist technique. Here, a second stencil is added using gold paint*.

Equipment
Stencil
Spray paint
Gold paint
Stencil brush
Cardboard
Masking tape

✳ Further information
Brushes *p.24*
Stippling gold fossil *p.92*
Registration marks *p.129*
Using spray paint with netting *p.131*

Spray stenciling
1 Secure the stencil with masking tape and shield the surrounding area with cardboard. Spray across the surface, maintaining a constant speed and a can-to-surface distance of about 9 in.

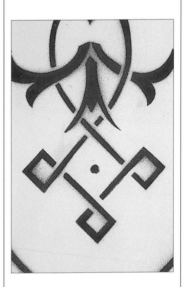

2 A close-up of the strong stencil shows how the smoky effect of off-spray shadows softens the overall effect.

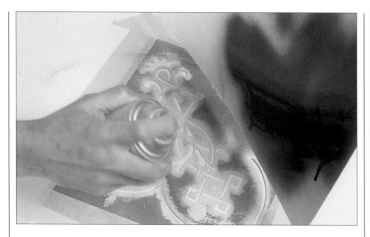

Spray and gold paint

1 Tape the stencil and the masking cardboard in position. Spray the paint onto the bounce cardboard and the off-spray, or rebounding particles, that are caught in the returning airstream will be deposited onto the stencil. Be careful to avoid a build-up of paint on the cardboard that may drip onto the work.

4 When the spray mist has dried, a second stencil is positioned by means of the registration marks*, and a peppery textured gold paint is stippled on* using a stencil brush.

Old gold stenciling

2 Gently remove the stencil to reveal the powdery effect.

3 The muted, dusty print acquired with this technique is perhaps the most charming of its type.

5 The completed stencil, exhibiting the qualities of a mixture of techniques and mediums.

Bronze powders* suspended in a solution of gold size* or latex glaze* can be used with stencils to emulate the gilded decoration found on japanned* pieces. Add an appearance of age by sponging* an aqua blue color – similar to that used in verdigris* – onto the underside of the stencil using a natural sponge*. Then attach the stencil to your chosen ground, which should be a dark color, such as black, dark green, or dark red, to set off the gold. Mix the gold in the same way as for gold fossil* or gold paint* making a fairly thick solution. Apply the mixture in the normal way, using a stencil brush*. When you remove the stencil, the gold figure will be apparent, speckled with flecks of verdigris*. Soften the effect by gently dusting it with a black enamel spray paint*. The finished effect will allow some areas of gold to shine more brightly than others, giving a dull, antique-like appearance.

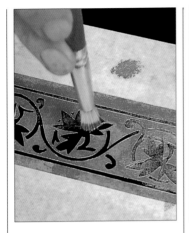

1 Apply the aqua blue latex to the underside of the stencil with a natural sponge, and secure the stencil to a dark-colored ground – here black has been chosen. Stipple the thick gold paint mixture onto the stencil in the usual way, using the stencil brush.

2 When the stencil is removed, the patches of aqua blue, which have been printed onto the surface by the underside of the stencil, are mingled with the gold.

Stenciling with an airbrush

Atomized paint need not come from a pressurized can. A fine, less regular coating of color can be obtained from a hand-powered airbrush. The airbrush in this example uses felt-tip pens, blowing a fine, concentrated jet of air across the tip to supply the color. The advantage of this type of application is that the risk of runs is dramatically reduced. The visual effect is light with varying shades of color.

Equipment
Stencil
Masking tape
Airbrush
Felt-tip pen

Equipment
Stencil
Masking tape
Aqua blue latex
Natural sponge
Stencil brush
Gold or bronze paint mixture
Black enamel spray paint

✳ Further information
Gold and bronze powders *p.28*
Gold size *p.122*
Mediums *p.10*
Japan work *p.122*
Verdigris *p.116*
Sponging on a dry ground *p.98*
Natural sponges *p.26*
Gold fossil *p.92*
Gold paint *p.127*
Brushes *p.24*
Stenciling with sprays *p.132*

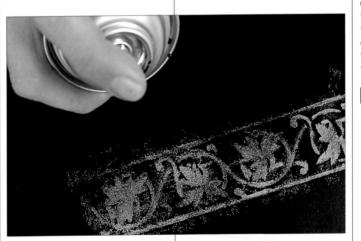

3 Apply the black enamel spray in a haphazard way to impart a feeling of age. This gives greater movement and character to the gold print and reduces the aqua blue speckles, helping the design to become part of the piece rather than merely a pattern laid on top.

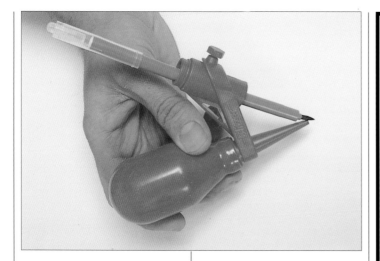

1 The airbrush – available from art and craft stores – which will atomize the ink from felt-tip pens.

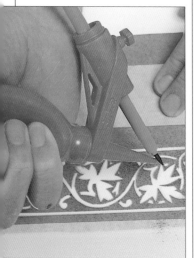

2 Position the stencil correctly on the surface and secure it with tape. Apply the color by squeezing the air bulb.

3 The gently curving speckled stencil has a soft and fugitive effect that could suit a quiet setting better than some of its more solid counterparts.

THE CURLING STENCIL

Problems with stencils normally revolve around the paint somehow encroaching onto the masked areas. The most common cause is the curling stencil. A useful way of reducing this phenomenon is to coat both faces of the stencil with nitrocellulose paint or lacquer. This effectively seals the cardboard and prevents any absorption from taking place. A build-up of paint on one side of the stencil, however, will eventually lead to certain sections of the stencil curling. As mentioned in connection with spray paint*, an adhesive spray can be used to hold the stencil in place. However, this technique is not feasible in an area which calls for many repeats – a border, for example. In this case, double-sided tape or masking tape folded back on itself can be a useful alternative.

1 The stencil is beginning to curl upward due to drying and therefore contracting paint.

3 Stick the tape gently but firmly into position.

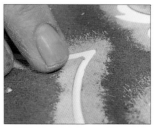

2 Cut double-sided or folded-back masking tape so that it fits snugly near the curling edge without interfering with the stencil shape.

4 Press the stencil back in place. Be extremely careful when you remove the stencil to avoid tearing.

Trompe-l'oeil

The French term, literally translated, means "tricking the eye," and this is a technique artists have used since ancient times to do just that: create the illusion of three-dimensional space on a flat surface. In Roman times, for example, building methods meant that walls were thick and windows narrow, so there were large areas of interior wall to be decorated. Vistas were painted to "open up" the dark, enclosed interiors with an impression of light and space. Skilled artists down the ages have continued to produce stunning effects, but even the simplest *trompe-l'oeil* can transform a bland surface or introduce a note of humor. It is easy to become so excited by the possibilities of this effect that you immediately want to seize the brush and paint a scene on a wall or some shutters. But probably the most effective *trompe-l'oeil* is so subtle that it is almost imperceptible, and this type of understated effect is the best starting point.

The manipulation of light and shade is essential to *trompe-l'oeil*. The light source must be first set and shadowing carefully painted in. It is this, together with foreshortening, which will give the feeling of depth. Choose a simple design with mainly straight lines, such as geometric paneling, and decide where it is to go. Prepare the ground well by cleaning it and keying it in lightly ready for paint*. Determine the size of your design and use a pencil and straight-edge to draw it. Choose a master color for the flat areas, and a lighter and a darker version of this to indicate highlights and shadows. When mixing these two shades, err on the side of subtlety. It is always easier to add definition than to take it away.

Equipment

Pencil
Measuring tape
Straight-edge
Triangle square
Artist's brushes
Master color
Master color tinted with black
Master color tinted with white

❋ Further information

Surface preparation *p.17*
Sanding *p.21*
Brushes *p.24*
Mixing colors *p.13*

1 Work out the size of your panel and draw it, using a soft pencil, straight-edge and triangle square.

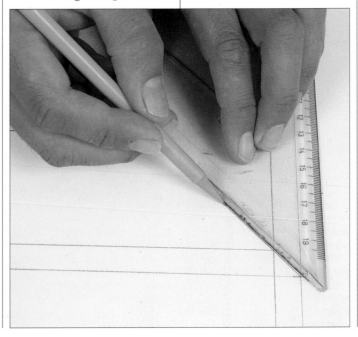

2 The completed drawing, together with the equipment used in its drafting. The mitered corners contribute to the impression of depth that will be reinforced by the paint.

3 Use an angled fitch* to apply the mid-tone, or master, color to the center of the panel and the area outside it.

5 Complete the areas of lighter tone before applying the darker shadow. Here, the darker tint is painted onto the wide molding at the bottom right-hand side of the panel.

6 The completed effect, with light coming from the upper left of the picture. Notice that when a molding catches the light its neighboring plane falls into shadow. This play of light and shadow using closely related tones of color is the key to *trompe-l'oeil*.

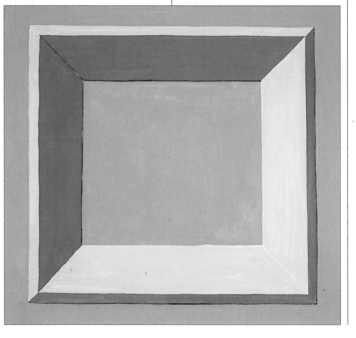

4 At this juncture it is important to determine where the major source of light is positioned. In this case, as the completed effect shows, the light is striking the frame from the top left-hand side. This places the upper and the left-hand sides of the thin molding in shadow, while the neighboring wide molding catches the light. The opposite tonal effect is created in the lower and right-hand sides of the panel. Here the pale tone is being applied to the thin outer molding which will form the bottom and right-hand edges of the finished panel.

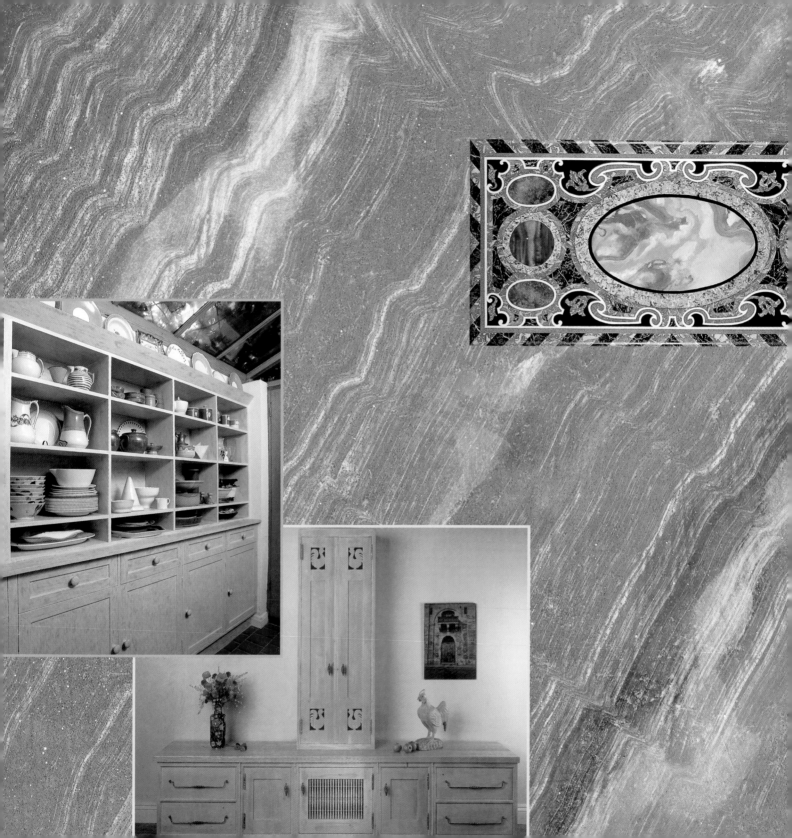

Themes

A decorative paint effect can only be judged in its overall setting. The gallery of rooms, walls, furniture and objects assembled here demonstrates a range of effects from the Techniques section. They are designed to show the techniques in a room setting or on specific objects and to inspire you to experiment. This gallery section is just a taster; if you keep your eyes open you will soon notice paint effects all around you in bars, restaurants, offices, and people's homes. Often you won't realize that you are looking at a paint effect until you have actually touched the "marble" or "wood" and found that it is false.

Floors

Treating a floor with paint effects can transform the appearance of a room. Many effects are suitable, from combing* and marbling* to stenciling* and *trompe-l'oeil**, depending on the setting and the desired mood. When choosing your effect, consider the area as a whole and visualize the overall pattern of your planned design in relation to the shape of the room and the furniture it will contain.

As with most jobs, planning and preparation* are the key to success. The floor must be repaired before any paint is applied. If you are working on floorboards, repair all loose and damaged boards, attached them securely with nails or screws. Next, achieve a smooth and even surface by sanding* the entire floor with a floor sander. These can usually be rented by the day. Then follow the sequence indicated for wood preparation*. Avoid sealing the cracks between each board as these allow movement and air circulation, and filling them could cause dampness.

✳ Further information

Surface preparation *p.19*
Sanding *p.21*
Combing *p.49*
Marbling *p.75*
Stenciling *p.128*
Trompe-l'oeil *p.136*

JASON BURKE/DAVID MENDAL
▲ This wonderful floor would require artistic ability to emulate. The peacock design was painted in oils onto stripped floorboards, sealed with flat varnish and polished with beeswax.

THOMAS LANE
▶ Although this beautiful floor looks as if it has been made in a mixture of natural woods, in fact the entire expanse has been painted with oils and then lacquered. Some of the design has been done freehand and some has been stenciled.

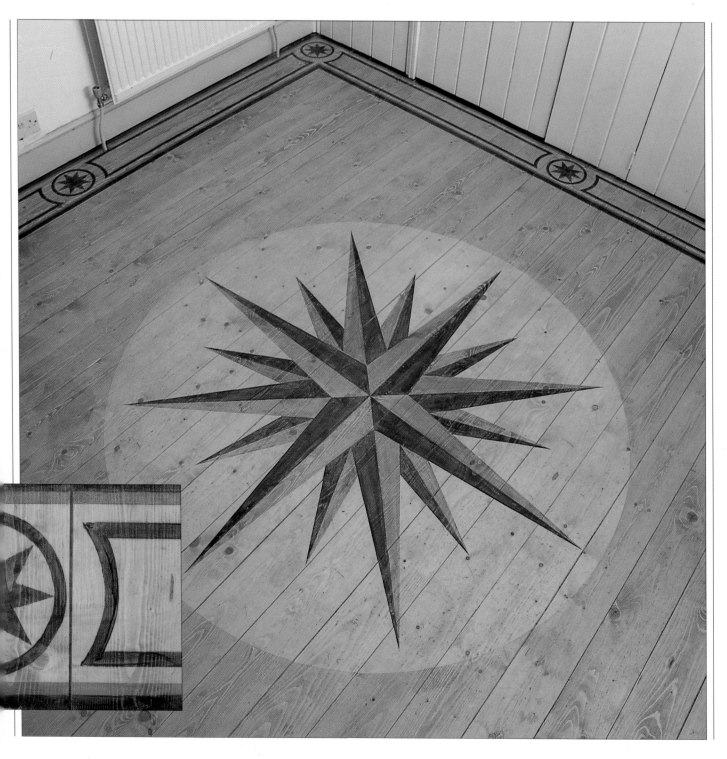

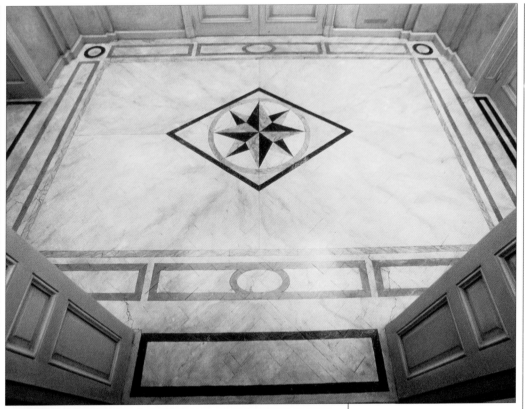

THOMAS MASARYK
▲ Floor cloths were popular during the 18th and 19th centuries and are now making a comeback. Painted on canvas, they can be moved from room to room, or indeed house to house. This floor cloth uses a variety of marble techniques in acrylic colors to create a fish design that is reminiscent of ancient Greece.

GONZALO GOROSTIAGA
◄ ▲ A quartered effect, with different colored frames of marble and a powerful central design, echoes the symmetry of the room, transforming an empty space into a luxurious vestibule. The painted cracks running from the baseboards lend an air of antiquity to the classical design. Beneath the effect lies parquet flooring, an ideal surface for painting because the tightly fitting pieces of wood can be sanded and filled to a smooth unbroken surface.

Walls

Doors

◆

Fireplaces

Choose the color of your walls with care. They are the largest area of a room and their color will be the key to your décor. Remember that a color will seem stronger when it is on the walls because of its increased area. Dark colors will reduce the size of a room and pale colors will add light. Consider which way the room faces, and check the color circle* for shades that will lend warmth or coolness*.

Because the wall is a large expanse, even the quickest finish will take some time, and the decoration of walls calls for a methodical approach. Preparation* is by far the most important part of the process. If the surface is not smooth and clean, even a specialist would have problems, and no amount of later care will make up for skimping in the early stages.

✱ Further information

Color circle *p.8*
Using color *p.9*
Preparation *p.17*

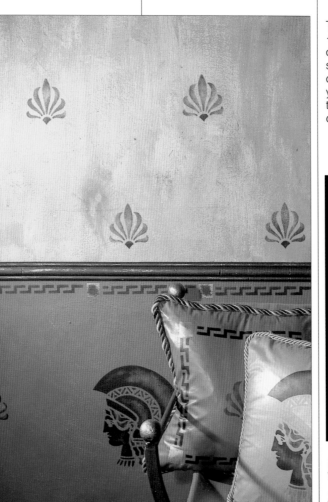

THE STENCIL LIBRARY
◄ With appropriate choice of colors and a classical design, stenciling can be used to create a period look. Making your own stencils enables you to echo the pattern on a cushion or a curtain border.

RICHARD LOWSLEY WILLIAMS
▲ Burl walnut graining gives this newel post a mellow richness, complemented by the golden cord with tassel which replaces the handrail.

PETER FARLOW
▼ A wealth of effects come together in this impressive hallway, which combines several types of marbling with *trompe-l'oeil* on walls and stairs and includes mahogany graining for the radiator cover. Above the *trompe-l'oeil* stair rail, a stone block effect provides a suitably imposing but refreshingly neutral counterpoint to the luxurious marbling below it on the wainscot and up the stairs.

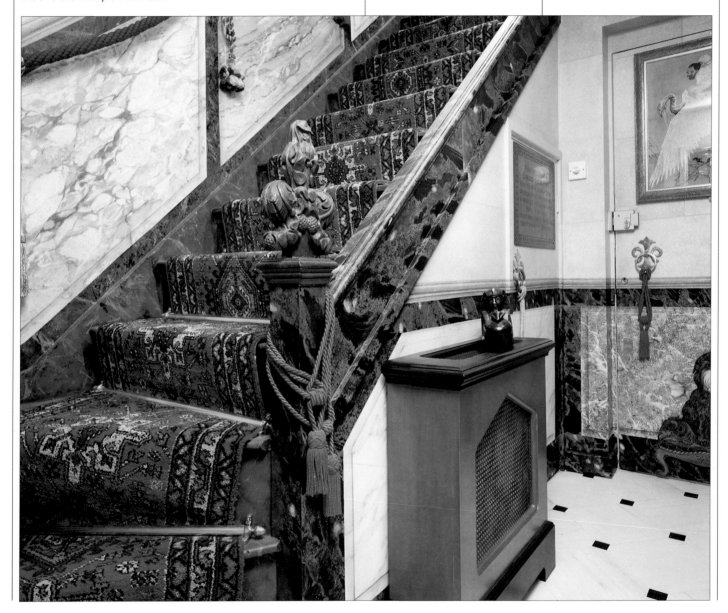

SIMON CAVELLE
▲ The blue and yellow of a curtain fabric are picked up separately on the wall, in a color wash above the wainscot rail and a rich blue drag below.

RICHARD LOWSLEY WILLIAMS
▲ A burl walnut grained door with textured frame closes onto a hallway made dramatic by stone blocking whose rich color is reflected by suitably splendid accessories.

RUPERT FORBES ADAM
▲ A white spatter over deep blue-gray, complemented with handsome mirrored stone vessels, gives this bathroom an opulent look.

ROGER F. SEAMARK
▼ This room conveys the artist's sense of humor as well as his skill in a series of *trompe-l'oeil* treatments across a flat wall. Contrasting textures are explored, from the wood effect mounts and feathered trophies to the marblized niche with ginger jar and the paper that curls to reveal brick. The floor is marbled in blocks, and the chairs are antiqued. Sparsely furnished, the room has an intentionally surreal flavor.

MARK WILKINSON
▶ In this Santa Fé style kitchen ash woodwork is set off by green walls that have been flogged with a rag in three different colored glazes – a combination of ragging and flogging.

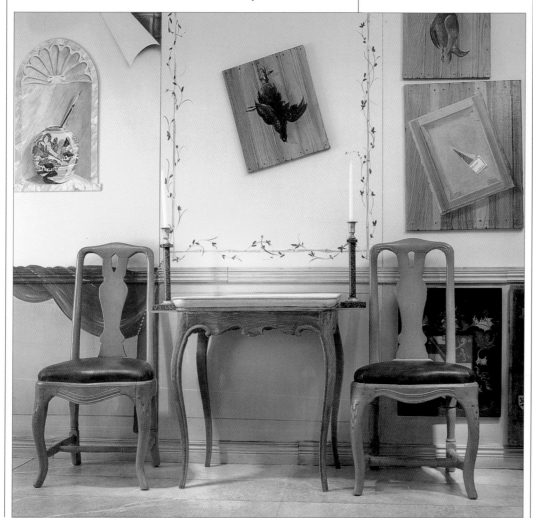

MICHELLE BLACKLER
▲ This luxurious marble treatment helps to give a palatial feel to a highly original bathroom.

BELINDA BALLANTINE
▶ Gilding and antiquing transform a plaster accessory into an opulent decoration.

JASON BURKE/JONATHAN BRUNSON
◀ This rich but subtle bathroom incorporates a variety of paint effects. The colorwashed walls have been painstakingly stenciled to imitate wallpaper; the ceiling has been eggshelled, colorwashed and varnished; the plaster surroundings are highlighted in lacquered bronze powder; the wall below the wainscot is ragged and real marble has been matched with faux marble.

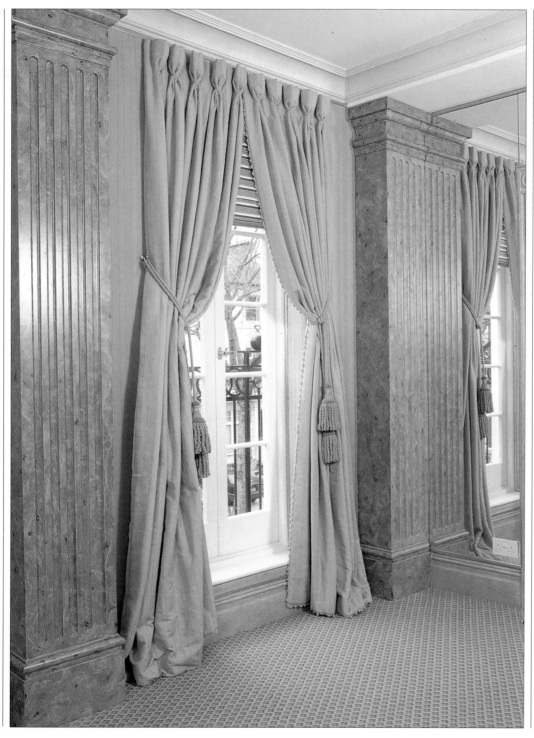

SIMON CAVELLE
◄ These twin fluted pilasters have been treated with a faux walnut grain which warms and enriches them and provides a frame for the French window. The color carries through the line from the ceiling and is light enough to blend with the neutral shades of the room.

TANIA VARTAN
▼ *Trompe-l'oeil*, featuring a motif suitably evocative of sweet music, poetry and dreams, uses oil on canvas to create a wonderfully romantic bedhead backed with blue sky.

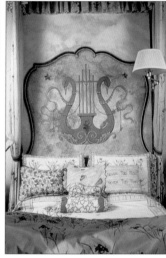

PETER FARLOW
► This imposing room scheme eschews wallpaper for a stencil design which has been employed over a green wash. The color is continued and deepened in the heavy, opulent marbling of the wainscot and the frame of the mahogany grained doors. The striking floor pattern is made of inlaid wood.

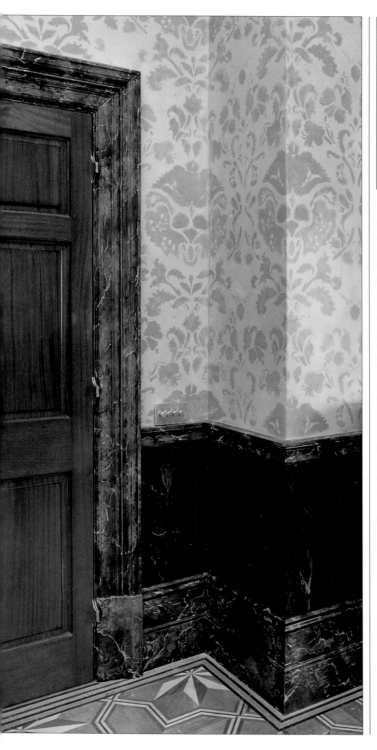

Doors

Doors are often overlooked when planning a decorating scheme. This is a pity since the door is a focus of attention as you enter a room – it heralds what is to come. The door, together with the surrounding molding, lends importance to the room, even before you see the room itself.

As a door is opened it will often glint in the light, revealing any flaws in the finish. This means it is particularly important to prepare* the door surface well (making sure it is sanded* until smooth) and to finish it with sealer or finish.

The handle should complement the finish or style of the door – a cheap modern handle, for example, will totally ruin an old paneled door, however beautifully it has been finished.

✻ Further information

Preparation *p.21*
Sanding *p.19*

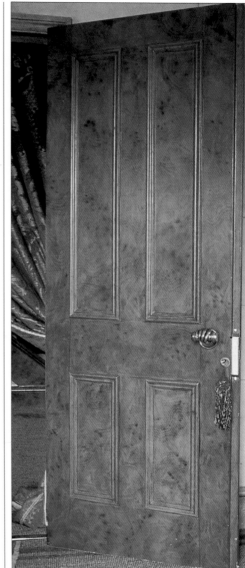

RICHARD LOWSLEY WILLIAMS
▲ Burl walnut graining transforms this ordinary paneled door. Its air of grandeur is reinforced by the stone blocking treatment of the wall and the textured stone baseboarding.

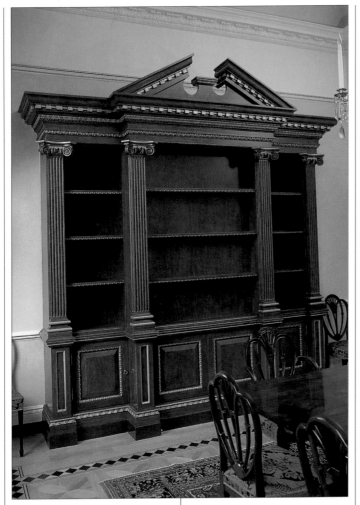

RICHARD LOWSLEY
WILLIAMS
◄ The sober stability of faux
stone blocks is here
contrasted with the natural
strength of an undressed
stone effect. Techniques for
both are similar, but the
plaster for the rough-hewn
effect is worked over more
vigorously before painting to
achieve its coarser texture.

JASON BURKE/JONATHAN
BRUNSON
▲ Rich yellow walls
complement the mahogany
graining of an unusual piece
that doubles as dining room
cabinet and concealed door
to the kitchen. Achieving a
finish of this quality requires
skill and patience – eight
coats have been applied
ranging from an eggshell base
through flogging,
checkrolling, glazing,
varnishing, and antiquing.

JASON BURKE/JONATHAN
BRUNSON
► This sumptuous entrance
to a woodgrained study
achieves its effect through the
contrast between simple off-
white and rich gold. The gold
is a mixture of bronze powder
and nitrocellulose lacquer.

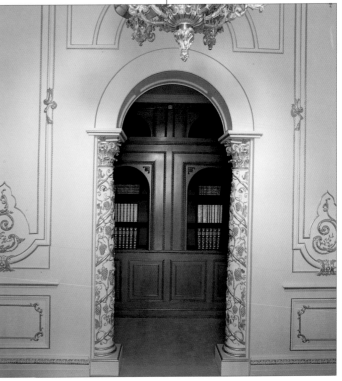

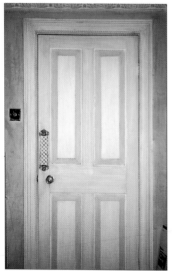

▲ These seemingly different door effects were both achieved by dragging. The four-panel door has received a standard dragging treatment. The other door has been dragged with the aid of tape to produce miter joints which match its construction.

Fireplaces

If you are lucky enough to have a fireplace in your room, it makes a natural focal point. There may already be an existing mantel and fireplace, or you may want to create an entirely new one. In either case, your choice of finish will be dictated by the kind of atmosphere you want to convey. A marble surrounding, for example, will immediately suggest a formal decor, while a brick surrounding may lend itself to a country look.

Marbling*, graining* and *trompe l'oeil** will all create spectacular focal points which contrast with the decor, while softer effects such as sponging can tone in with the surrounding walls, meaning that attention is focused more on the decorative objects on the mantel, or on the picture above the fireplace.

✱ Further information
Marbling *p. 75*
Graining *p. 63*
Trompe l'oeil *p. 136*

RUPERT FORBES ADAM
▶ This delightfully patterned fireplace with its subtle shading is gently complemented by the pale green ragging of the walls.

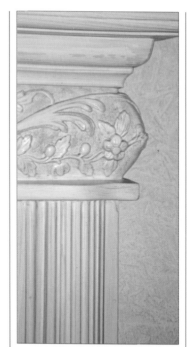

BILL HOLGATE
▼ This classically inspired broken pediment design has been finely marbled over golden yellow to suggest a discreet opulence. This is a good example of how paint effects benefit from subtlety, particularly when the ground is unusual or dramatic.

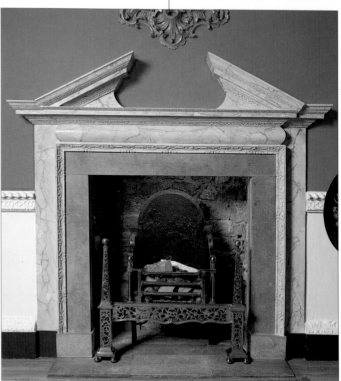

Furniture

Tables
◆
Chairs
◆
Cabinets

Furniture lends itself particularly well to paint effects. Traditional designs can be shown to their best using marbling* and graining* techniques. More contemporary pieces benefit from the fresh use of color, which has never before been available in such a wide and exciting choice. As a rule, ornate furniture profits from subtle treatment, and a simple design can often be enhanced by a bold finish. Color can modify the character and even the apparent dimensions of a piece. A dark color tends to reduce the thickness of the legs on a table or chair. Bright, sunny colors give a country look, and dark, rich shades convey an air of elegance and refinement.

Painted furniture demands a much higher quality of finish than that of walls, and it can be more intricate to work on. It helps to turn a table or chair upside down and treat the innermost surfaces first. Often it is advisable to allow one area to dry before continuing, and you may occasionally need to varnish areas that could be damaged if left unprotected. All furniture should be safeguarded from wear and tear by two or three coats of varnish at least.

❋ Further information
Marbling *p. 75*
Graining *p. 63*
Varnishing *p. 29*

Tables

The word table derives from the old French *tablel* meaning a *tableau* or painted scene. Ironically, tables today are seldom given an interesting paint finish. Instead, they are simply stained or varnished. Decorative paint effects allow you the opportunity to try something different – marbling, woodgraining, lapis lazuli, malachite, spattering, dragging, pickling, liming, *trompe l'oeil* – these are just some of the ways of turning an ordinary table into an exciting decorative accessory.

Obviously, tables differ dramatically in build and appearance – ranging from a robust kitchen table with scrubbed top and heavy legs to a delicate occasional table with such fine legs that the top seems to float. When considering the decoration of a table, ask yourself how it will be used and spend some time considering its design. The finish should complement the piece of furniture, not fight it.

LILLI CURTISS
▲ Multicolored sponging gives texture and weight to this modern coffee table. The stone effect suits the wrought iron design, and the choice of color prevents it from appearing too heavy.

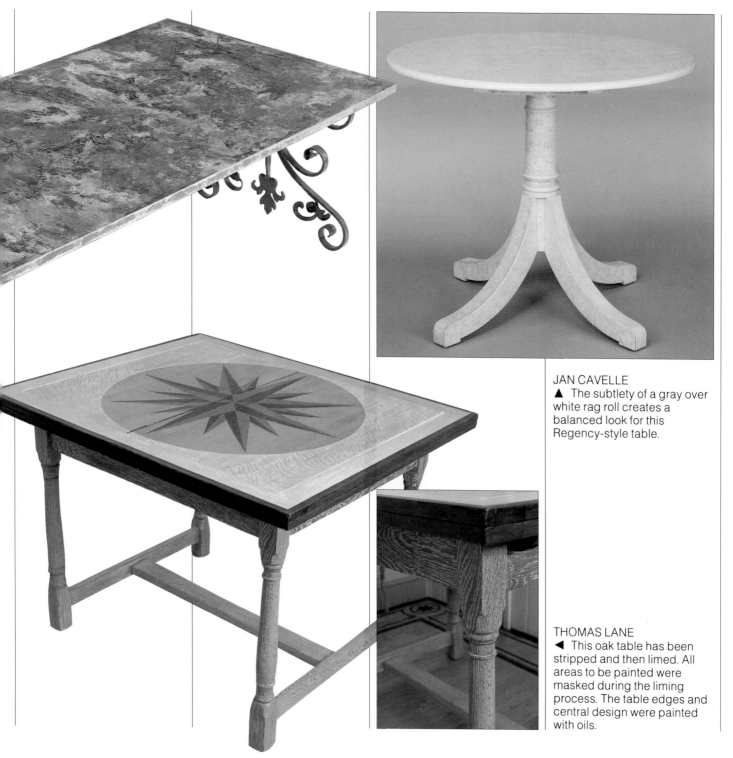

JAN CAVELLE
▲ The subtlety of a gray over white rag roll creates a balanced look for this Regency-style table.

THOMAS LANE
◄ This oak table has been stripped and then limed. All areas to be painted were masked during the liming process. The table edges and central design were painted with oils.

ROGER F. SEAMARK
► The antiqued glazes on this table pick up the blue in chairs and walls to contribute to the romantic pastoral theme of this room with its air of chic prettiness.

THE BERMUDA COLLECTION
▼ This understated table, antiqued with a lovely honey-colored craquelure holds a surprise in its two *trompe-l'oeil* postcards.

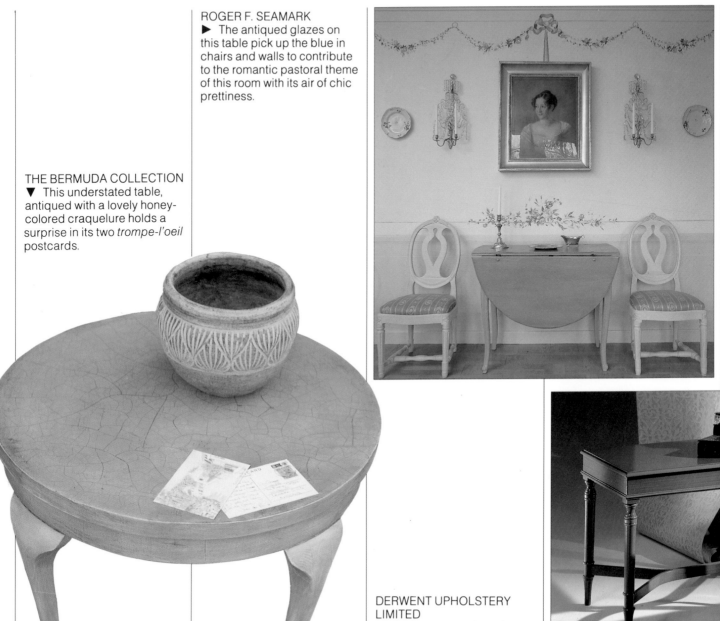

DERWENT UPHOLSTERY LIMITED
► Red over gray dragging gives these tables an oriental feel, which has been emphasized by the choice of curtain material and ornaments. Entirely different effects can be produced by varying the colors.

SARAH DELAFIELD COOK
◄ A chess table decorated with découpage in the rococo style. The gold designs evoke the noble and ancient origins of the game, and the craquelure varnish adds to the feeling of antiquity.

LILLI CURTISS
▲ The charming proportions and details of this dainty table have been highlighted with antiqued gold leaf. Notice where the red ground has been allowed to show here and there through the gold.

Chairs

A chair is a far more complicated piece of equipment than you might think. It not only has to withstand the weight of a human frame, but also survive bad treatment such as rocking back and forth. This means that before you think about finishing a chair, you should check its structural soundness and make any necessary repairs.

A chair can be very complicated to paint and it is advisable to approach it in a well-planned manner. Begin with the chair upside-down and tackle the stretchers and then the legs. Next comes the underside of the seat. At this point the chair can be turned back onto its legs. Check that you have painted all the parts below seat-level before starting on the back, the arms and finally the seat.

Chairs, like tables, can be treated adventurously. Pickling and liming are popular choices, as are sponging, dragging, graining, and gilding. Much depends on your overall decor – is it period or modern, rural or sophisticated, simple or elaborate?

SASHA WADDELL
▶ The distressed finish of this chair makes it blend into its environment. The blue echoes the blues of the curtains and bed, while the bright throw pillow both enlivens it and ties in with one of the bed pillows.

JOYCE HOWARD
▲ An ordinary chair has been turned into folk art by the clever use of paint. Designs like these can be painted freehand or drawn on tracing paper and then transferred. Varnish is essential to protect the piece.

SIMON CAVELLE
▲ The detailing of this chair back is picked out with liming paste to give a chalky appearance suggestive of years of use.

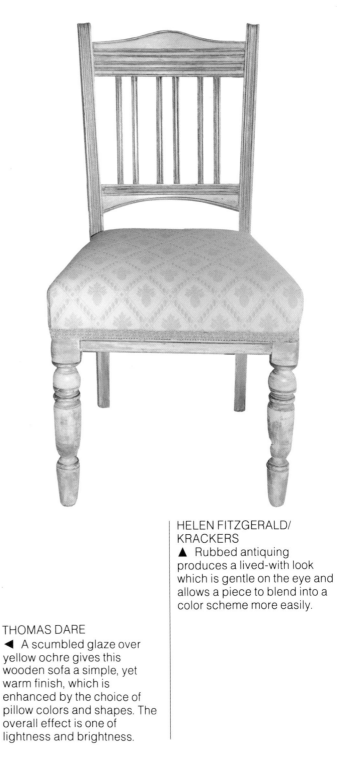

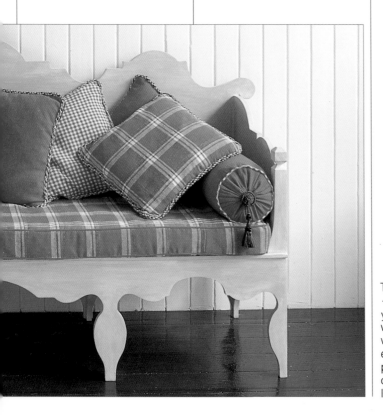

THOMAS DARE
◀ A scumbled glaze over yellow ochre gives this wooden sofa a simple, yet warm finish, which is enhanced by the choice of pillow colors and shapes. The overall effect is one of lightness and brightness.

HELEN FITZGERALD/ KRACKERS
▲ Rubbed antiquing produces a lived-with look which is gentle on the eye and allows a piece to blend into a color scheme more easily.

Cabinets

Kitchen cabinets or units, more than any other item of furniture, require protective finishing. Regardless of the paint effect you choose, always finish with several coats of polyurethane varnish. Kitchen units are a popular subject for decorative paint effects and a successful finish can make all the difference to the appearance of the kitchen. Liming, pickling, dragging,

distressing, color wash and stenciling are just some of the choices available.

An ordinary non-kitchen cabinet receives less wear and tear, but you still need to think about the demands that will be made upon it and to consider the design. Does it have drawers, doors, or both? How are these fitted to the carcase? Do the drawer fronts stand proud or lie flush with the frame? All these moving parts need to be checked before you start decorating. Before you begin painting, make sure that all moving parts are masked to prevent a build-up of paint that will jam or impede their movements. Never paint the drawer runners (pieces of wood that the drawer slides on), as this will impede their smooth operation.

THOMAS MASARYK
▲ The harmonious finish for this Oriental piece is provided by distressing with different shades of oil glaze used over wood.

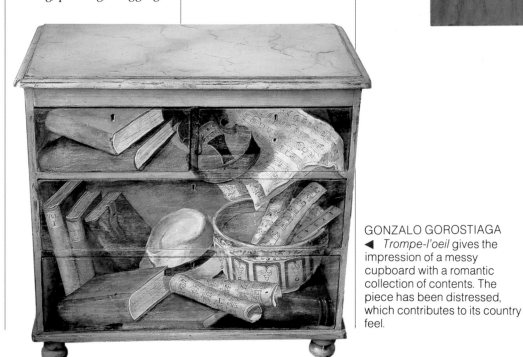

GONZALO GOROSTIAGA
◄ *Trompe-l'oeil* gives the impression of a messy cupboard with a romantic collection of contents. The piece has been distressed, which contributes to its country feel.

PAVILION ORIGINALS LIMITED
► This stenciled cabinet blends with the dragged stripes of the wall, creating a fresh relaxed atmosphere due to its colors and graceful symmetrical patterning. The lines that partially frame the design anchor it to its setting. Without them the design would lack focus.

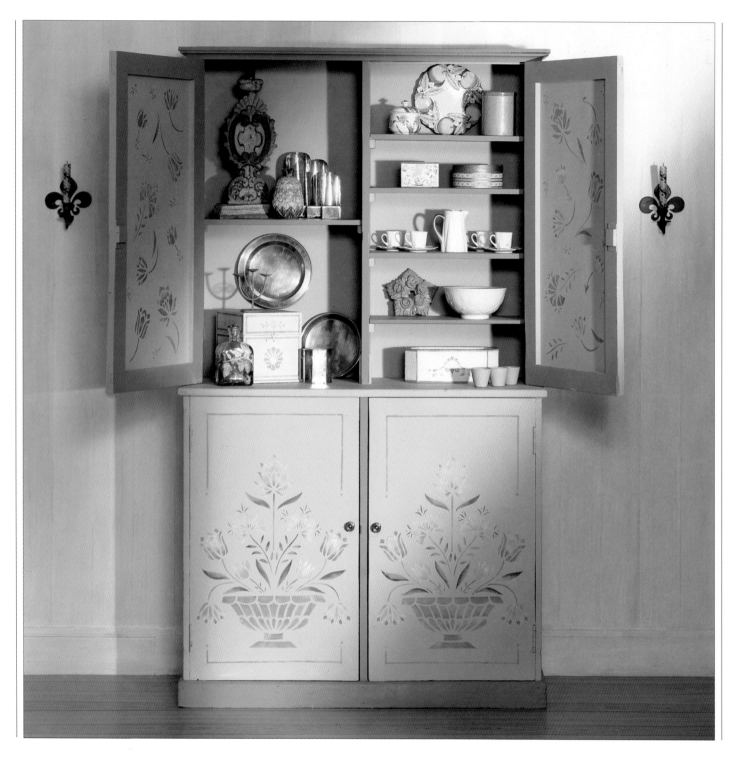

THOMAS MASARYK
▼ The diversity of coloring and effects achievable in marbling is displayed by this desk. The inset geometrical design is reminiscent of illuminated manuscripts.

MARK WILKINSON
▲ This Provençal-style sideboard has been painted with layers of blue-green color wash, antiqued by rubbing, and waxed to achieve a translucent effect.

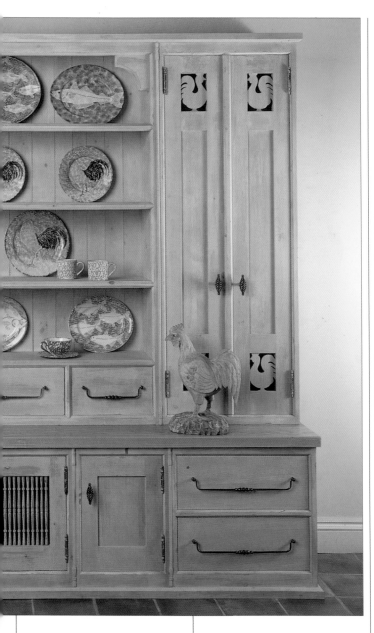

JOYCE HOWARD
▶ This detail from a sideboard shows what can be achieved with some artistic skill. The design is drawn on tracing paper, transferred, painted, antiqued, and then varnished.

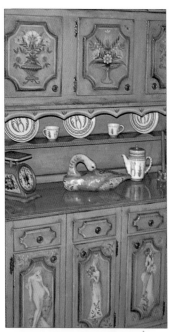

JASON BURKE/JONATHAN BRUNSON
▼ A mixture of burl walnut and fantasy woodgraining provides a fitting setting for the leatherbound books in this study. Oil glazes were applied over a water-based ground and then finished with varnishes – five coats in total.

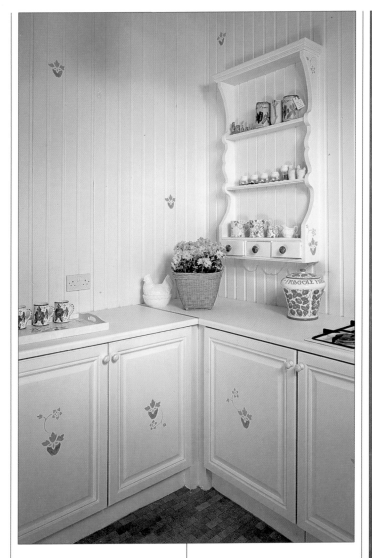

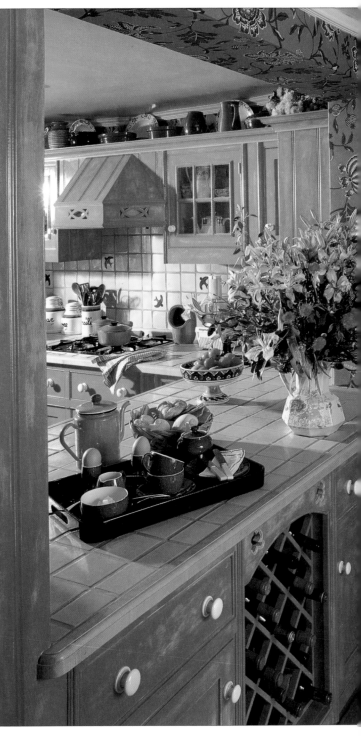

PAVILION ORIGINALS
LIMITED
▲ Surfaces dragged in clear
pale lemon glaze make this
Scandinavian style kitchen
appear more spacious.
Unadorned, it could be bland
or over-cool. But the
strawberry stencils provide
the simple note that gives the
room its charm.

SMALLBONE
▶ The paintwork in this
kitchen has been distressed to
imitate the effect of wear and
tear, giving it the warm,
relaxed atmosphere of a much
used and loved room.

SIMON CAVELLE
▶ This new alcove caninet has been treated with a pāle antiquing effect, given definition by the gilded moldings, and topped with a highly polished faux slate effect which picks up the dark marble from the fireplace.

MARK WILKINSON
▼ Light sponging in a warm salmon pink gives this kitchen an atmosphere at once elegant and intimate.

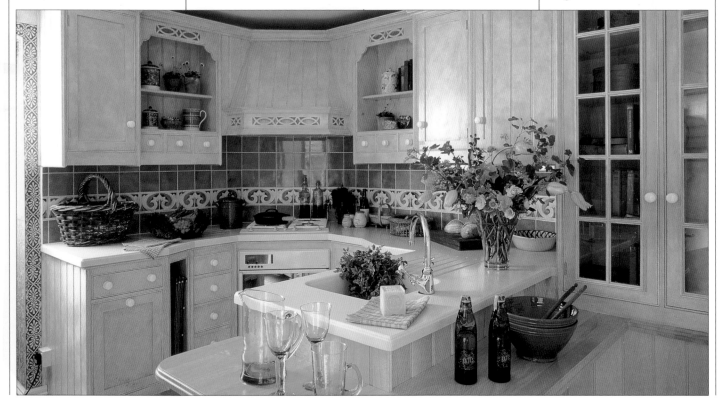

MARK WILKINSON
▶ This classy kitchen with its twisted columns and uncluttered cornice is skillfully stained to add weight and importance to various sections and to bring out the knots and grain of the wood. The walls are treated with the gently blurred wash effect known as scumbling.

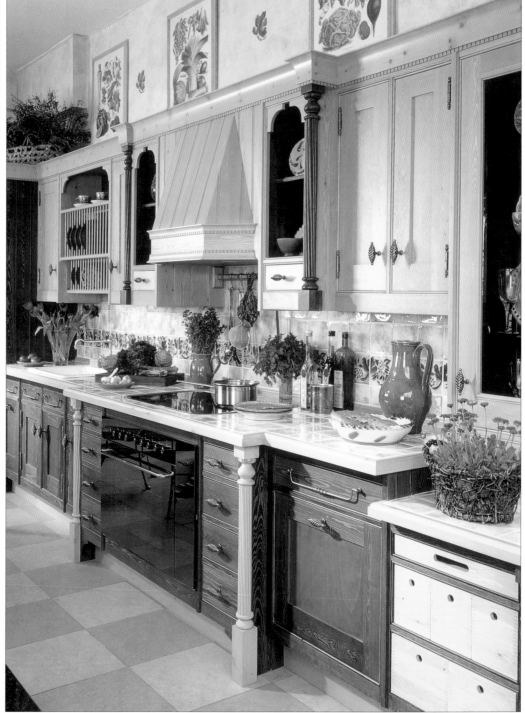

SMALLBONE
▲ Pretty soft-toned stencil designs over dragged blue are given definition by the strong box lines. The stencil pattern has been varied to suit the dimensions of the doors and drawers.

Decorated accessories

Almost any item for the home can be given a decorative paint treatment. Mirror and picture frames, chests, wastebaskets, boxes, clocks – the list is endless. Cheap items, picked up in secondhand stores and garage sales, can be entirely transformed with clever use of découpage*, stenciling*, *trompe l'oeil** and other paint effects.

Smaller items, particularly when you are new to paint effects, are less daunting than major projects such as an entire room or a large piece of furniture. You can feel free to experiment and to learn and, as a result, you can have a great deal of fun for a minimum amount of expenditure.

The pictures in this section show a small sample of decorative accessories, ranging from chests to milk churns, with the aim of sparking off your creativity.

❋ Further information

Découpage *p.120*
Stenciling *p.128*
Trompe l'oeil p.136

CAMILLA J. H. REDFERN
▼ These two imposing candle-holders, have been painted black and skillfully gilded to give the brilliant but mellow finish appropriate to an antique object.

◄▼► Four different treatments for old chests illustrate the diversity of styles achievable with paint. *Trompe-l'oeil* gives an illusory peep at a mellowed and non-existent collection of sports equipment; highly varnished stenciling in vibrant colors on black conjures up the folk art of the canal narrow boats; a blanket box has been color-washed and stenciled in muted colors, then rubbed to emphasize its age; and hand painted figurative designs have been given an antiqued finish.

JANE DARBY DESIGNS
▲ A hatbox delicately decorated with découpage and antiqued with a golden varnish reflects the fanciful details of a bygone age of elegance.

CHARLOTTE OAKES
► This arabesque wall sconce is the ideal ground for a verdigris effect, which lends it the characteristic blue-green patina of weather-worn antique metalwork.

► This oak clock has been stripped and then limed. Oak is particularly suitable for liming because of its open grain.

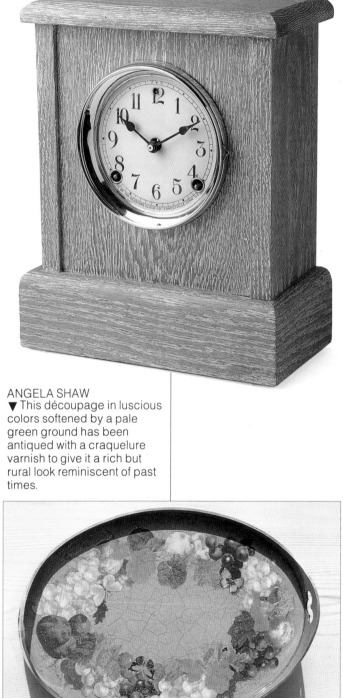

ANGELA SHAW
▼ This découpage in luscious colors softened by a pale green ground has been antiqued with a craquelure varnish to give it a rich but rural look reminiscent of past times.

JANE DARBY DESIGNS
▲ A bold découpage in light-filled colors, given depth by the rounded surface and dark ground, assigns this old milk can a new role as a beautiful decorative object.

CHRISTIAN THEE
◄ This screen, designed to stand in front of a window, adds humor to its jungle view with the inclusion of monkeys peeping through the greenery. The scene, which hints at the exotic imaginary landscapes of Rousseau, is given increased perspective by the box, which has been treated with the same effect.

GONZALO GOROSTIAGA
◄ A wooden screen painted in a *trompe-l'oeil* manner. Clever use of light and shade in the fabric folds, and coloring that echoes and enriches that of the background, draws the eye to admire the effect itself rather than simply seeking to deceive it.

MARK WILKINSON
▼ This screen has been heavily distressed to give the impression of a worn, battered piece of Provençal-style furniture.

CAMILLA J. H. REDFERN
▼ This ornate mirror frame has been gilded and gently antiqued using a raw umber glaze. The patina of age gives the piece greater weight and style and will add elegance to any room.

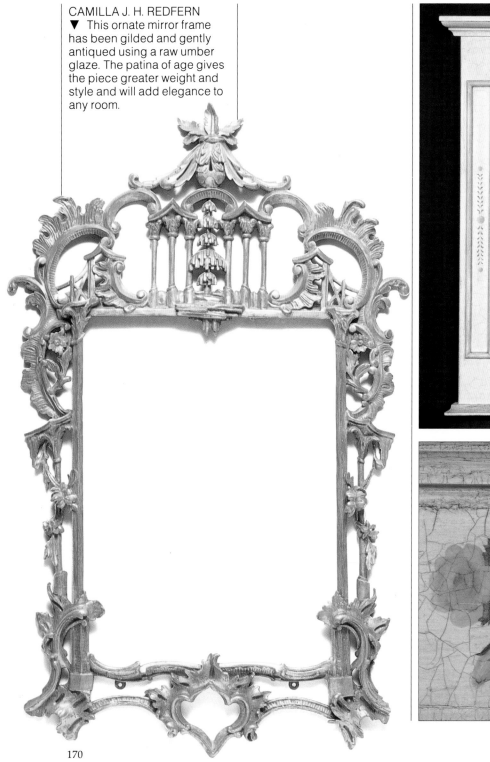

ANGELA SHAW
◀ This pretty mirror frame, decorated with blue and gold moldings and hand-painted floral designs, has been treated with craquelure to give it a faded, time-worn look. The fine cracks have been highlighted by rubbing in an umber glaze, without which they would be almost invisible.

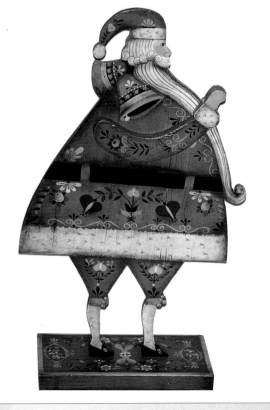

JOYCE HOWARD
◀ This colorful folk art Santa Claus will brighten your festive season. Made from wood, it has been painted, antiqued, and then varnished.

RUPERT HANBURY DESIGNS
▼ These wastebaskets have been transformed by dragging and sponging. The dark lines gently emphasize their shapes and add interest.

LILLI CURTISS
▲ Silver leaf and gilding combine to make an elegant surrounding for a mirror. In this case, the mirror has an unconventional finish, making it more artistic than functional.

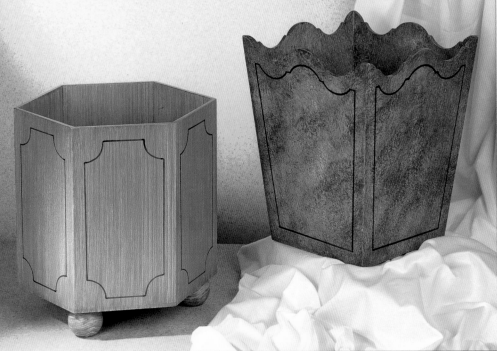

Index

Credits

The author would like to thank Sally MacEachern, Penny Cobb, and Mary Senechal for their incredibly hard work and whole hearted support, Jo Foster for transcribing the manuscript, John Wyland for the step-by-step photography, and the entire staff of K.L.C. School of Interior Design for their enthusiastic help. A special thanks to Jenny Gibbs, Kate Young, and my family, without whom this book would not have been possible.

Quarto would like to thank the following suppliers who loaned materials for photography or contributed materials for use in the demonstrations:

Airtoys; Belinda Ballentine School of Painted Furniture; J W Bollom & Co Ltd; C Brewer and Sons Ltd; E Polton (Sundries Ltd); The Cast Iron Shop; Daler-Rowney; Finer Frames Ltd; John Myland Ltd; Oakleaf Reproductions Ltd; J H Ratcliffe & Co (Paints) Ltd; Sainsbury's Homebase.

Quarto would like also to thank the following for contributing pictures of their work and for permission to reproduce copyright material:

Rupert Forbes Adam, Richardson's, Skipworth, Selby, North Yorkshire, YO8 7SQ;

Belinda Ballentine School of Painted Furniture, The Abbey Brewery, Malmesbury, Wiltshire, SH16 9AS;

The Bermuda Collection, Jamie and Betsy Sapsford, Unit 63, Smithbrook Kilns, Cranleigh, Surrey GU6 8JJ;

Michelle Blackler, Studio Southwest, 49 Fulham High Street, London SW6;

Jason Burke/Jonathan Brunson, Alternative Interiors, 13 School Road, Hampton Hill, Middlesex TW12 1Ql;

Jan Cavelle, 7 Station Road, Clare, Suffolk CO10 8NJ;

Lilli Curtiss, 401½ Workshops, 401½ Wandsworth Road, London SW8 2JP;

Jane Darby Designs, Jopes Mill, Trebrownbridge Nr Liskeard, Cornwall PL14 3PX;

Sarah Delafield Cook, 7A Anhalt Road, London SW11 4N3;

Derwent Upholstery Ltd, Greenhill Industrial Estate, Greenhill Lane, Riddings, Derbyshire DE55 4BR;

John and Sheila Elliot, Elliot Studio Galleries, 304 Highmount Terrace, Upper Nyack-on-Hudson, New York 10960;

Peter Farlow, 199 Westbourne Grove, London W11 2SB;

Helen Fitzgerald, The Lane, Newark, East Sussex BN8 4QX;

Gonzalo Gorostiaga, 6 Puma Court, London, E1 6QG;

Susie Gradwell, Southview, Moorlynch, Bridgewater, Somerset TA7 9BU;

Rupert Hanbury, The Kernals, Bartlow, Cambridge;

Bill Holgate, The Bungalow, 62 Littlemoor Road, Clitheroe, Lancashire BB7 1EW;

Thomas Lane, Painted Interiors, 57 Wellington Row, London E2 7BB;

Richard Lowsley Williams, Flat 4, 82 Cambridge Gardens, London W10 6HS;

Thomas Masaryk, 4260 Main Street, Stratford, Connecticut, 06497, USA;

Charlotte Oakes, 376 St Johns Street, London EC1V 4NN;

Pavilion Originals Ltd, 6A Howe Street, Edinburgh EH3 6TD;

Camilla J H Redfern, 32 Abbey Business Centre, Ingate Place, London SW8 3NS;

Roger F Seamark, Karlavagen 68, 114 59 Stockholm, Sweden;

Angela Shaw, Flexford House, Hog's Back GU3 2JP;

Smallbone, 105–109 Fulham Road, London SW3;

The Stencil Library, Nesbit Hill Head, Stamfordham, Northumberland NE18 0LG;

Christian Thee, 49 Old Stage Coach Road, Weston, CT 06883, USA;

Tania Vartan, Ecole Et Atelier, Le Bariel, Rond Point Ste Claire, 06570, St Paul De Vence, France;

Sasha Waddell, c/o Codrington Furniture, Arch 80, Chelsea Bridge Business Centre, Queenstown Road, London SW8;

Mark Wilkinson Furniture, Overton House, Bromham, Wiltshire SN15 2HA.

Additional picture credits:

p12 **Peter Farlow** p13 **Simon Cavelle** p118–19 from top left **G. Gorostiaga, Susie Gradwell, Camilla J. H. Redfern** p138–9 from top left **Thomas Lane, Mark Wilkinson, Thomas Masaryk, Thomas Lane.**

Quarto would like to thank the following:

Theo Woodham Smith Public Relations for supplying transparancies of Mark Wilkinson's work; Halston PR Ltd for supplying work by Smallbone; The Royal Pavilion, Brighton; John Elliot for supplying transparancies of Joyce Howard's work.

Useful addresses

For all types of faux finishing supplies:
Dick Blick, P.O. Box 1267, Galesburg, IL 61401, (800) 447-8192

Daniel Smith, 4130 First Avenue South, Seattle, WA 98134, (800) 426-6740.

For specialist brushes:
Janovic/Plaza, 30–35 Thomson Ave, Long Island City, NY 11101. (800) 772- 4381